GREAT MOMENTS IN
IRISH RUGBY

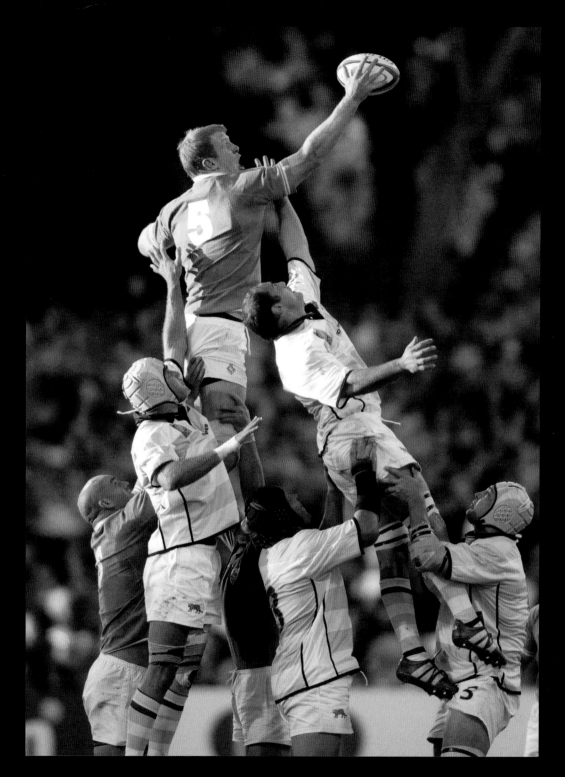

26 October 2003

Paul O'Connell of Ireland wins a lineout against Gonzales Longo of Argentina during their 2003 Rugby World Cup clash in Adelaide. Ireland v Argentina, 2003 Rugby World Cup, Pool A, Adelaide Oval, Adelaide.

Brendan Moran / SPORTSFILE

GREAT MOMENTS IN
IRISH RUGBY
from SPORTSFILE

THE O'BRIEN PRESS
DUBLIN

First published in hardback in 2018 by The O'Brien Press Ltd,
12 Terenure Road East, Rathgar,
Dublin 6, D06 HD27, Ireland.
This updated paperback edition published 2019
Tel: +353 1 4923333; Fax: +353 1 4922777
E-mail: books@obrien.ie
Website: www.obrien.ie
The O'Brien Press is a member of Publishing Ireland.

ISBN: 978-1-7884-133-4

Thanks to Oscar Rogan, Gerard Siggins, Donn O'Sullivan, John Byrne,
Nicola Reddy, Ivan O'Brien & Brendan Moran for their assistance with captions.

10 9 8 7 6 5 4 3 2 1
23 22 21 20 19

Layout and design: The O'Brien Press Ltd.
Printed by L&C Printing Group, Poland.
This book is produced using pulp from managed forests.

Published in:

DUBLIN
UNESCO
City of Literature

CONTENTS

Introduction 7

1960s 9

1970s 17

1980s 29

1990s 45

2000s 57

2010s 123

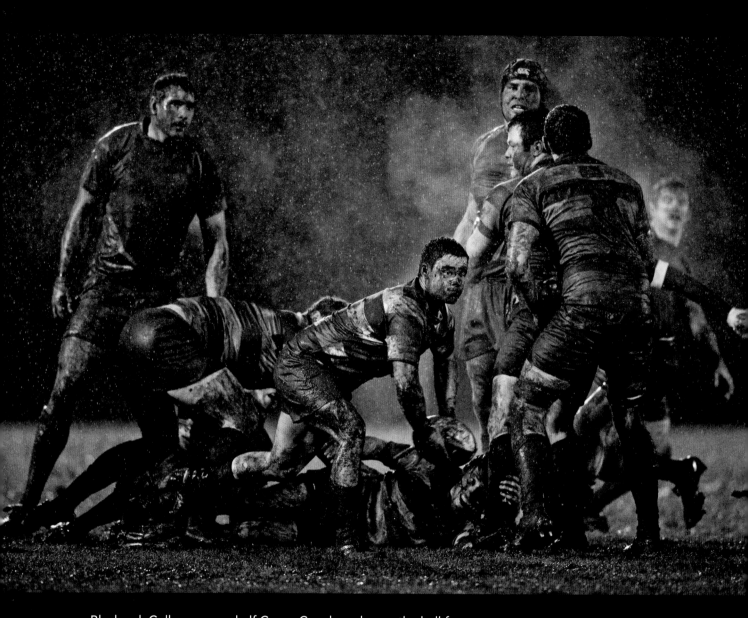

Blackrock College scrum-half Conor Crowley releases the ball from
a ruck during their Ulster Bank All-Ireland League Division 1A game
at Anglesea Road. This photograph won 2nd prize in the Sports
Singles' category of the 55th World Press Photo Contest in 2012.

Ray McManus / SPORTSFILE

INTRODUCTION

In 2012, my photograph of a ruck in the game between Blackrock and Old Belvedere in Anglesea Road, won second prize in the sports singles category at the World Press Photo contest, one of the world's most renowned annual photojournalism competitions. Among photographs of professional sportspeople playing at the highest level, there was something about this photo of the amateur game that just worked.

For an Irish agency to win the award was a fantastic achievement. In some ways it was the best day of my career, but in others it was just another day's work. Because whether you're photographing professional sportspeople, or a local match on a rain-sodden Irish pitch, the essence of good sports photography is the same – it's about reading the game, reading the players and anticipating where the magic will happen.

Since I set up Sportsfile in the early 1980s, based purely on my passion for sport and sports photography, I've travelled the world, covering sports events from Olympic Games to international soccer and rugby. From the very beginning, Sportsfile provided top-class, up-to-the-minute images. Over the years we have expanded and, by insisting on the highest standards, have become a multiaward-winning sports photo agency.

We've been photographing Irish rugby for decades, long before the advent of the professional game. Our photographers were pitch-side for provincial games in front of small crowds, and we shot the national team back in the eighties, when figures like Ollie Campbell brought some sparkle to what was then the Five Nations. We captured the huge transformation of Irish rugby with the dawn of the professional era in the mid-nineties. Today, rugby is a very different game, but whether it's an amateur game in atrocious weather, like the one I photographed, or a professional game in a world class stadium, the stamina, the slog and the guts are what shine through. And that's what Sportfile's talented team of photographers are there to capture, match after match – the images here are a testament to their talents. It's all in a day's work for us!

Ray McManus 2018

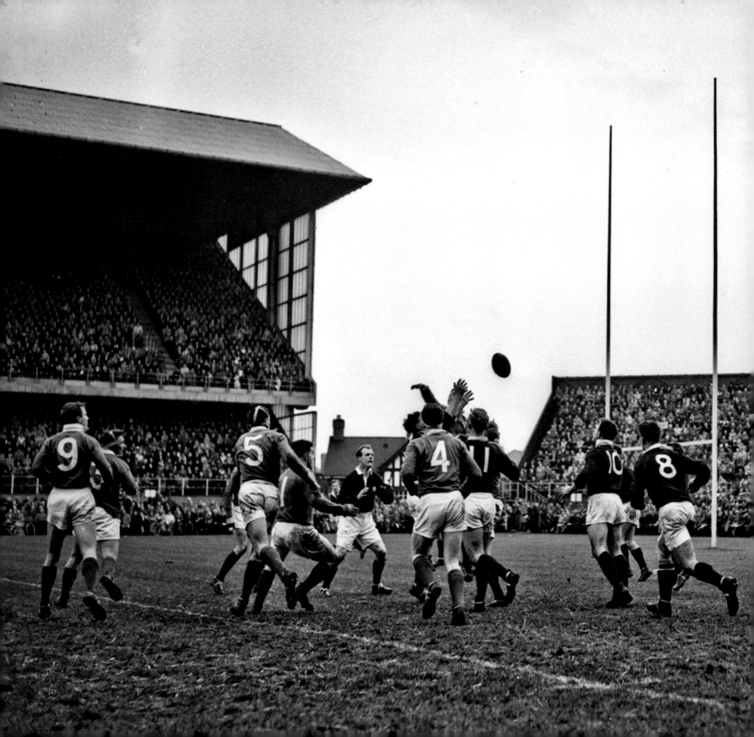

27 February 1960

Ireland narrowly lost to the Scots in Lansdowne Road, with a final score of 5-6, and failed to win any of their other matches in the 1960 Five Nations. England and France ended up tied at the top, with the English also taking the Triple Crown.

Connolly Collection / SPORTSFILE

1960s

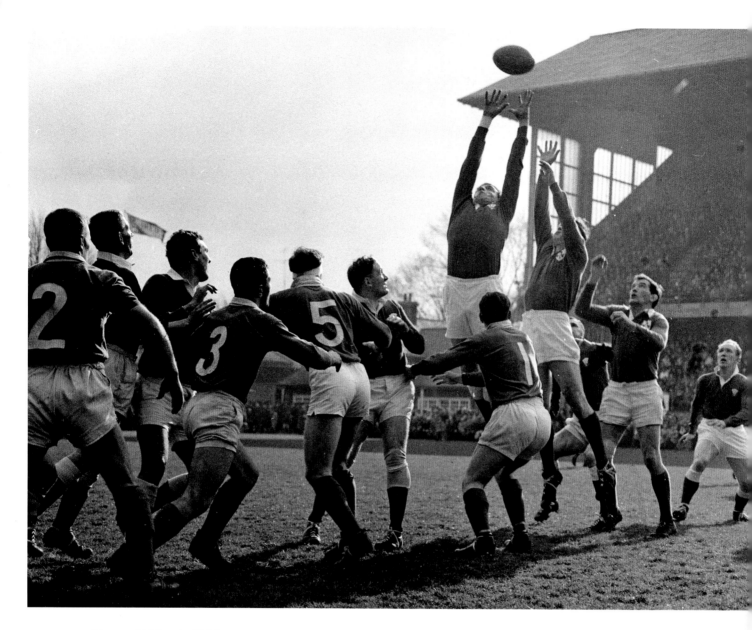

Above: 7 March 1964

A lineout being contested during the Five Nations clash between Ireland and Wales. The visitors won easily, 15-6, and went on to tie with Scotland for the trophy.

Connolly Collection / SPORTSFILE

Opposite page: 26 February 1966

Ireland and Scotland battle it out during their 1966 Five Nations clash in Lansdowne Road. The Scots won by 11-3 over the home side. Lansdowne Road, Dublin.

Connolly Collection / SPORTSFILE

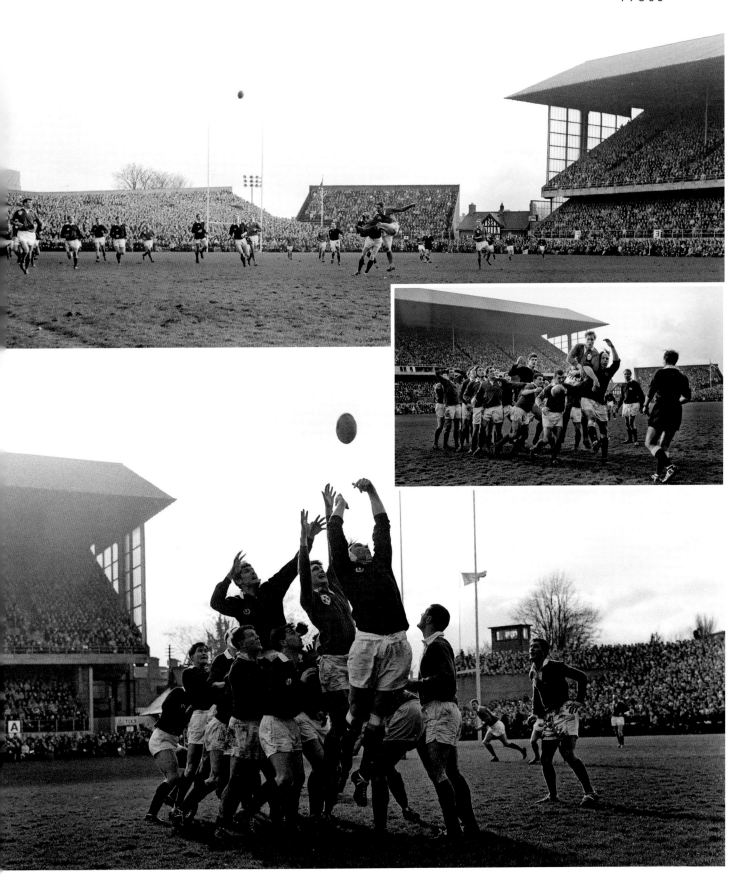

12 March 1966

Ireland and Wales contesting a lineout in Lansdowne Road, as a few intrepid supporters try to find a better view on the North Terrace. The Irish won 9-6 and prevented the Welsh from taking that year's Triple Crown.

Five Nations Championship, Ireland v Wales, Lansdowne Road, Dublin.

Connolly Collection / SPORTSFILE

Pages 14-15: 24 February 1968

Ireland beat the Scots 14-6 in Lansdowne Road; their only loss in that year's Five Nations was to France, who took the Grand Slam. The following year, Ireland elected a coach for the first time: Dubliner Ronnie Dawson, erstwhile hooker and Lions captain.

Five Nations Championship, Ireland v Scotland. Lansdowne Road, Dublin.

Connolly Collection / SPORTSFILE

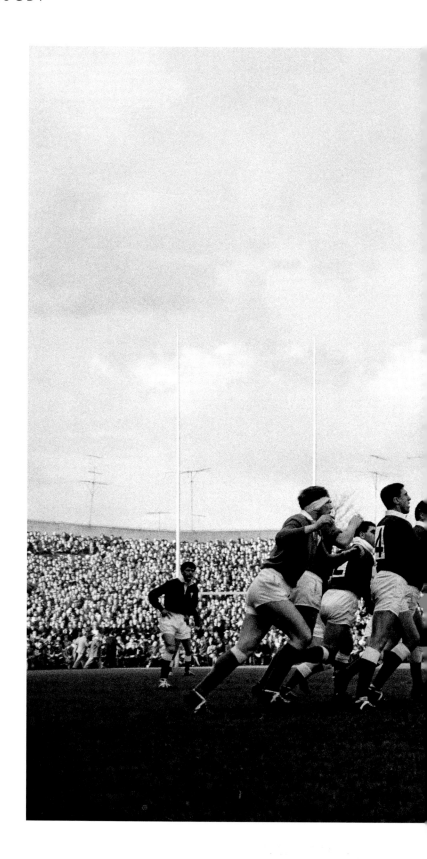

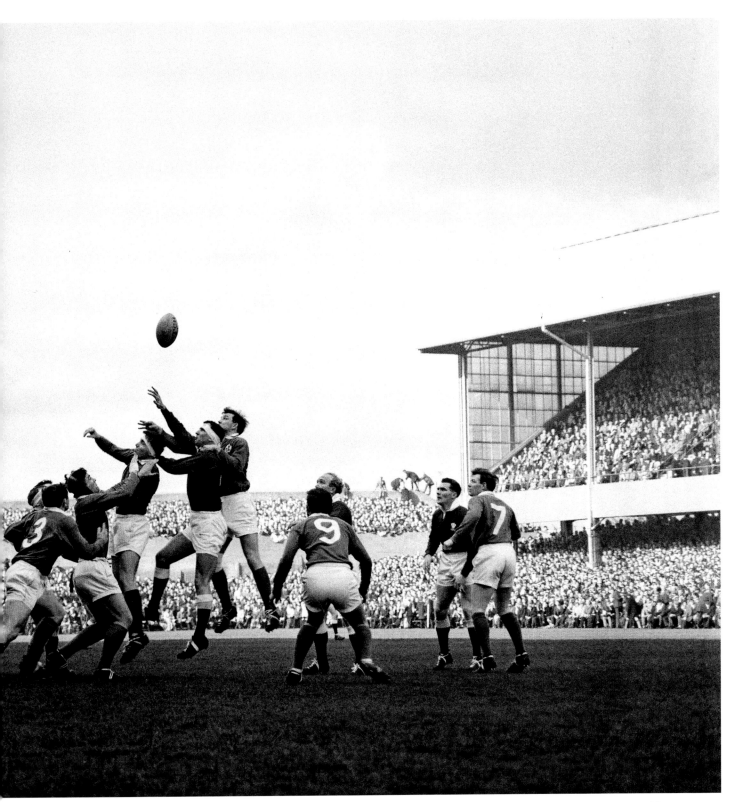

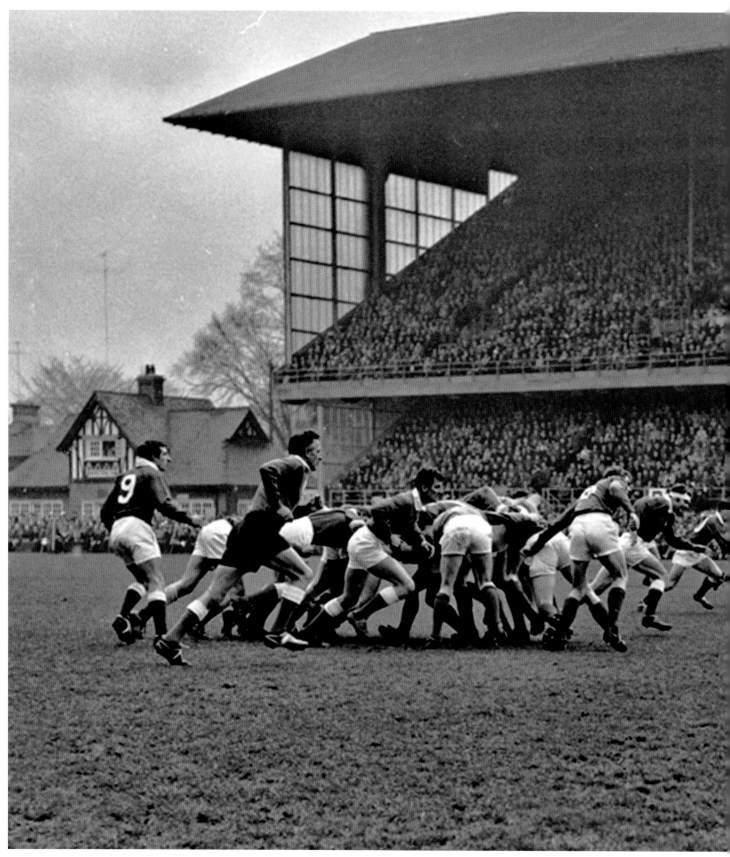

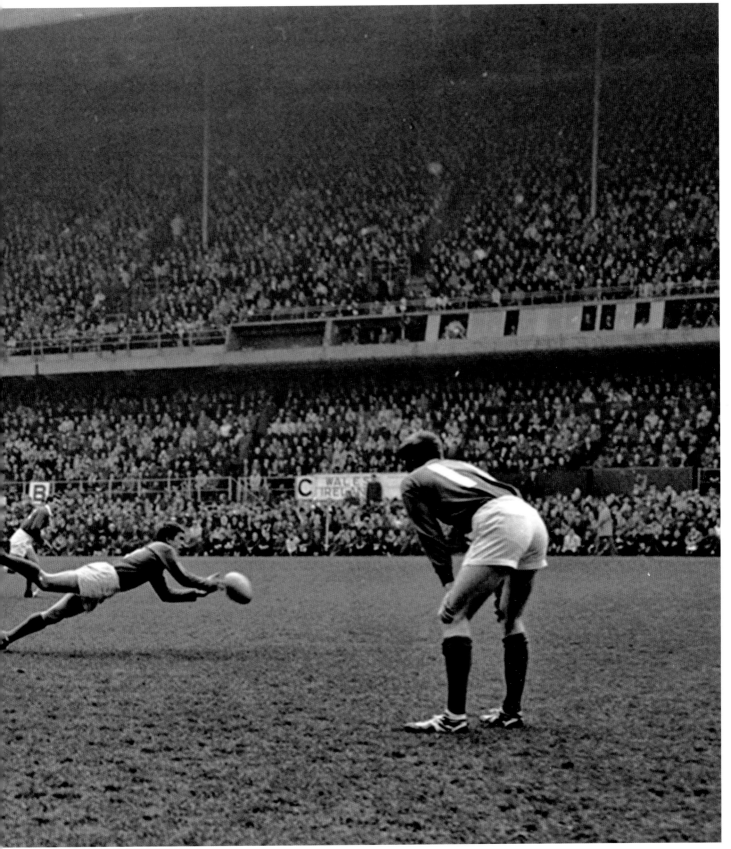

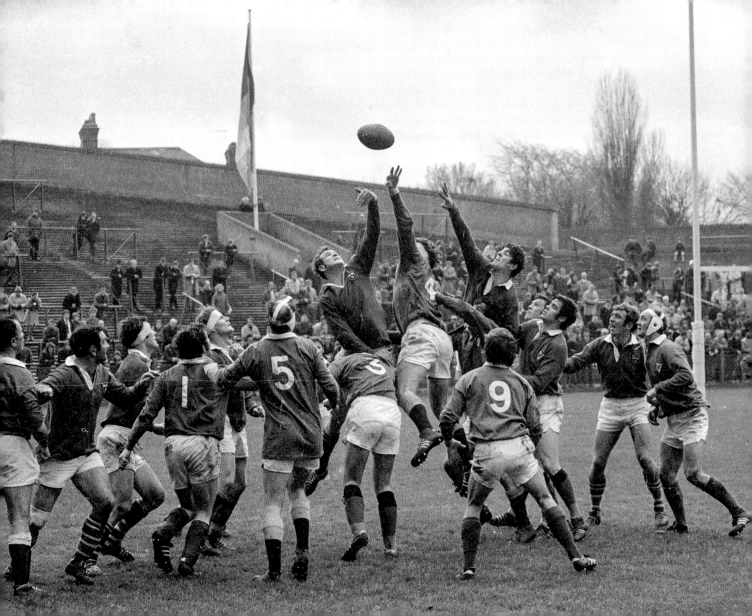

1970

Brendan Foley of Munster reaches for the ball in a lineout during a Leinster v Munster game at Lansdowne Road, Dublin. Foley was a renowned Munster lock who won 11 caps for Ireland between 1976 and 1981. His son, Anthony 'Axel' Foley, was the Munster coach and rugby international who died suddenly in 2016.

Connolly Collection / SPORTSFILE

1970s

1970

Johnny Moloney of Leinster in action against Munster at Lansdowne Road, Dublin. Leinster won this game 10-0 against their southern rivals.

Connolly Collection / SPORTSFILE

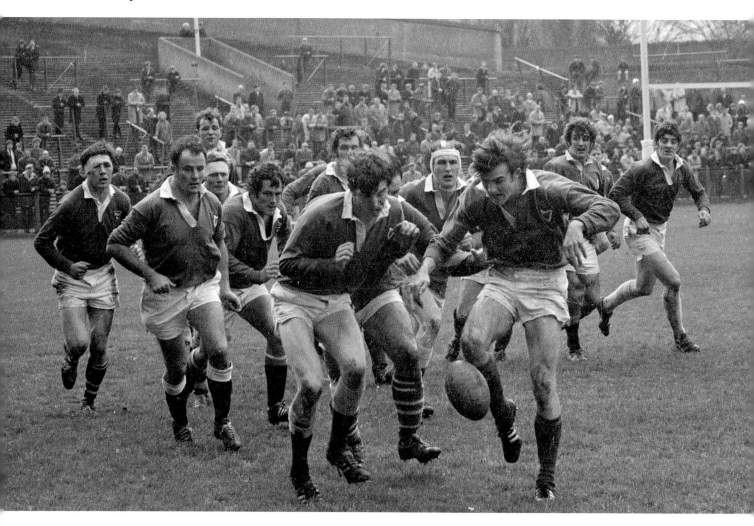

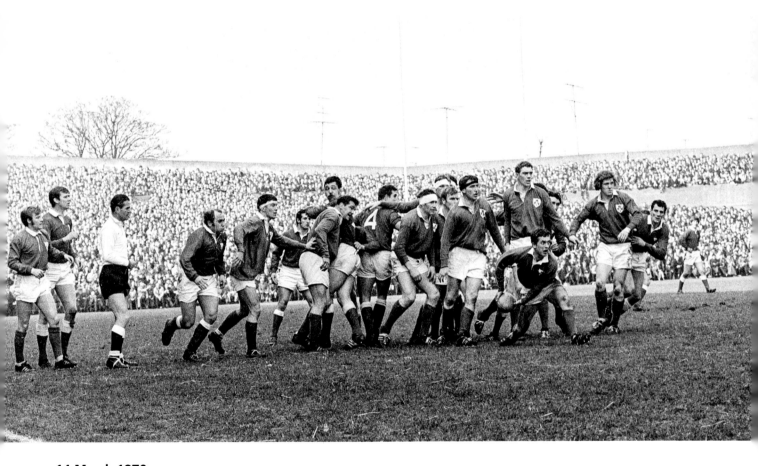

14 March 1970

Roger Young of Ireland gets the ball away from a line-out during the

Five Nations game between Ireland and Wales at Lansdowne Road,

Dublin. The final score was 14–0 to Ireland.

Connolly Collection / SPORTSFILE

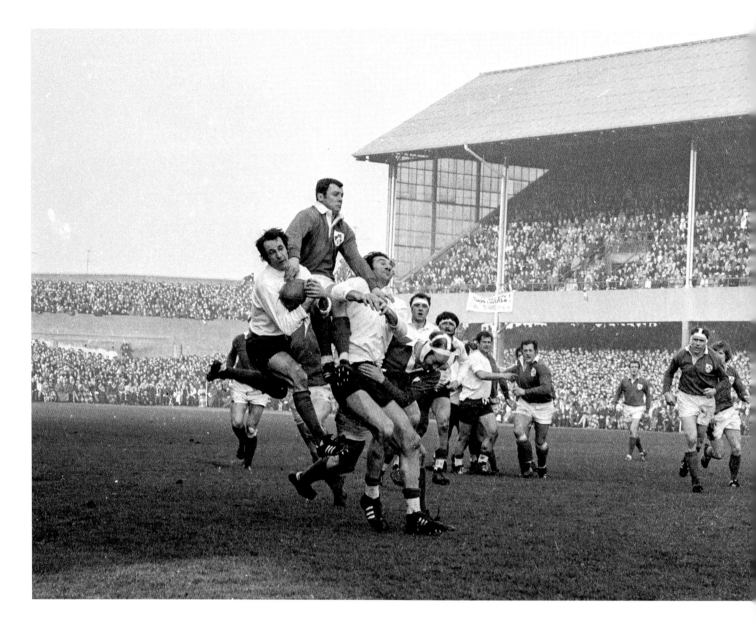

30 January 1971

Alan Duggan of Ireland in action against France. This was the last Five Nations tournament where a try was worth 3 points. Ireland v France, Five Nations Rugby Championship, Lansdowne Road, Dublin.

Connolly Collection / SPORTSFILE

13 February 1971

Denis Hickie of Ireland – an uncle of 1990s-2000s-era
Leinster and Ireland player Denis Hickie – in action
against England during the Five Nations game between
Ireland and England at Lansdowne Road, Dublin.
England finished ahead, with a final score of Ireland 6,
England 9.

Connolly Collection / SPORTSFILE

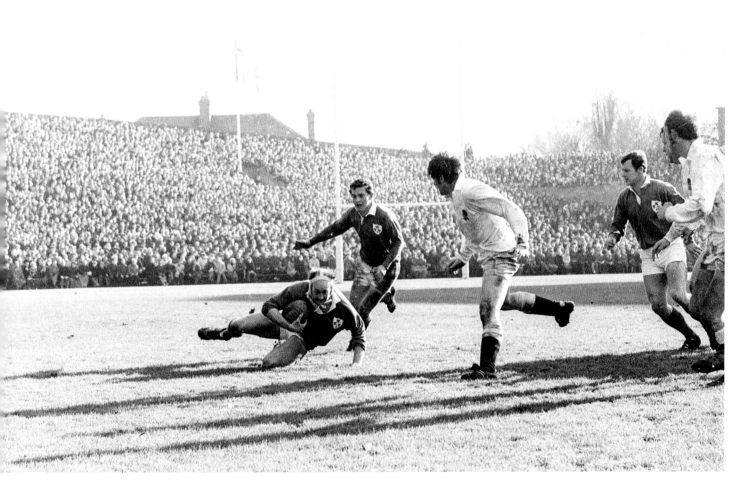

29 April 1972

Mike Gibson of Ireland during the France tour game between Ireland and France at Lansdowne Road, Dublin. For the first time since World War II, the championship was not completed; 1972 was one of the most violent years of the 'Troubles' in Ireland, with the Bloody Sunday killings in Derry and the burning of the British Embassy in Dublin. Some of the Welsh and Scottish players received death threats, purported to come from the IRA, and the decision was taken that the teams would not come to Dublin. Their scheduled matches at Lansdowne were cancelled. Because Ireland and Wales won all their matches, neither could claim the title.

Connolly Collection / SPORTSFILE

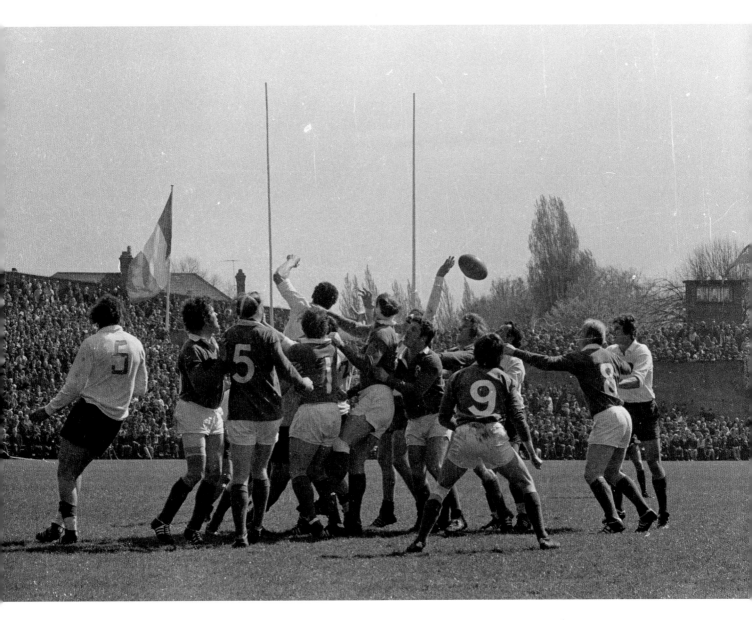

29 April 1972

Forwards from both sides compete for a line-out during the France tour game between Ireland and France at Lansdowne Road, Dublin. The French were welcomed with open arms when they travelled to Dublin for this friendly match after the Welsh and Scottish teams elected not to travel to Dublin for their championship matches. Ireland won 24–14, and the 35,000 strong crowd revelled in the display of international-level play.

Connolly Collection / SPORTSFILE

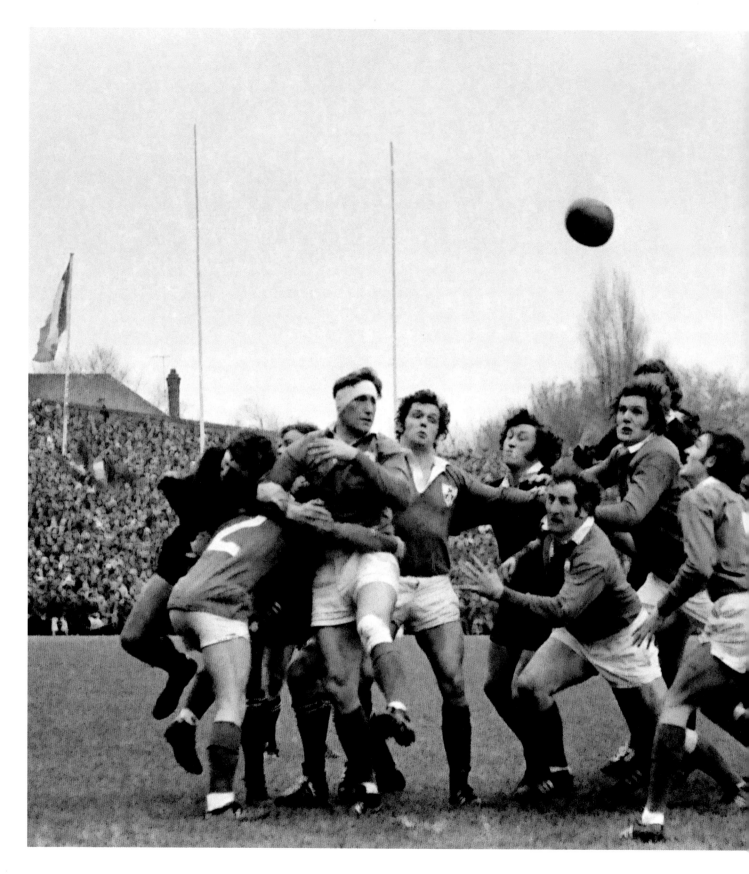

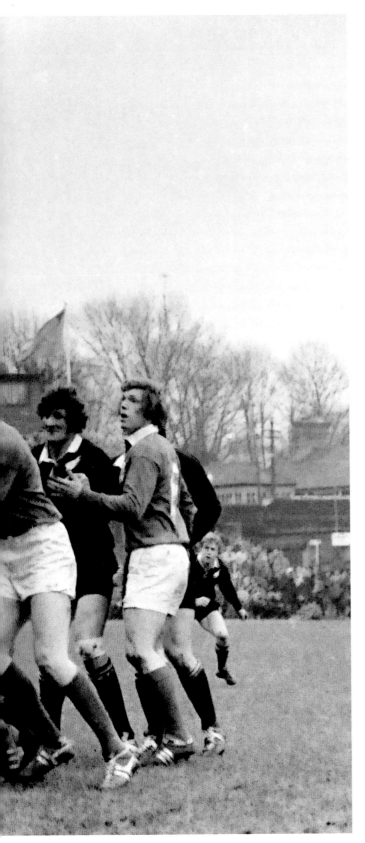

20 January 1973

A general view of the action in the Ireland v
New Zealand International Rugby Test Match at
Lansdowne Road features Willie John McBride,
Sean Lynch, Ray McLoughlin, Kevin Mays, John
Moloney, Terry Moore, and Fergus Slattery.
The match was part of the All-Blacks rugby
union tour of Britain, Ireland, France and North
America and ended in a 9-9 draw.

Connolly Collection / SPORTSFILE

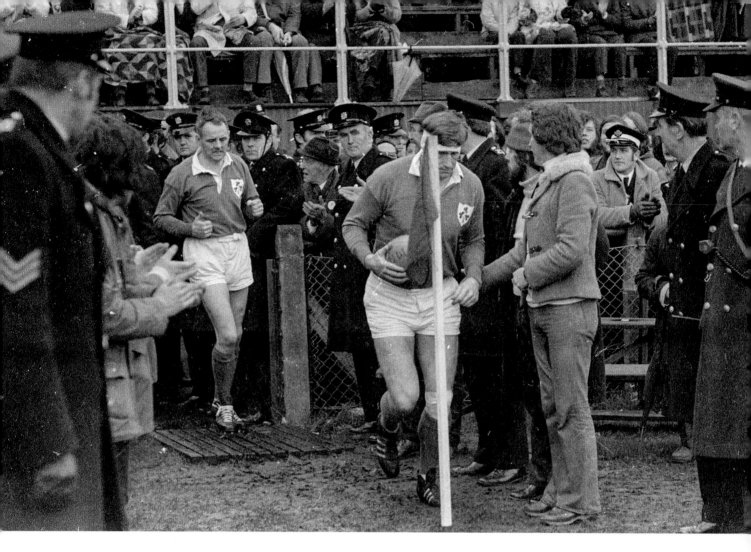

10 February 1973

Willie John McBride, followed by Tom Kiernan of Ireland, enters the field
ahead of the game between Ireland and England at Lansdowne Road,
Dublin. Ireland won, 18-9, but the very fact that the match was played at
all was what went down in history. After the previous year's cancellation
from Scotland and Wales, the applause for the English team echoed
around the stadium for a full five minutes before kick-off.
'We might not be any good, but at least we turned up,' said England
captain John Pullin at the post-match banquet.

Connolly Collection / SPORTSFILE

10 February 1973

Terry Moore of Ireland in action against England during the game between Ireland and England at Lansdowne Road, Dublin. As each side won their two home matches and lost their two away games, the championship was shared between all five sides, for the first and only time.

Connolly Collection / SPORTSFILE

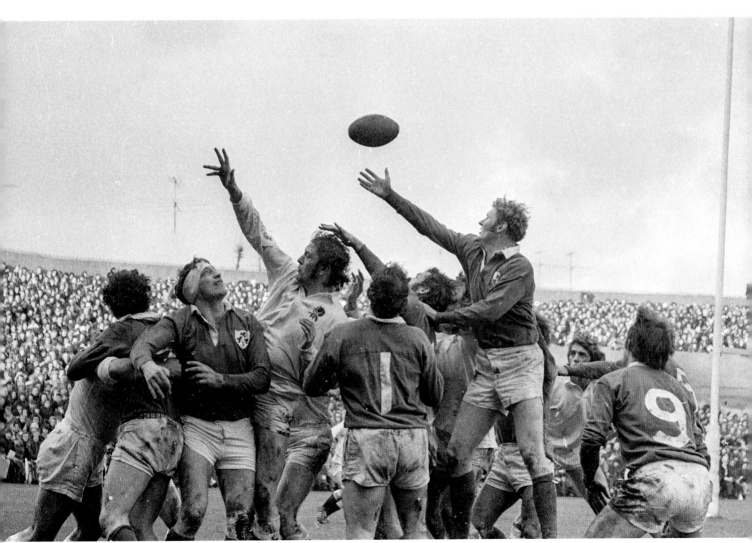

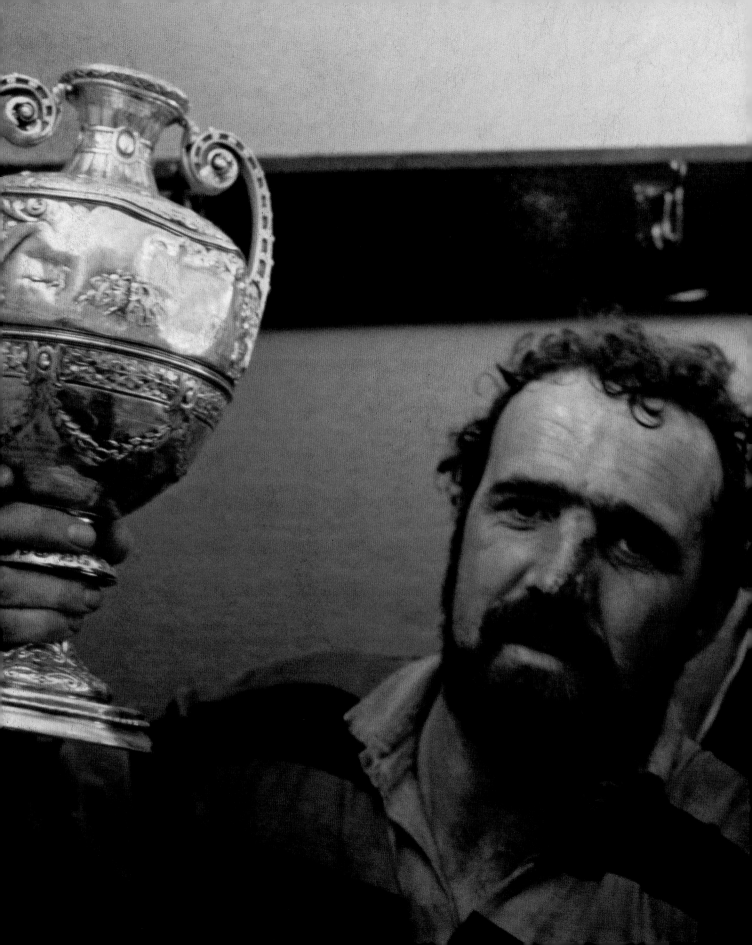

1980

Richie Daly from Young Munster rugby club, Limerick, after a sensational win over neighbours Bohemians in the Munster Senior Cup final 1980, which brought to an end his club's 42-year wait for their fourth title.

Ray McManus / SPORTSFILE

1980s

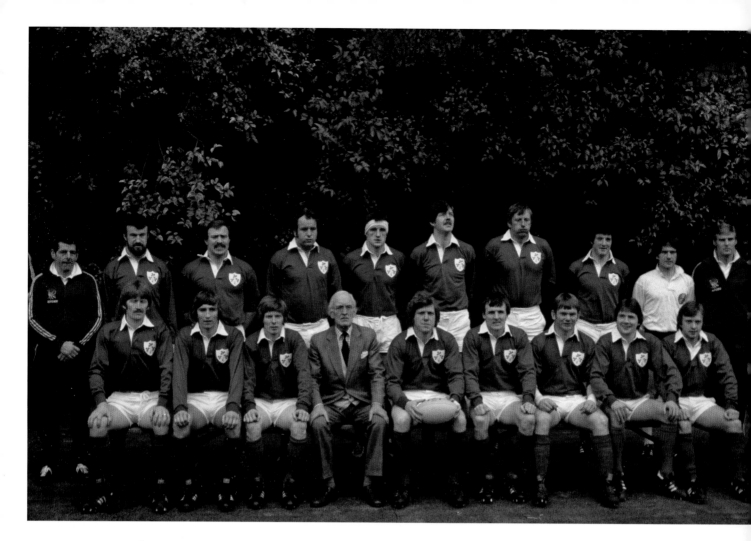

15 March 1980

Coming into the Five Nations in 1980, Ireland hadn't beaten the Welsh in a decade. That was to change on 15 March in Lansdowne Road, when the home team exploded into life in the second half of the game, running away with a 21-7 win. Back row, from left (players only): Mick Fitzpatrick, Phil Orr, Brendan Foley, John O'Driscoll, Donal Spring, Moss Keane and Rodney O'Donnell. Front row, from left (players only): Paul McNaughton, David Irwin, Ollie Campbell, Fergus Slattery, John Moloney, Ciaran Fitzgerald, Terry Kennedy and Colin Patterson.

Ireland v Wales, Five Nations Rugby Championship, Lansdowne Road.

Ray McManus / SPORTSFILE

Below: 8 October 1980

The Leinster team before their game against Romania in Donnybrook
Stadium, 8 October 1980 – the only challenge Romania lost during their
1980 rugby union tour of Ireland.

Ray McManus / SPORTSFILE

Pages 32-33: 23 January 1982

Fergus Slattery dives for the ball during Ireland's Five Nations
clash with Wales on 23 January 1982 in Lansdowne Road, which
the Irish won 20-12. The game had been delayed by a week due
to the 'Big Snow of 1982'.

Ray McManus / SPORTSFILE

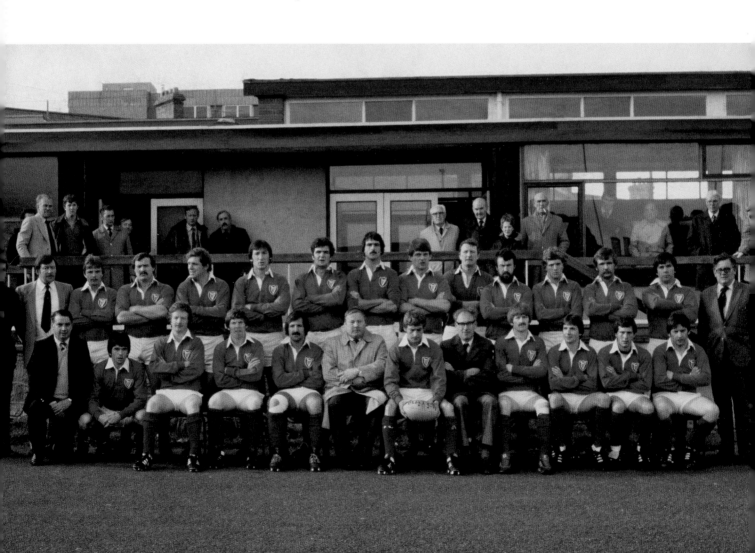

February 1982

Referee Allan Hosie signals a try for Limerick man Gerry 'Ginger'

McLoughlin, who dragged half of the English pack over the line with him.

England v Ireland, Five Nations Rugby Championship, Twickenham Stadium,

London.

Ray McManus / SPORTSFILE

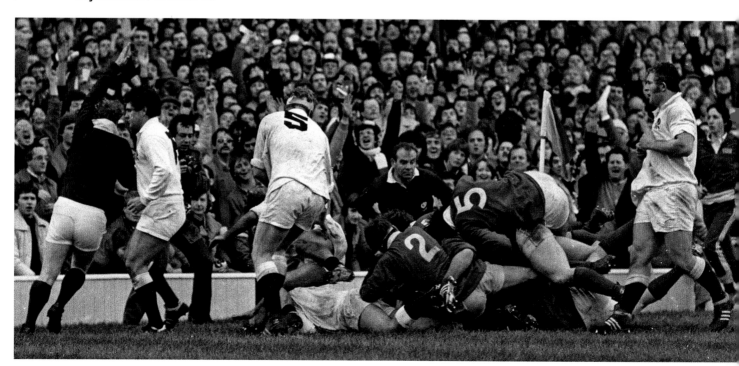

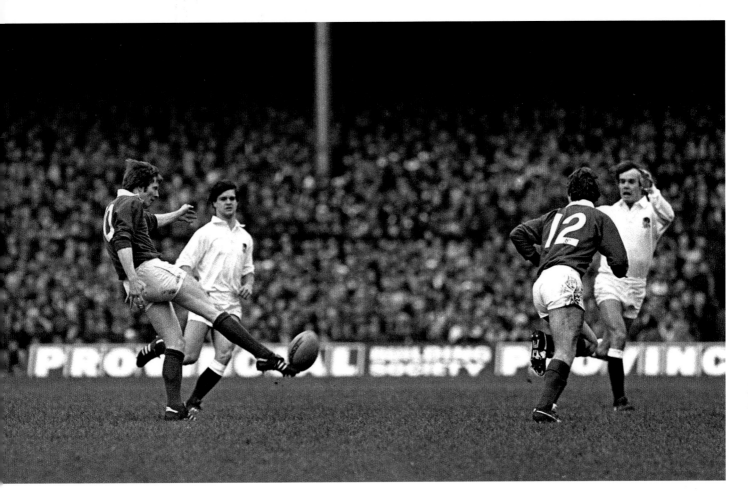

6 February 1982

Fly-half sensation Ollie Campbell in action against England in Twickenham.

Campbell was the leading scorer in that year's Five Nations, with 46 points.

Ray McManus / SPORTSFILE

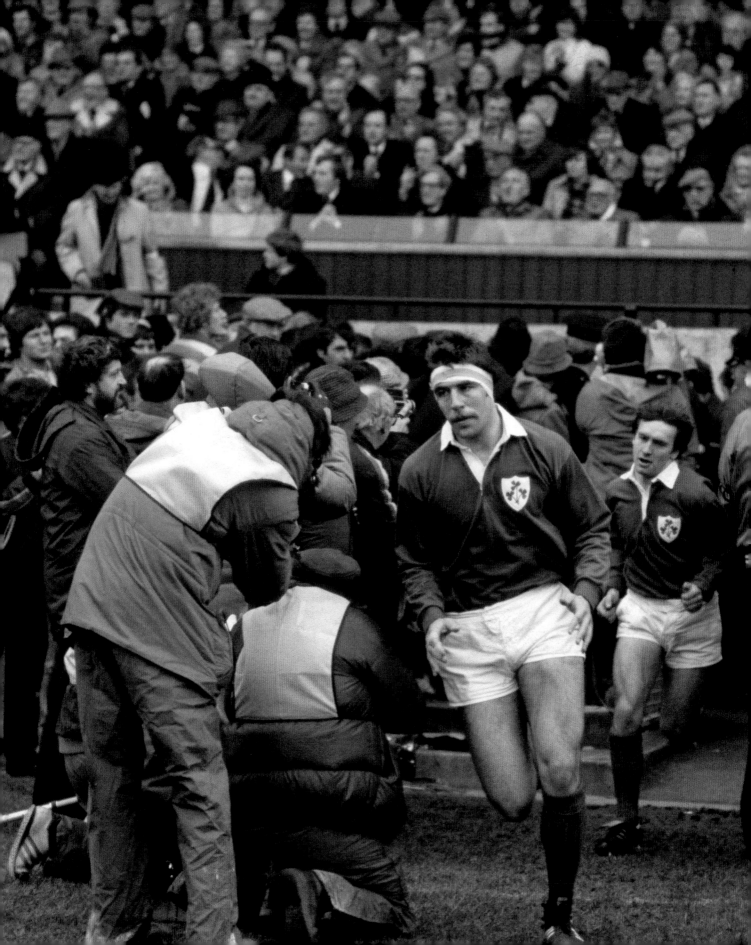

20 February 1982

Having already defeated England
and Wales in the 1982 Five
Nations, the Triple Crown was
in sight as Ireland ran on against
Scotland. Ollie Campbell scored
all of Ireland's points, kicking six
penalties and a drop goal, to give
them a decisive 21-12 win. Here
second-row Donal Lenihan, with
centre Keith Crossan following,
enters the field ahead of the game.
Ireland v Scotland, Five Nations
Rugby Championship, Lansdowne
Road, Dublin.

Ray McManus / SPORTSFILE

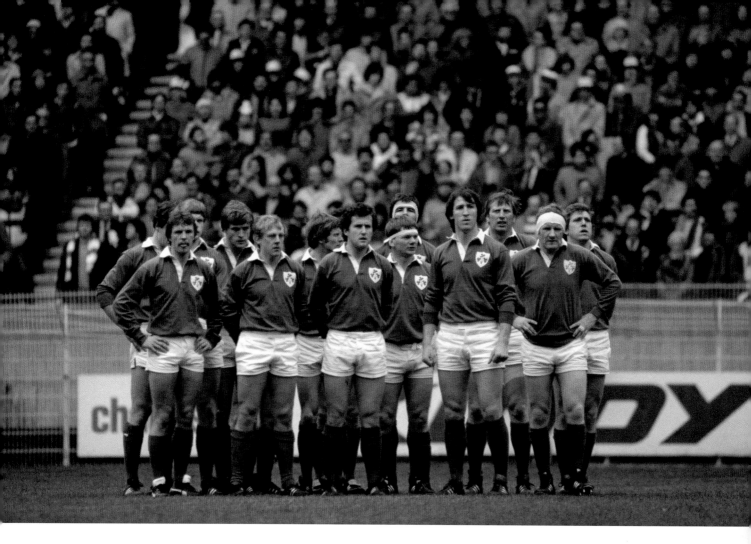

20 March 1982

Members of the Ireland team before their final match of the 1982 Five Nations Championship, against France in Parc des Princes. The group includes, from left, Paul Dean, Hugo MacNeill, Robbie McGrath, Ollie Campbell, Moss Finn, Ciaran Fitzgerald, Ronan Kearney, Moss Keane, Gerry 'Ginger' McLoughlin and Fergus Slattery. Ireland 9 France 22.

Ray McManus / SPORTSFILE

20 March 1982

Ollie Campbell with team-mates John O'Driscoll, left, Ronan Kearney and Moss Keane, right, during France v Ireland game in Parc des Princes. The Irish lost the game 22-9, but still came away with the Five Nations trophy and the Triple Crown.

Ray McManus / SPORTSFILE

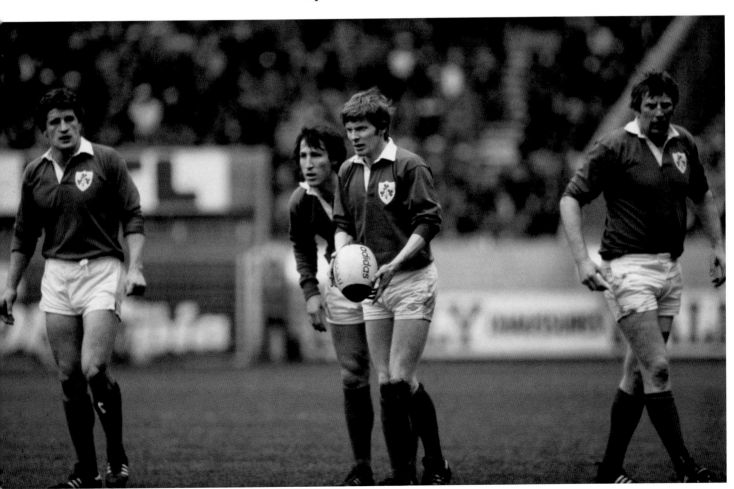

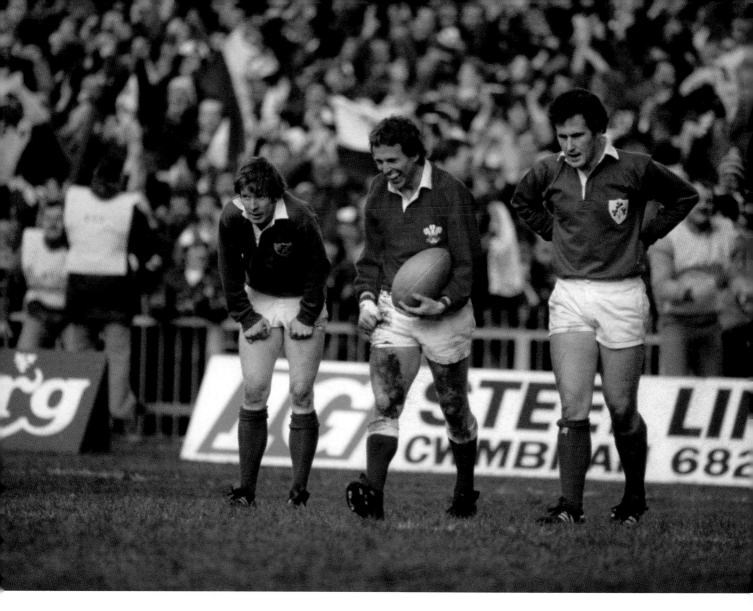

5 March 1983

Elgan Rees of Wales walks between Ollie Campbell and Moss Finn. Ireland lost on the day, but still shared the 1983 Five Nations title with France; the tie-break procedure was not brought in until the 1990s. Wales v Ireland, Five Nations Rugby Championship, Cardiff Arms Park, Cardiff.

Ray McManus / SPORTSFILE

4 February 1984

Ireland's Willie Duggan, left, in conversation with team-mate Tony Ward
during the Five Nations Rugby Championship game between Ireland v
Wales at Lansdowne Road, Dublin.

Ray McManus / SPORTSFILE

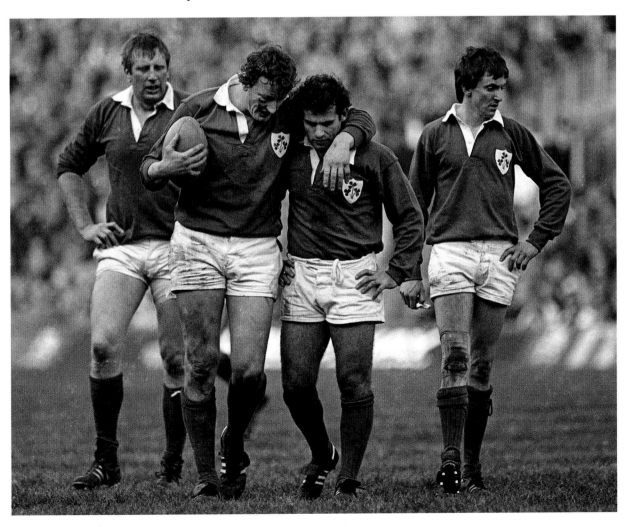

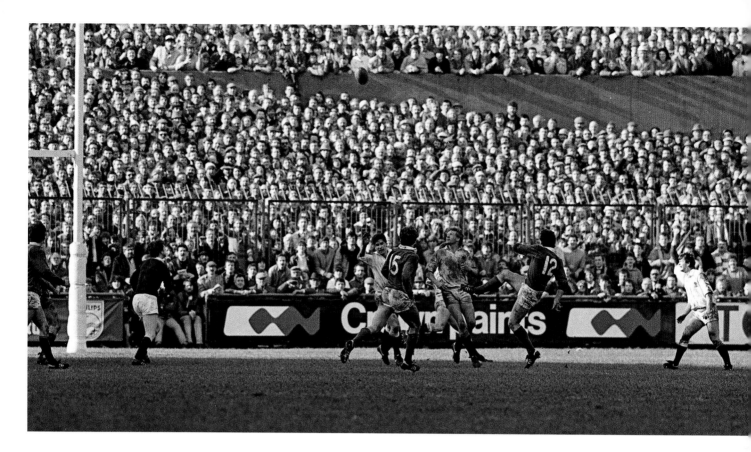

30 March 1985

Michael Kiernan watches as his drop goal attempt goes over to seal Ireland's victory against England and win the Triple Crown. Ireland v England, Five Nations Rugby Championship, Lansdowne Road, Dublin.

James Meehan / SPORTSFILE

Opposite top: 1 February 1986:

The Ireland players in advance of their game against France. From left: Jim McCoy, Willie Anderson, Donal Lenihan, Robert Morrow, Michael Bradley, Paul Dean, Ronan Kearney, Ciaran Fitzgerald, Trevor Ringland, Brendan Mullin, Michael Kiernan, Phil Orr, Moss Finn, Hugo MacNeill and Brian Spillane. Ireland ultimately were defeated by France 29-9. France v Ireland, Five Nations Rugby Championship, Parc des Princes, Paris.

Opposite bottom: Michael Bradley in action against France. Having won the Triple Crown the year before, Ireland's fortunes changed drastically in the 1986 Five Nations and they went home with the wooden spoon.

Ray McManus / SPORTSFILE

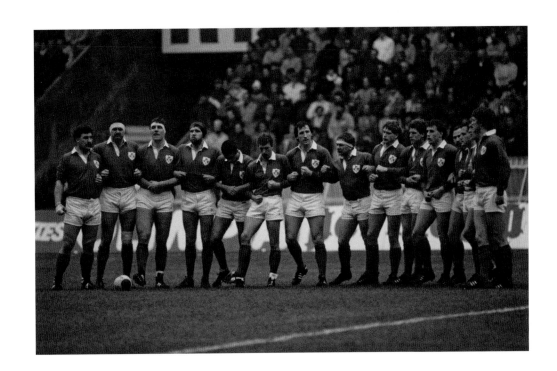

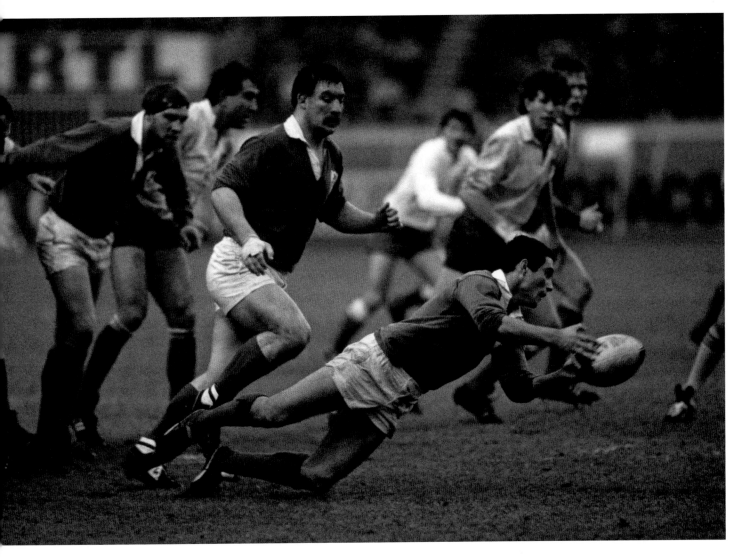

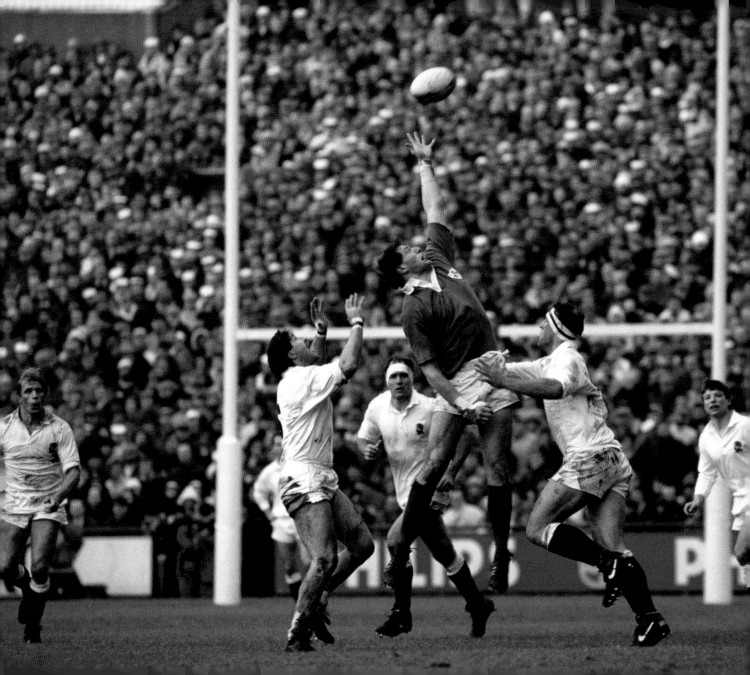

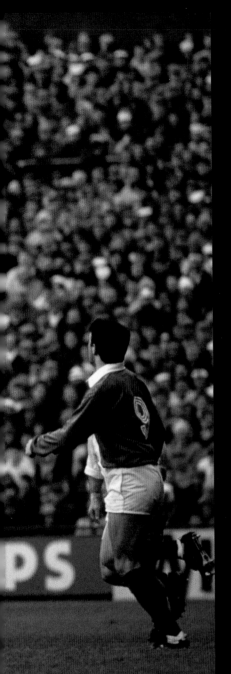

2 March 1991

Ireland's Neil Francis leaps for the ball in a match that would finish in victory for England. Later that month, England would win the 1991 Five Nations Championship, beating France 21–19 in their final game, along with the Grand Slam, their first in eleven years. France and Scotland took second and third places, while Ireland and Wales placed fourth and fifth. Ireland 7 England 16. Ireland v England, Five Nations Rugby Championship, Lansdowne Road, Dublin.

Ray McManus / SPORTSFILE

1990s

20 October 1991

Brendan Mullin, right, Ireland, contests the ball in the Ireland v Australia
World Cup quarter final in Lansdowne Road. After an unsuccessful Five
Nations for Ireland, the match was expected to be a walkover for the
Aussies. But, with just under six minutes to play, and three points between
the teams, against all expectation Gordon Hamilton scored a try for Ireland,
putting the score at Australia 15-Ireland 16. Though the boys in green
couldn't hold on for the win – a try from Australia's Michael Lynagh turned
victory into defeat – the match went down as a classic 'nearly' moment.
Lansdowne Road. Ireland 18-Australia 19.

Ray McManus / SPORTSFILE

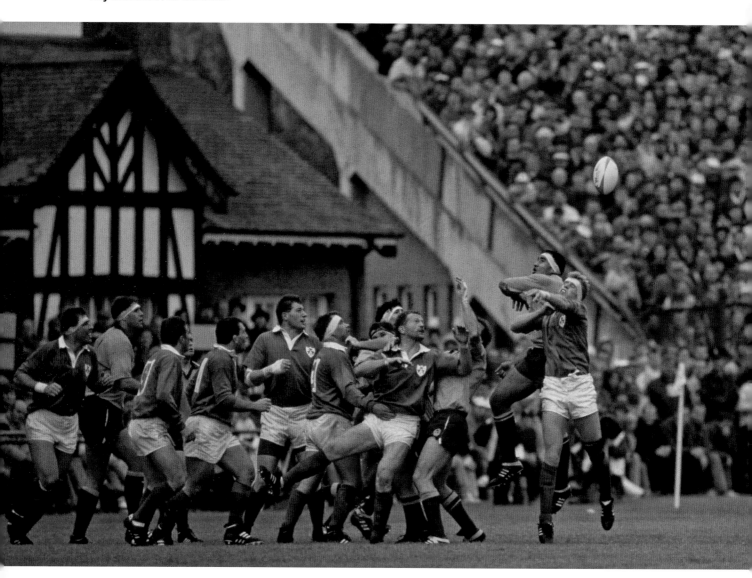

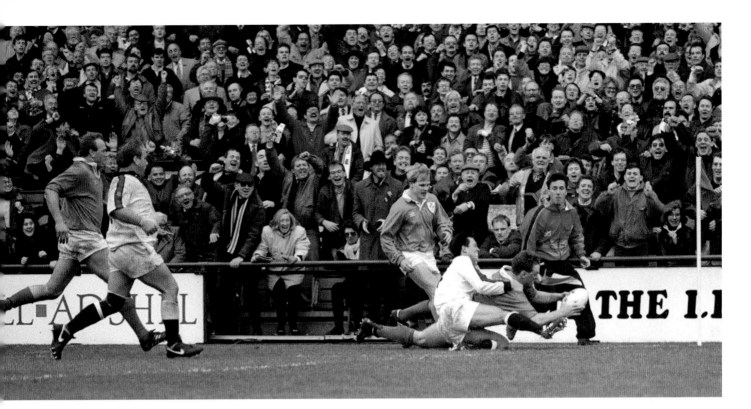

20 March 1993

Coming into this game, England were the favourites, with a team stuffed full of Lions, but the match is famous for Mick Galwey's storming try (above); the big Munsterman was himself selected for the Lions team later that year. Ireland's Terry Kingston (right) encourages the crowd. Recalling the support, the pitch invasion and fans carrying him shoulder high, Galwey, the only winner of an All-Ireland in both rugby union and Gaelic football, later said, 'The crowd carried us off that day. It was a fantastic feeling.' Ireland 17-England 3. Five Nations Rugby Championship, Ireland v England, Lansdowne Road, Dublin.

David Maher / SPORTSFILE

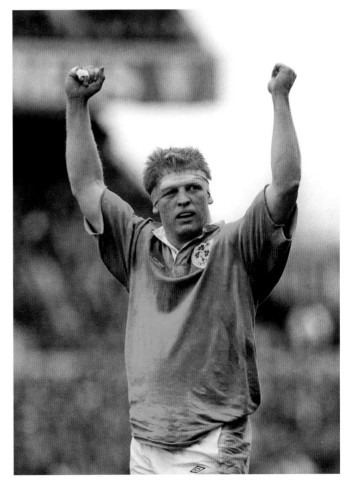

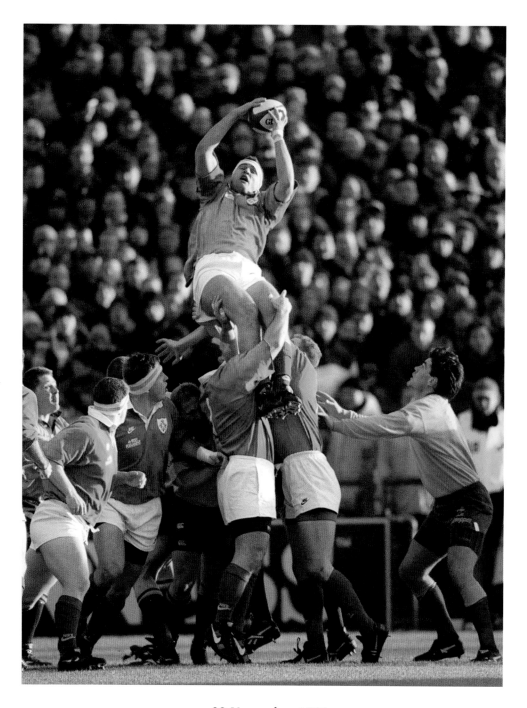

23 November 1996

Ireland's Jeremy Davidson leaps skyward in the Ireland v Australia friendly, Lansdowne Road, Dublin. It was Ireland's eighth rugby union loss in a row to Australia. Australia 22-Ireland 12, Ireland v Australia, Autumn International, Lansdowne Road, Dublin.

Brendan Moran / SPORTSFILE

7 February 1998

Fly-half David Humphreys, Ireland, fends off Craig Chalmers, Scotland,
during their Five Nations match. Ireland were hopeful that new coach Brian
Ashton could help them break a decade-long losing streak against Scotland.
Instead, Ireland lost, 16-17 and Ashton resigned on 20 February; he was
replaced on 24 February by the then 34-year-old Connacht coach, Warren
Gatland. Humphreys himself later went on to have a successful coaching
career with Ulster Rugby and Gloucester Rugby. Ireland v Scotland, Five
Nations Rugby Championship. Lansdowne Road, Dublin.

Brendan Moran / SPORTSFILE

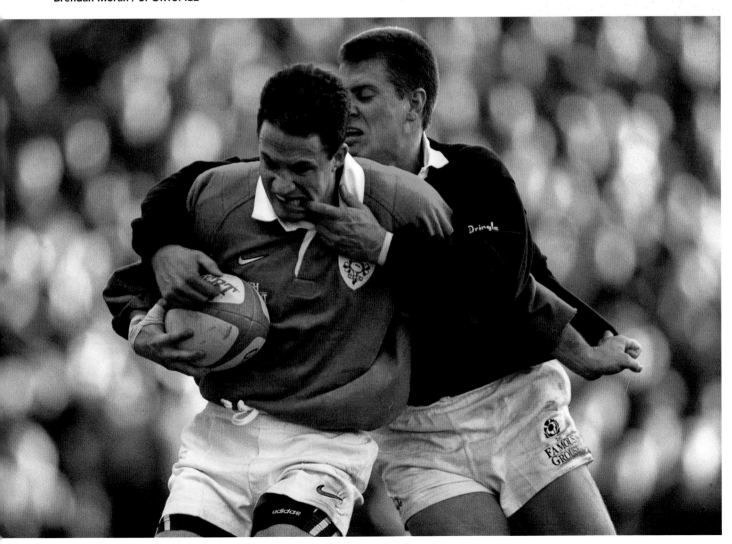

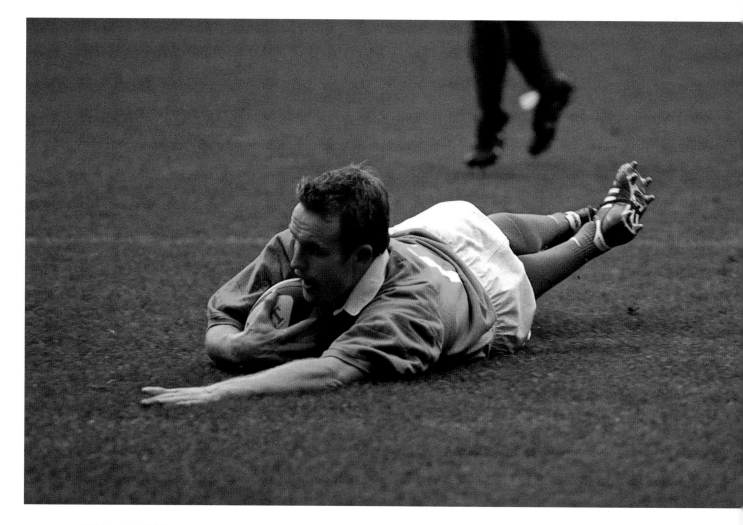

7 March 1998

Denis Hickie dives over to score Ireland's first try in Paris since Freddie
McLennan in 1980. Ireland led 13-6 at half time only for France to
score a late try and win the Five Nations Championship game 18-16 in
Stade De France.

Brendan Moran / SPORTSFILE.

30 January 1999

Ulster captain David Humphreys, who kicked a crucial drop-goal in the match, is lifted by his team-mates after their side's victory. Ulster became the first Irish side to win the newly established European Cup. Along with other key players in that legendary Ulster team, Humphreys had a very successful rugby career; by the time her retired he was Ireland's most-capped out-half. Heineken European Cup Final, Ulster v Colomiers, Lansdowne Road, Dublin.

Brendan Moran / SPORTSFILE

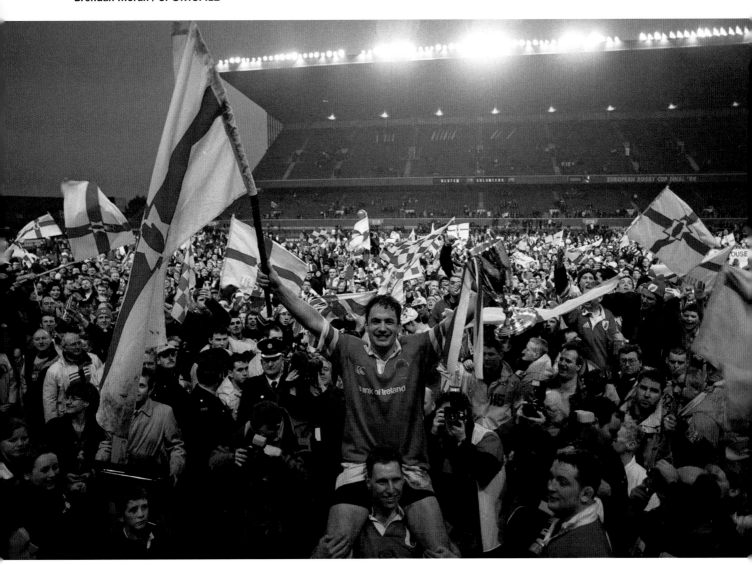

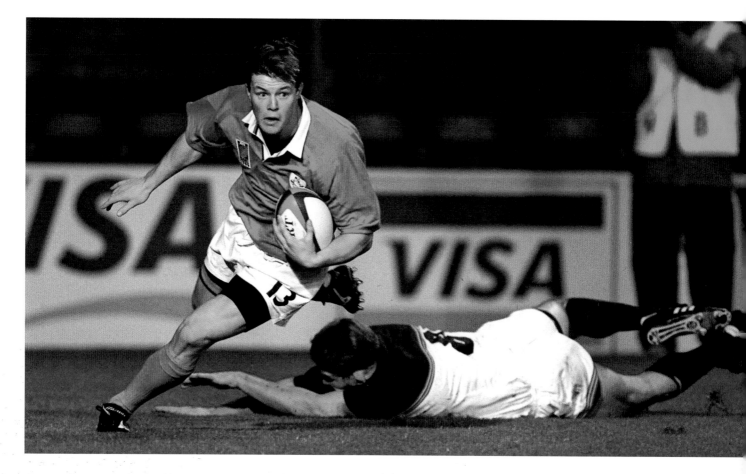

2 October 1999

Twenty-year-old Brian O'Driscoll goes past Dan Lyle, USA, to score
Ireland's second try – and his very first for Ireland. O'Driscoll went on to
become a legend of Irish rugby: he was capped 133 times and returned 46
international tries in a career of over 15 years. Ireland v USA, 1999 Rugby
World Cup, Pool E, Lansdowne Road, Dublin.

Brendan Moran / SPORTSFILE

20 October 1999

Ireland 24-Argentina 28. Ireland v
Argentina, 1999 Rugby World Cup,
Quarter-Final Play-off, Stade Felix
Bollaert, Lens, France.

Matt Browne / SPORTSFILE

Ireland were expected to win this World-Cup game in Lens
in Northern France. We were leading in the second half, but
Argentina came back, and unfortunately it was the clock that beat
us in the end. Ireland were camped on the Argentina try line for
the last few minutes, but couldn't get over. This shot shows the
devastation of the Irish players at the full time whistle. It was a real
opportunity missed as they would have had a quarter-final against
France in Lansdowne Road had they won.

Matt Browne

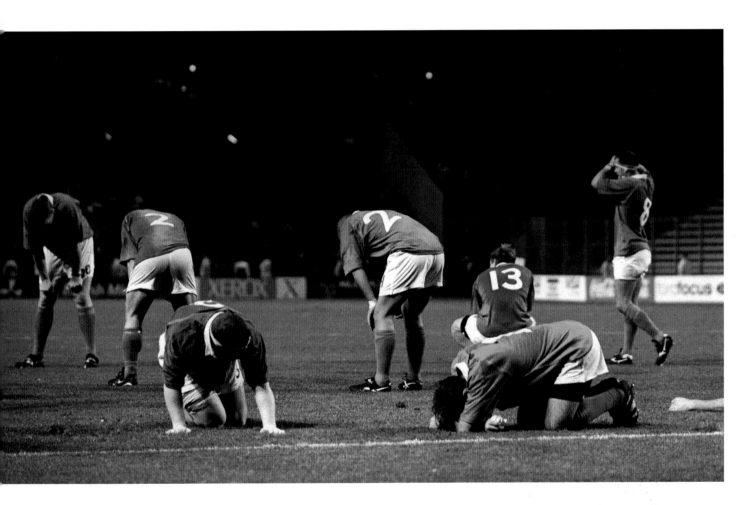

28 November 1999

Munster coach Declan Kidney, along with players, left to right, David Wallace, Peter Stringer, Jeremy Staunton and Ronan O'Gara, and fitness coach Fergal O'Callaghan, celebrate their side's one-point victory, 35-34, over Saracens. This was Munster's first win on English soil in the Heineken Cup. Saracens v Munster, Heineken European Cup, Pool 4, Vicarage Road, Watford, London.

Brendan Moran / SPORTSFILE

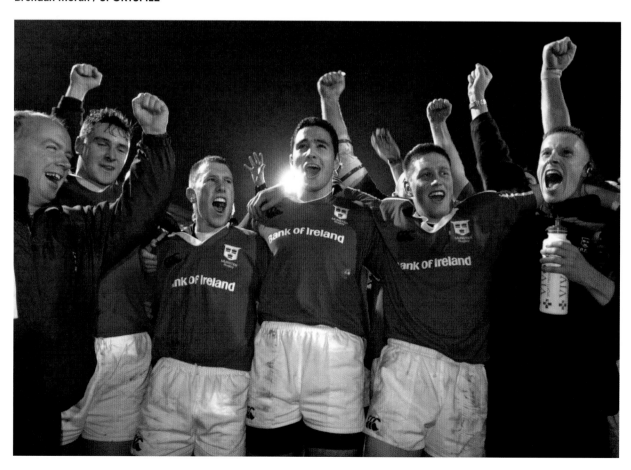

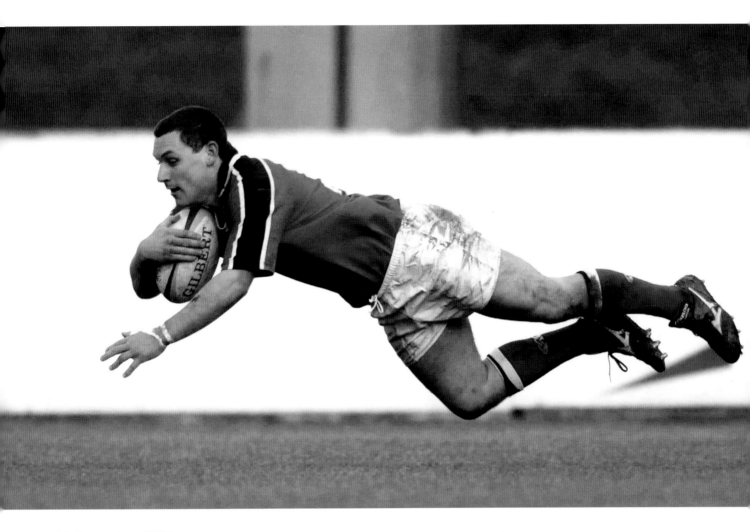

11 December 1999

Munster's Jason Holland scores his second try in their victory over
Colomiers. Munster recorded their first win in France in the competition
and exacted revenge on Colomiers who beat them in the previous year's
quarter-final. Colomiers v Munster, Heineken European Cup, Pool 4,
Stade Toulousien, Toulouse.

Brendan Moran / SPORTSFILE

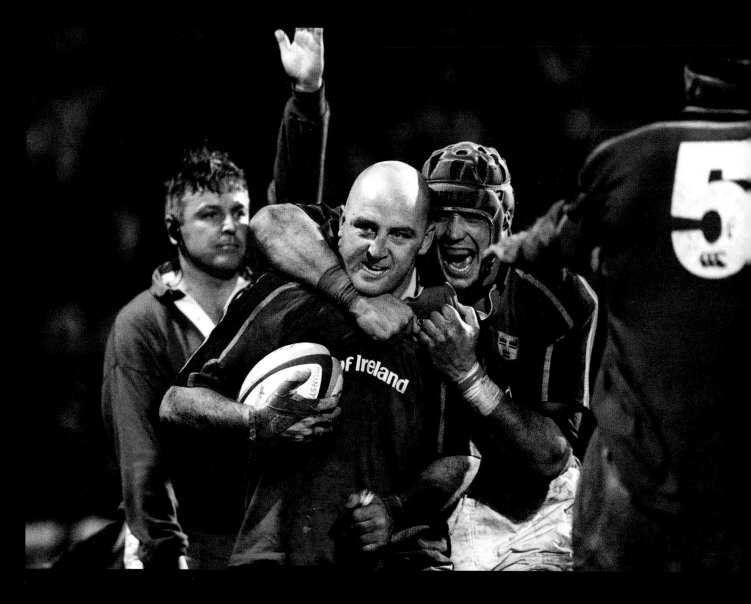

8 January 2000

Keith Wood and his Munster team-mate Alan Quinlan celebrate
Wood's last-minute try in a thrilling Heineken Cup match against
Saracens on 8 January 2000 in Thomond Park. Ronan O'Gara's wobbly
conversion would carry the side to victory – and into the knockout
stages – by a single point. Munster v Saracens, Heineken European
Cup, Pool 4, Thomond Park, Limerick.

Brendan Moran / SPORTSFILE

2000s

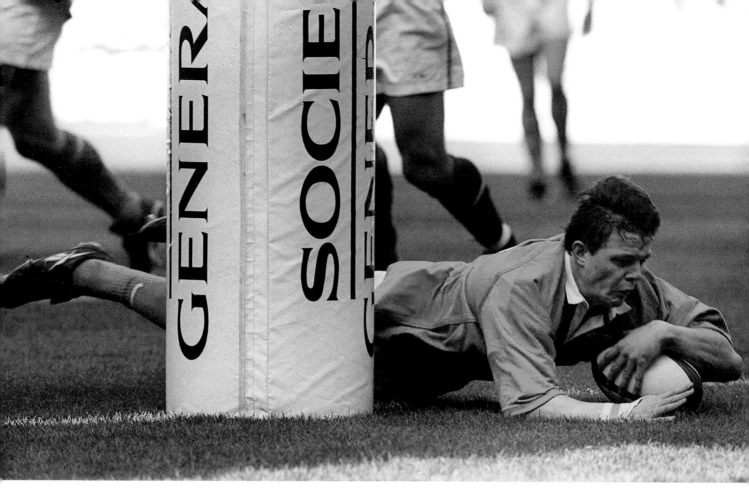

19 March 2000

A star is born: 21-year-old Brian O'Driscoll goes over to
score his first try against France in the inaugural Six Nations
Championship at the Stade de France. His blistering Parisian
hat-trick would ensure Ireland's first away victory over Les Bleus
since 1972.

Ray Lohan / SPORTSFILE

19 March 2000

Brian O'Driscoll is held aloft by Trevor Brennan, left, and Frankie Sheahan after arguably the best individual performance ever by an Irish player on the international stage. The 21-year-old scored tries in the 23rd, 58th and 74th minutes of the game. France v Ireland, Lloyds TSB 6 Nations Rugby Championship, Stade de France, Paris.

Ray Lohan / SPORTSFILE

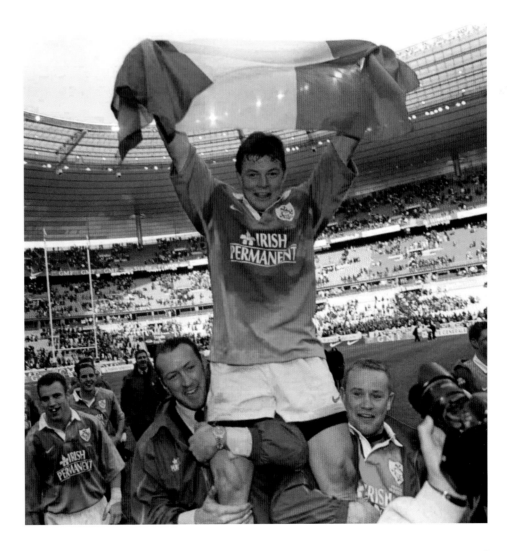

29 April 2000

St Mary's College RFC after becoming the first non-Munster
club to win the AIB All-Ireland League Division One in 2000.
The Dublin side at this time had Brent Pope as coach and Trevor
Brennan as captain and featured Malcolm O'Kelly, Denis Hickie
and Victor Costello. St. Mary's College v Cork Constitution, AIB
League Division One, Templeville Road, Dublin.

Matt Browne / SPORTSFILE

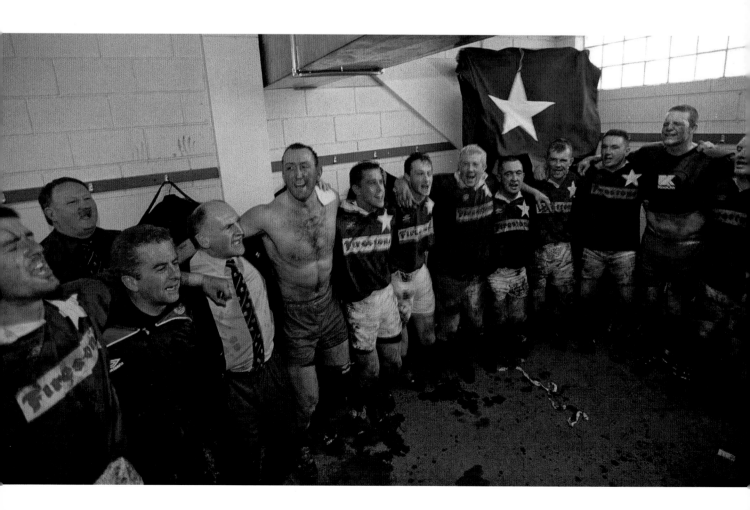

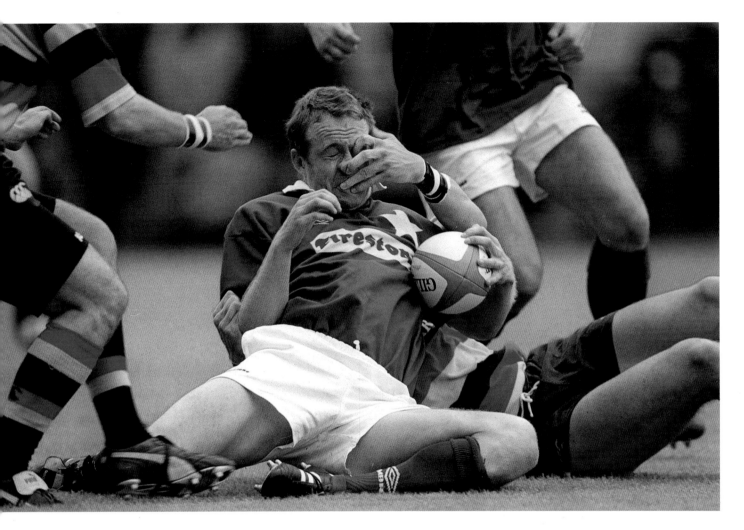

20 May 2000

Denis Hickie of St Mary's is tackled by Lansdowne's Shane
Horgan in the final of the AIB All-Ireland League on 20 May
2000, which St Mary's took by 22-25. St. Mary's College v
Lansdowne RFC, AIB League Division One Final, Lansdowne
Road, Dublin.

Brendan Moran / SPORTSFILE

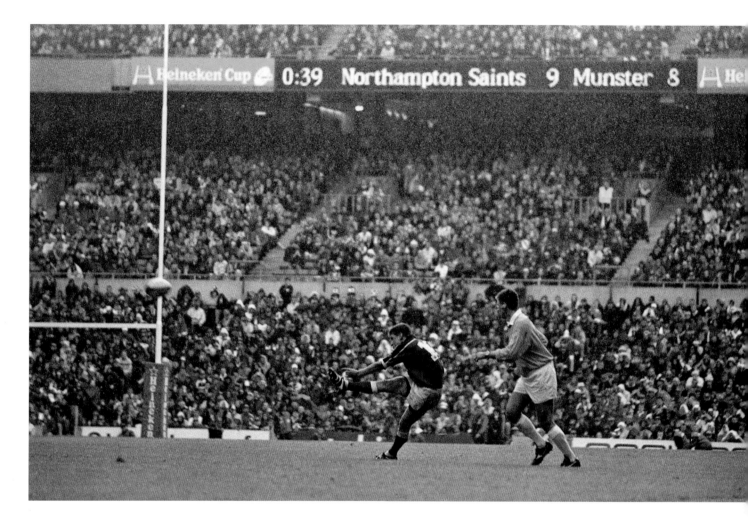

27 May 2000

Ronan O'Gara misses a last-minute penalty that could have
secured a win against Northampton in Munster's first ever
Heineken Cup final, in Twickenham, 27 May 2000. David Wallace
scored the game's only try for Declan Kidney's side, but O'Gara
had a nightmare of a match, missing four penalties out of four.

Brendan Moran / SPORTSFILE

17 February 2001

A superb 'one-handed' try by Brian O'Driscoll – despite the
best efforts of Xavier Garbajosa – in their first home victory over
France in eighteen years .Ireland v France, Lloyds TSB 6 Nations
Rugby Championship, Lansdowne Road, Dublin.

Brendan Moran / SPORTSFILE

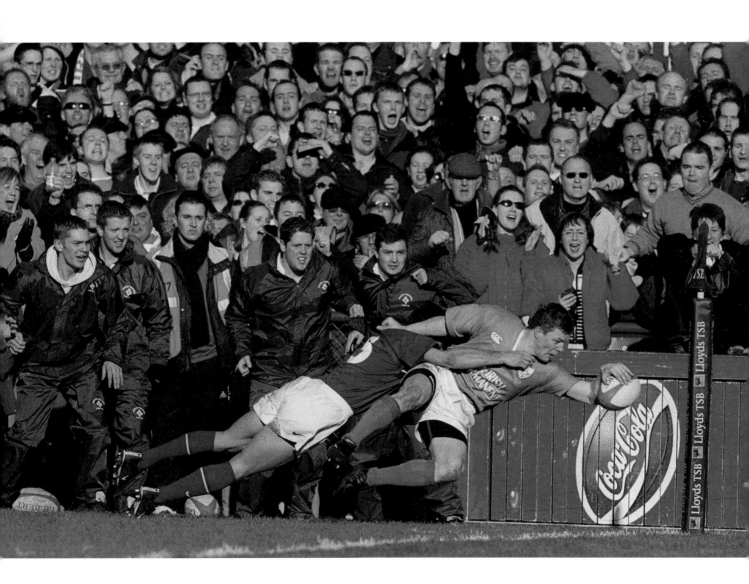

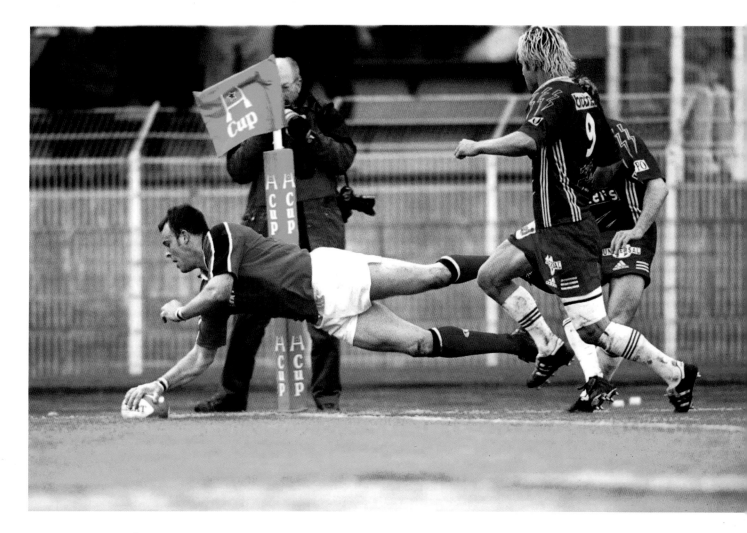

21 April 2001

Munster's John O'Neill scores a try that was subsequently disallowed.
Munster lost the game by a point, but would have won if the try had
been allowed. A Television Match Official was used in rugby for the
first time in 2001 – but not in this game. Heineken European Cup
semi-final, Stadium Lille Metropole, Lille, France.

Brendan Moran / SPORTSFILE

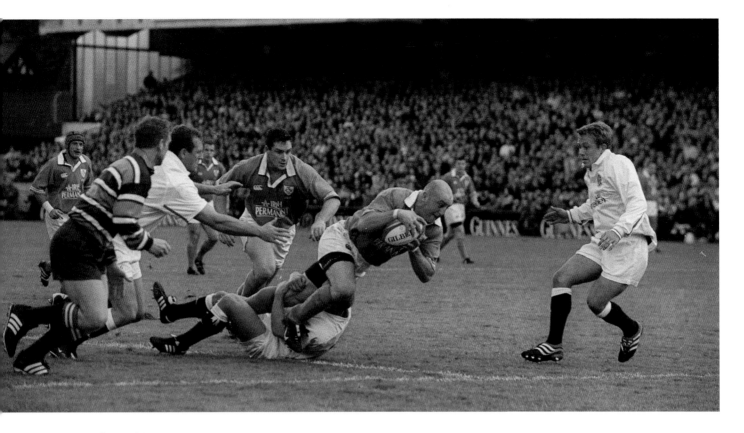

20 October 2001

Captain Keith Wood dives over for a try in the fifteenth minute of
Ireland v England in Lansdowne Road.

Brendan Moran / SPORTSFILE

The foot-and-mouth outbreak meant Ireland's games against Scotland, Wales and England were put back to the
autumn. Ireland had beaten France and Italy. England had beaten Ireland six times in succession.
Ireland ended England's chances of winning the Grand Slam thanks to a try from Captain Keith Wood and the accurate
boot of Ronan O'Gara. David Humphreys, who had kicked three penalties for the Irish, limped off in the final quarter,
but any chance of the game swinging back in England's favour were dashed by O'Gara, who came on to kick two late
penalties and secure their first win over their rivals in six meetings.

 Mick Galwey won the lineout and fed the ball to Anthony Foley who popped up a lovely soft pass for a charging
Keith Wood to run onto; he crashed over for the try, and Neil Back was never going to stop him. I don't remember much
of the game itself, but I still remember Wood taking the ball at speed and diving over the line and the reaction of the
crowd thereafter. England's expansive passing game was superbly countered by Ireland's hunger and aggressiveness and
Wood's try only gave Ireland more confidence and momentum. Ireland duly won the game and while England were still
Champions and presented with the Championship trophy, the celebrations that day were all Irish.

Brendan Moran

20 October 2001

Kevin Maggs, left, and Denis Hickie celebrate a decisive
win over England and a thrilling final match of the 2001 Six
Nations season. Ireland v England, Lloyds TSB 6 Nations Rugby
Championship, Lansdowne Road, Dublin.

Brendan Moran / SPORTSFILE

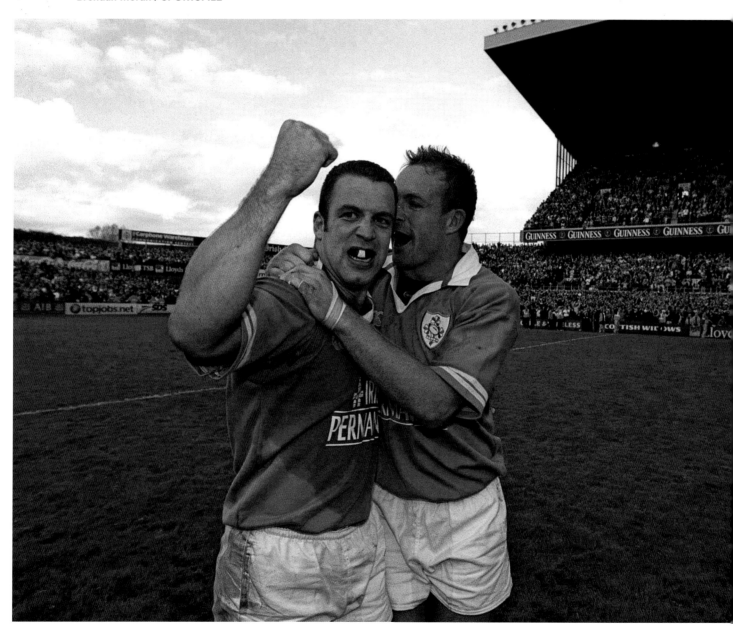

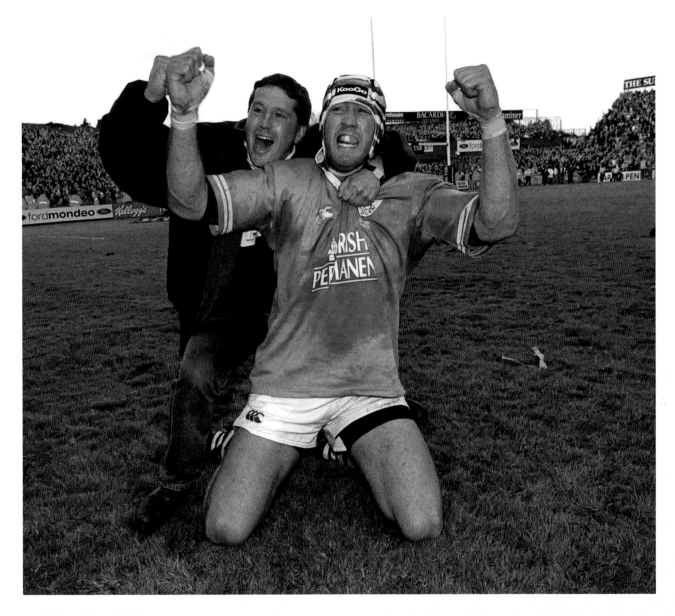

20 October 2001

Trevor Brennan celebrates with a supporter after Ireland's 20-14
victory. England were the Six Nations winners, but this marked
the third year in a row that they were denied the Grand Slam.

Matt Browne / SPORTSFILE

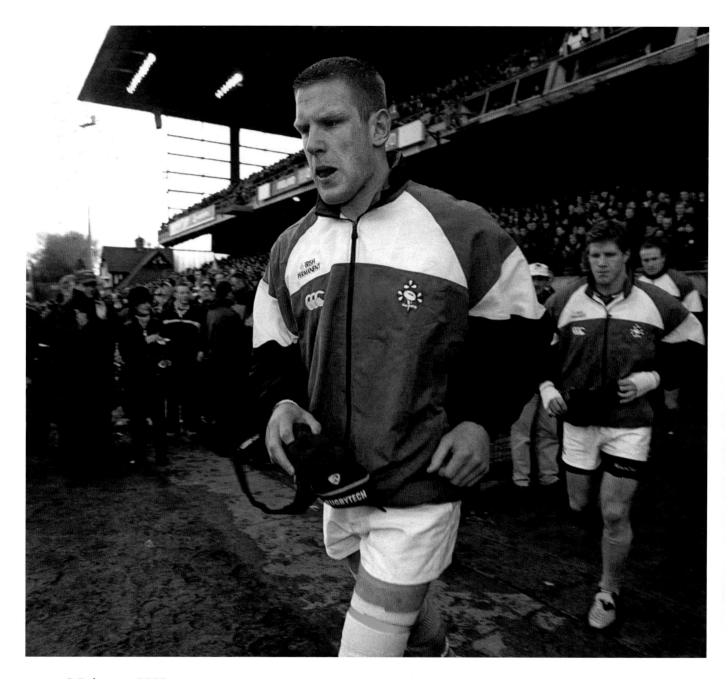

3 February 2002

On a stormy day in Lansdowne Road, Paul O'Connell, on his international
debut, makes his way onto the pitch to earn the first of his 108 caps for
Ireland. Ireland v Wales, Lloyds TSB 6 Nations Rugby Championship,
Lansdowne Road, Dublin.

Brendan Moran / SPORTSFILE

3 February 2002

Brian O'Driscoll is tackled by Kevin Morgan of Wales. This Six Nations match was Eddie O'Sullivan's first as head coach and saw Ireland put an amazing six tries past the Welsh side. Ireland v Wales, Lloyds TSB 6 Nations Rugby Championship, Lansdowne Road, Dublin.

Matt Browne / SPORTSFILE

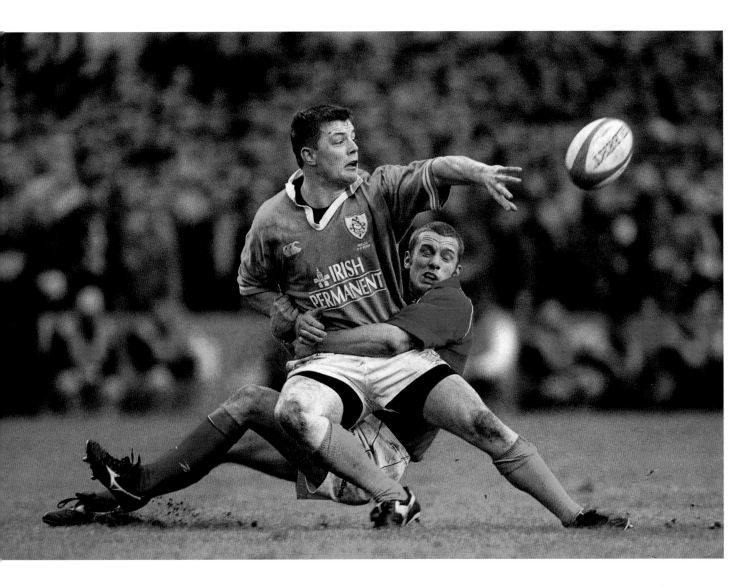

3 February 2002

Paul O'Connell celebrates with Peter Stringer, right, after scoring one of Ireland's six tries. O'Connell famously admitted afterwards that he has no memory of the try; he had been knocked unconscious during a tackle from Craig Quinnell earlier in the match. Ireland v Wales, Lloyds TSB 6 Nations Rugby Championship, Lansdowne Road, Dublin.

Brendan Moran / SPORTSFILE

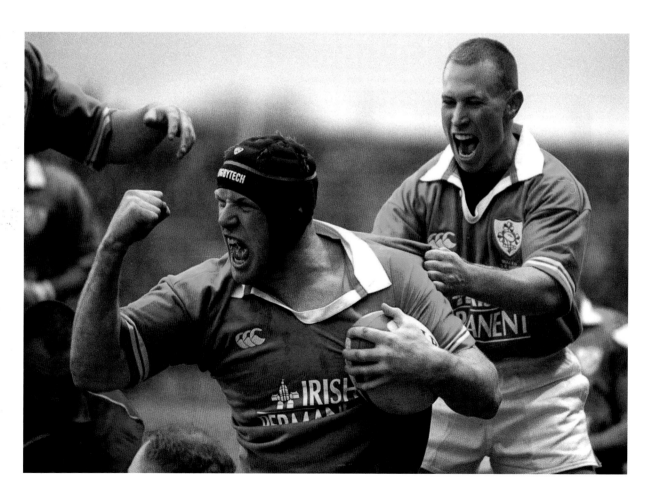

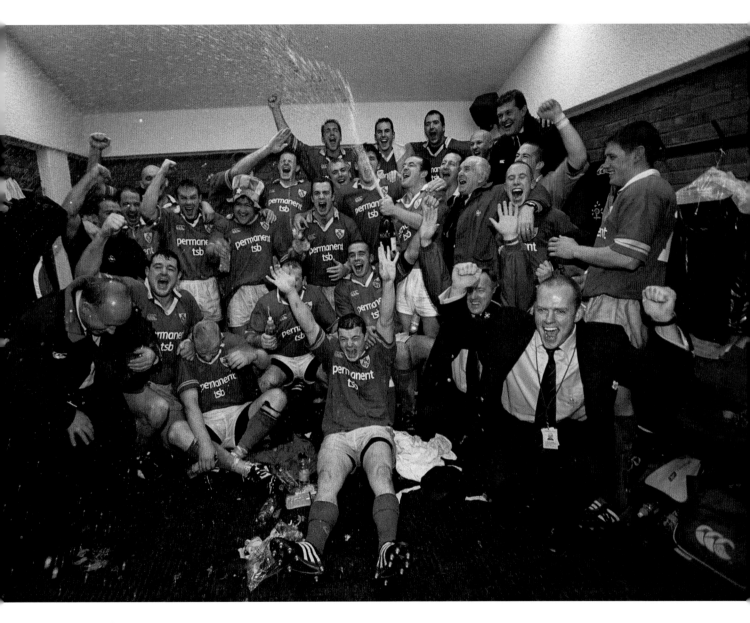

9 November 2002

The dawn of the golden age: The Irish team celebrate an 18-9 win over World Champions Australia in Lansdowne Road. This rainy game was Brian O'Driscoll's debut as captain, and out-half Ronan O'Gara nailed a magnificent six penalties. Ireland v Australia, Autumn International, Lansdowne Road, Dublin.

Matt Browne / SPORTSFILE

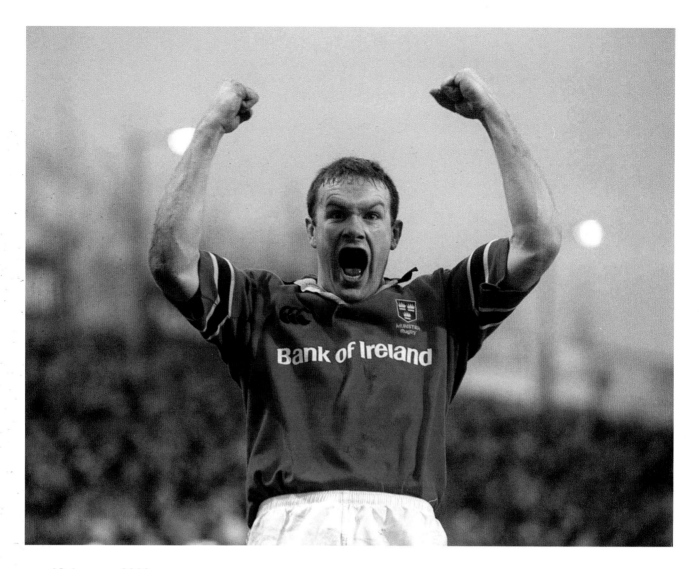

18 January 2003

The 'Miracle Match': Munster go through to the quarter-finals of the
2003 Heineken Cup after an astonishing 33-6 win over Gloucester in
Thomond Park. The Irish side needed four tries and a minimum margin
of 27 points – which is exactly what they achieved. Here, John Kelly
celebrates after scoring the crucial fourth try in the last minute of the
game. Munster v Gloucester, Heineken European Cup, Pool 2, Thomond
Park, Limerick.

Pat Murphy / SPORTSFILE

16 February 2003

The late Anthony Foley, along with Alan Quinlan, Guy Easterby
and Malcolm O'Kelly, celebrates a decisive 6-36 win over Scotland
in the 2003 Six Nations, their first victory in Murrayfield since
1985. Scotland v Ireland, RBS Six Nations Rugby Championship,
Murrayfield Stadium, Edinburgh.

Matt Browne / SPORTSFILE

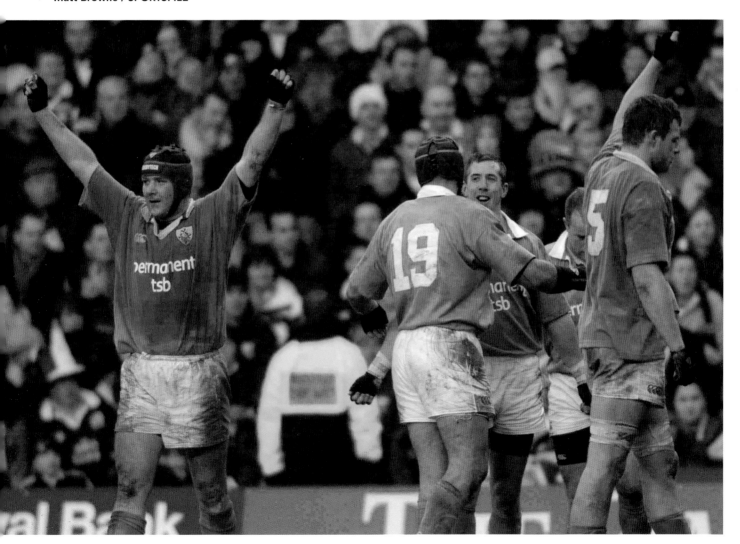

30 March 2003

Before the Ireland v England Six Nations match in Lansdowne Road, the visitors lined up on the left-hand side, facing the tunnel – traditionally Ireland's 'lucky' side. England captain Martin Johnson refused to move, so Ireland lined out further to their left, meaning that President Mary McAleese had to walk on the grass rather than the red carpet when meeting the Irish team. Ireland v England, RBS Six Nations Rugby Championship, Lansdowne Road, Dublin.

Brendan Moran / SPORTSFILE

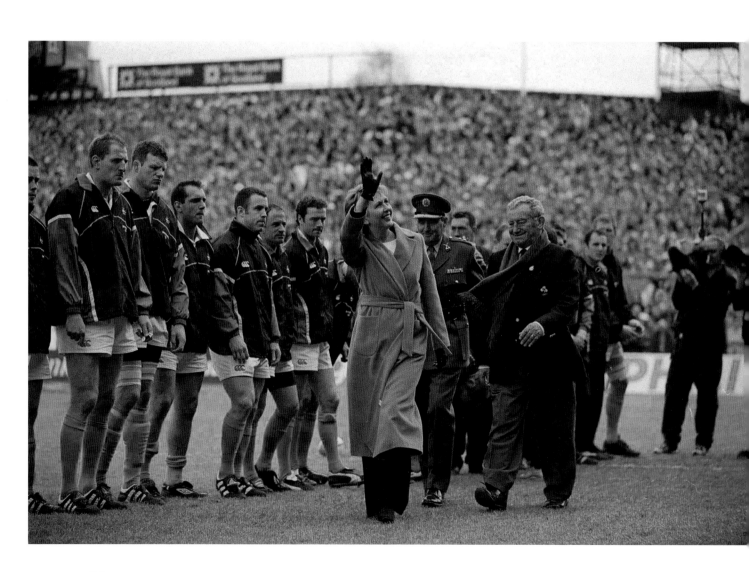

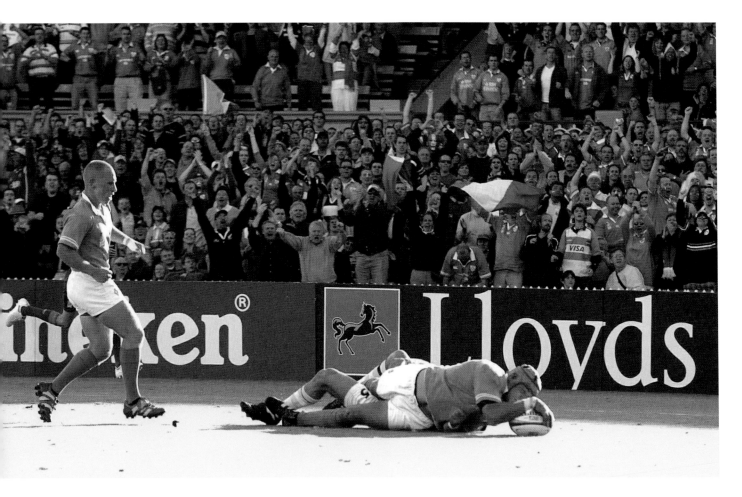

26 October 2003

Alan Quinlan holds off the challenge of Argentina's Ignacio Corleto in match three of the 2003 Rugby World Cup in Adelaide. Quinlan's effort ended in a crucial try for Ireland – and a dislocated shoulder. Ireland v Argentina, 2003 Rugby World Cup, Pool A, Adelaide Oval, Adelaide, Australia.

Brendan Moran / SPORTSFILE

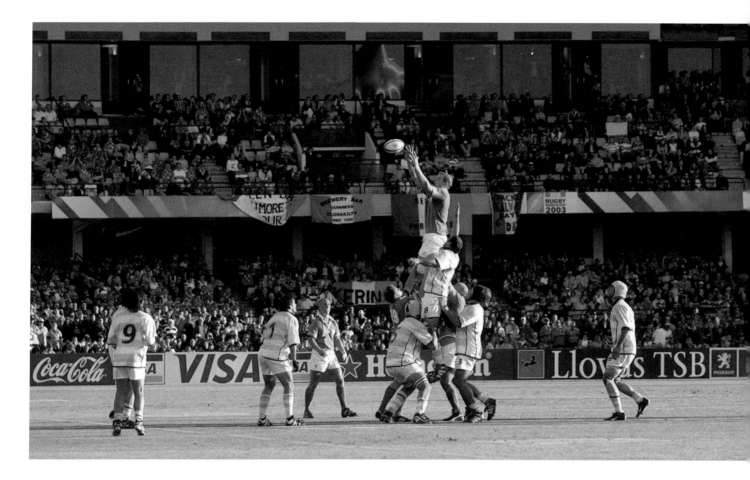

26 October 2003

Paul O'Connell wins a lineout against Argentina in the 2003 RWC in
Australia. Ireland scraped a 16-15 victory; Keith Wood would later say
he had never been so tired. Ireland v Argentina, 2003 Rugby World Cup,
Pool A, Adelaide Oval, Adelaide, Australia.

Brendan Moran / SPORTSFILE

9 November 2003

Distraught captain Keith Wood leaves the field, accompanied by
IRFU Public Relations Officer John Redmond, after a storming 43-21
defeat by France in the quarter-finals of the 2003 Rugby World Cup in
Australia. Wood announced his retirement during the post-match news
conference. Ireland v France, 2003 Rugby World Cup, Quarter-Final,
Telstra Dome, Melbourne, Australia.

Brendan Moran / SPORTSFILE

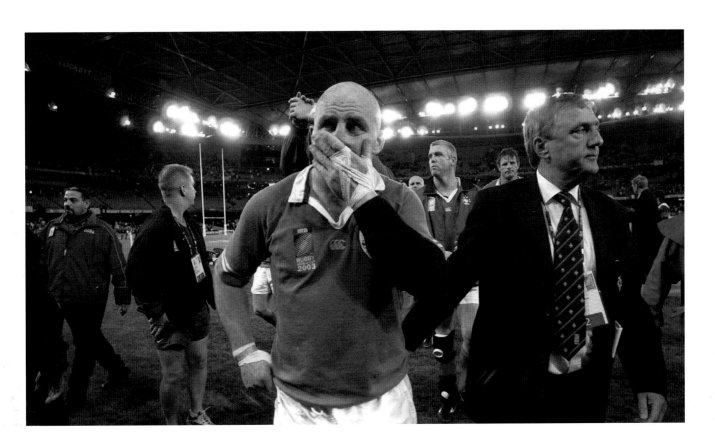

6 March 2004

Girvan Dempsey scores Ireland's only try in their famous Twickenham win over world champions England in the 2004 Six Nations. England v Ireland, RBS Six Nations Rugby Championship, Twickenham, London.

Brendan Moran / SPORTSFILE

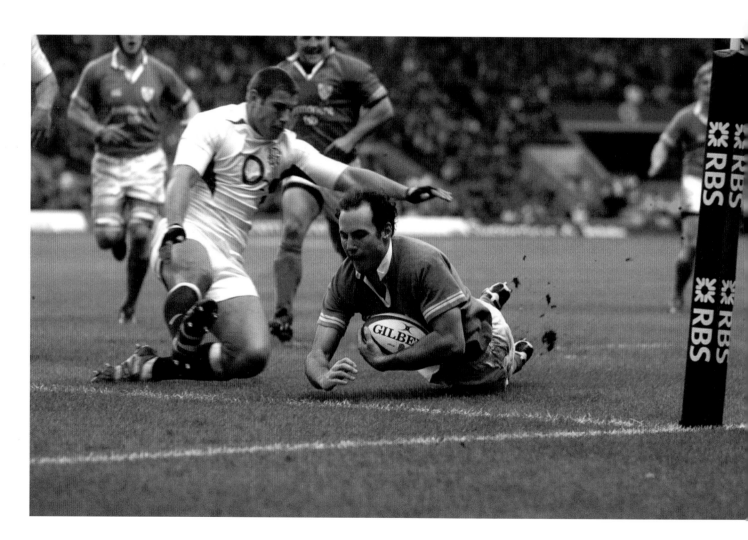

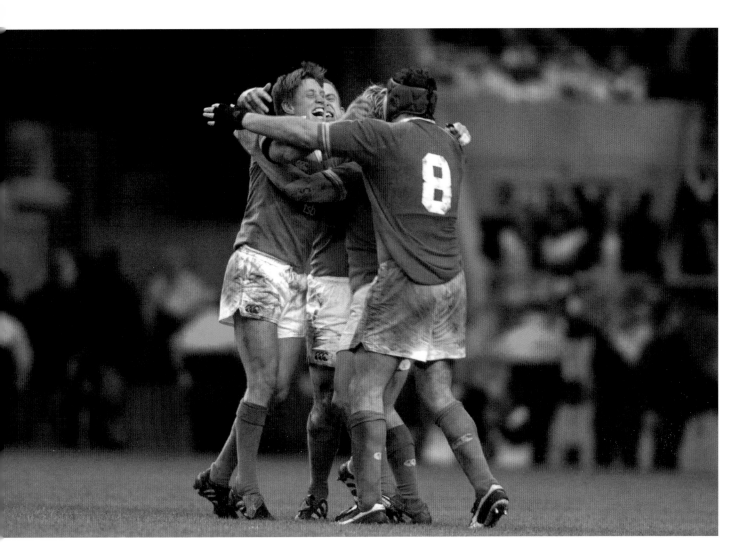

6 March 2004

A watershed moment: Ireland end the twenty-two-game home record

of the English and shake the rugby world order with a determined 13-19

victory in Twickenham.

Brendan Moran / SPORTSFILE

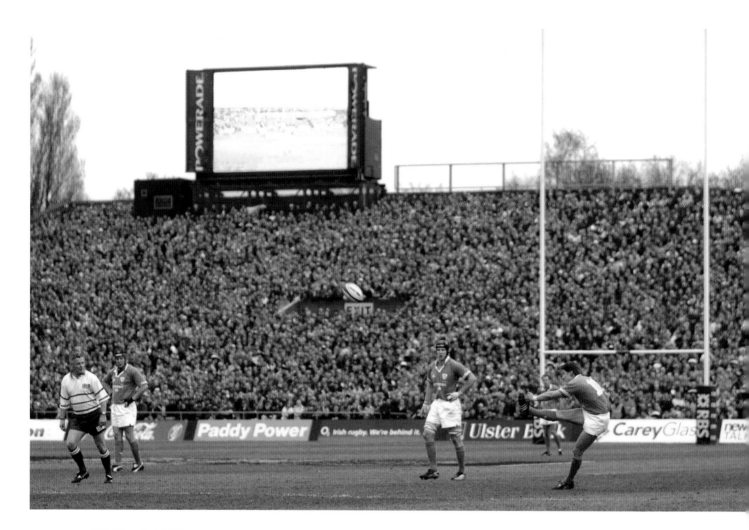

27 March 2004

Watched over by fans in Lansdowne Road's South Terrace, Ronan
O'Gara kicks a penalty during Ireland's encounter with Scotland. Ireland
v Scotland, RBS Six Nations Rugby Championship, Lansdowne Road,
Dublin.

Brendan Moran / SPORTSFILE

27 March 2004

Brian O'Driscoll and head coach Eddie O'Sullivan celebrate Ireland's
37-16 win over Scotland and their first Triple Crown in nineteen years.
Ireland v Scotland, RBS Six Nations Rugby Championship, Lansdowne
Road, Dublin.

Brendan Moran / SPORTSFILE

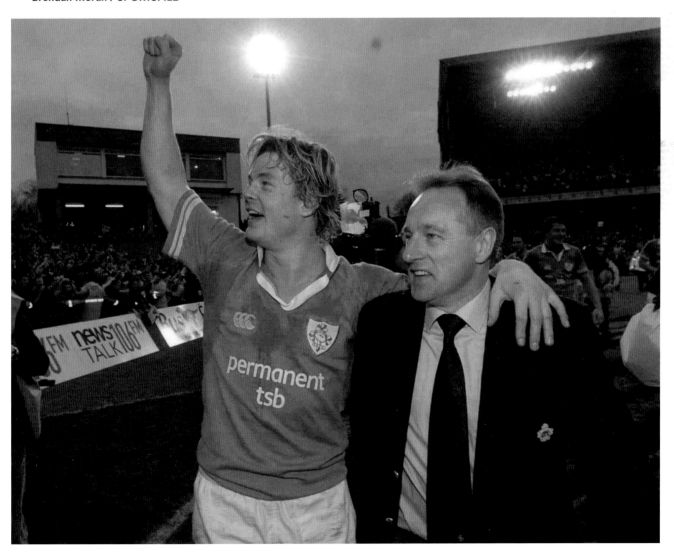

8 May 2004

The champagne flows as the players of Shannon RFC celebrate a remarkable sixth All-Ireland title after their 22-16 win over Cork Constitution. AIB All-Ireland League, Division 1 Final, Lansdowne Road, Dublin.

Brendan Moran / SPORTSFILE

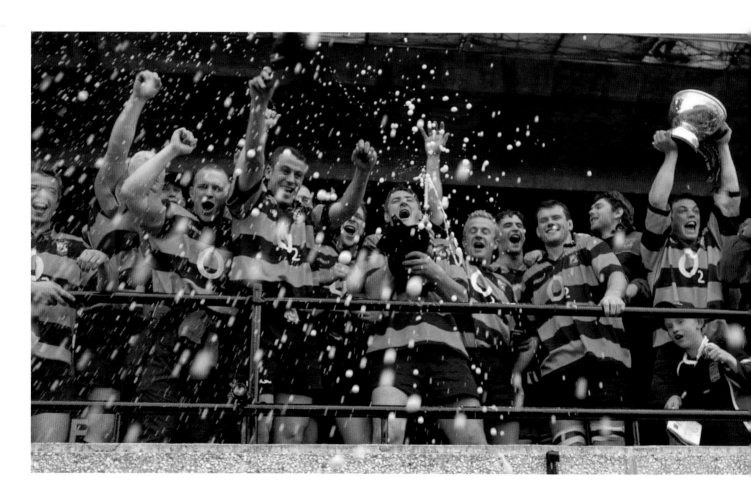

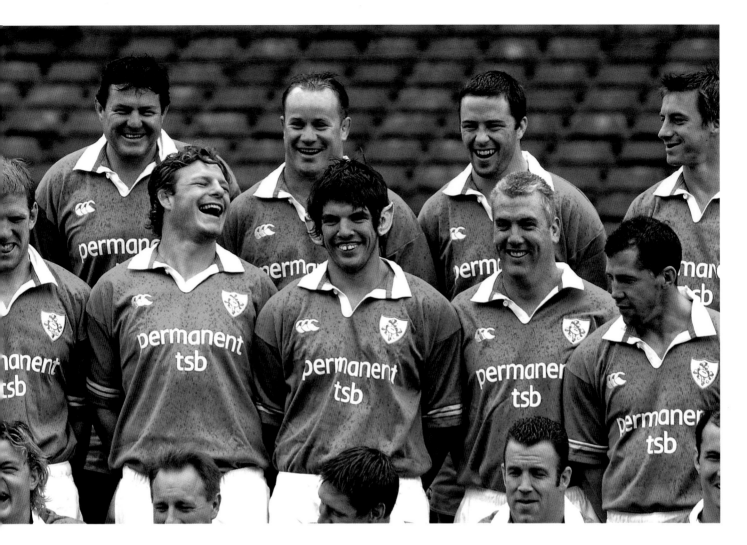

3 June 2004

Donncha O'Callaghan gives his team-mates a laugh during the Irish squad's photo shoot before their 2004 rugby union tour of South Africa. Included in the photo are, back row, from left, Reggie Corrigan, Frank Sheahan, Marcus Horan and Tyrone Howe, centre, from left, Paul O'Connell, Malcolm O'Kelly, Donncha O'Callaghan, Victor Costello, and Guy Easterby and front, Brian O'Driscoll, Eddie O'Sullivan, Ronan O'Gara, Kevin Maggs and Girvan Dempsey.

Brendan Moran / SPORTSFILE

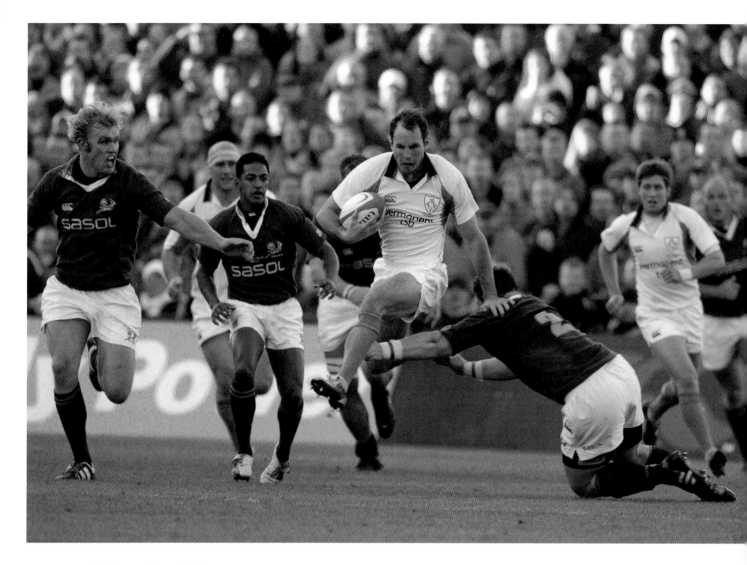

13 November 2004

Girvan Dempsey jumps to avoid the tackle of South Africa's John Smit
and races clear of Schalk Burger and Breyton Paulse during the game.
Ireland v South Africa, Permanent TSB Autumn International, Lansdowne
Road, Dublin.

Brendan Moran / SPORTSFILE

13 November 2004

Wicklow man Shane Byrne celebrates Ireland's second-ever win over the
South Africa, after a tense and closely fought match in Lansdowne Road.
Ireland v South Africa, Permanent TSB Autumn International, Lansdowne
Road, Dublin.

Brendan Moran / SPORTSFILE

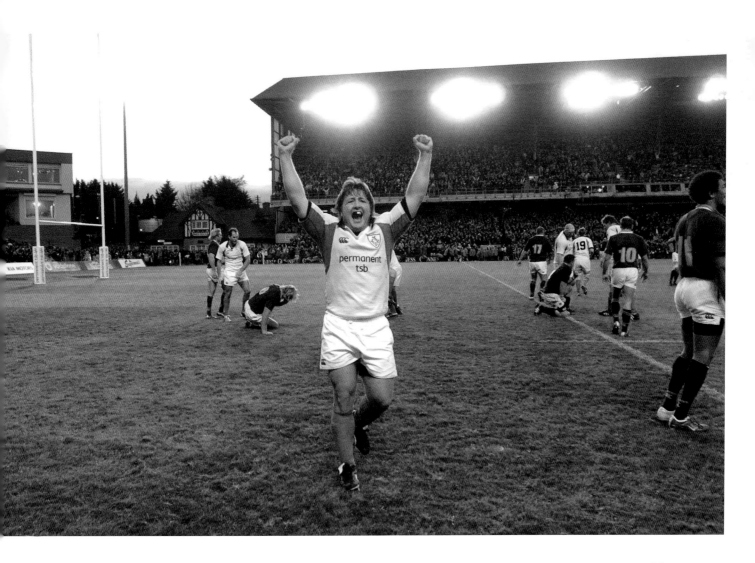

27 February 2005

Captain Brian O'Driscoll after scoring Ireland's first and only try against England. Ireland would go on to win 19-13, consigning England to their third tournament defeat in a row. Ireland v England, RBS Six Nations Championship, Lansdowne Road, Dublin.

Brendan Moran / SPORTSFILE

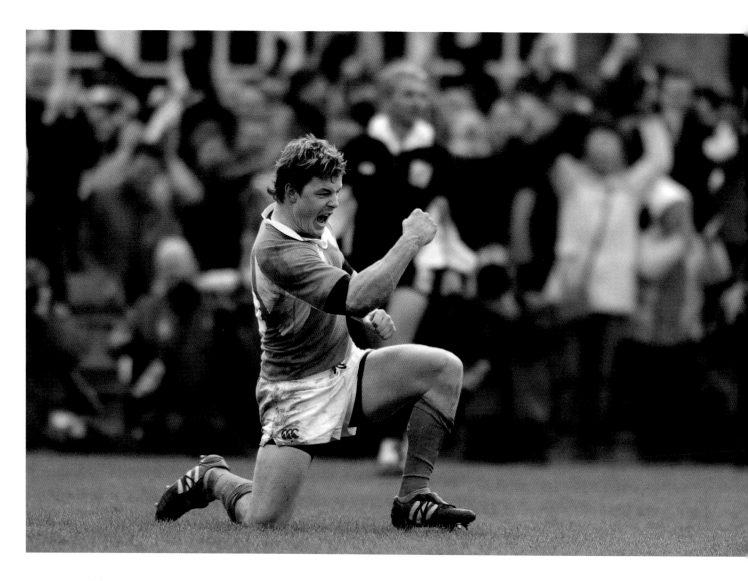

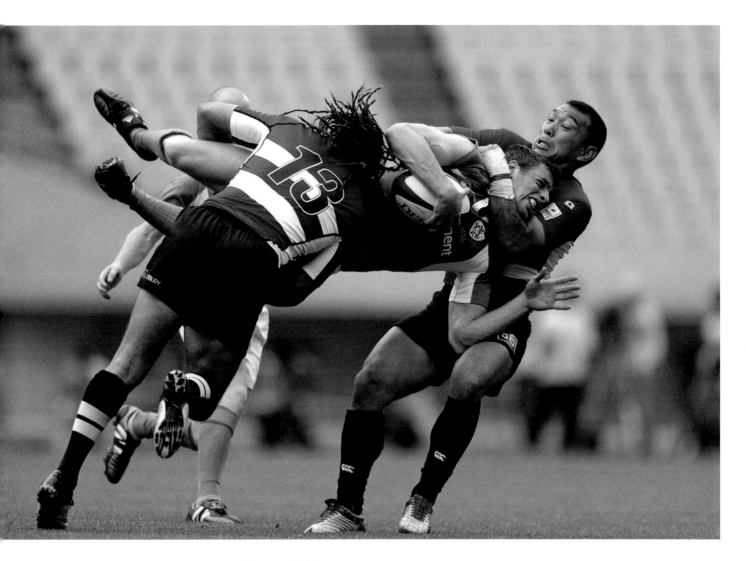

12 June 2005

Gavin Duffy is tackled by Reuben Parkinson, left, and Yukio Motoki.

Japan v Ireland, Ireland Summer Tour 1st Test, Nagai Stadium, Osaka.

Brendan Moran / SPORTSFILE

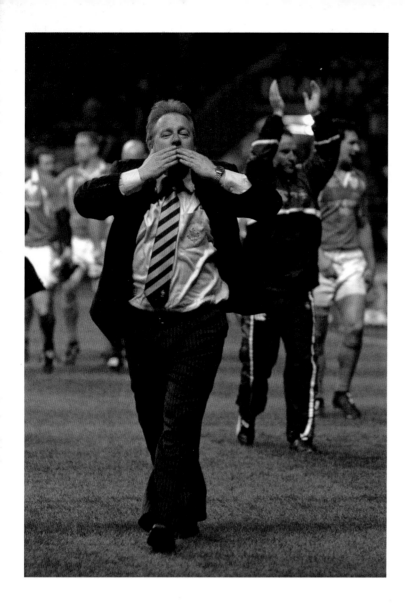

Left: 18 March 2006

Blowing kisses; Head coach Eddie O'Sullivan celebrates as Ireland wins the Triple Crown after a dramatic 28-24 victory over England at Twickenham. England v Ireland, RBS Six Nations Championship, Twickenham Stadium, London.

Brendan Moran / SPORTSFILE

Opposite page:

Denis Leamy, left, and Ronan O'Gara with the RBS Triple Crown trophy. The Ireland v England match came down to the final minutes, when Shane Horgan scored a last-gasp try and O'Gara followed with a conversion.

Captain Brian O'Driscoll with the RBS Triple Crown trophy. Ireland lost the Six Nations to France on points difference.

Brendan Moran / SPORTSFILE

This was Ireland's eighth Triple Crown win, but it was the first time a trophy was presented for winning the Triple Crown so Ireland had silverware to show. After the presentation and champagne on the pitch, the players headed for the dressing room. A quick word with John Redmond, the Ireland team press officer at the time, and we were granted access to the Ireland dressing room to record the celebrations. He realised the value of highlighting the Ireland team's success.

People think after match dressing rooms are like a party. But the truth is, it takes time for the players to recover from the physicality of the game, so it can be subdued for a little while after a game. Having taken a few group photos of various players and staff with the trophy, I decided to switch to a longer lens and noticed captain Brian O'Driscoll pick up the trophy and examine it in detail. He is the first captain to ever lift this trophy, history could never take away that honour from him. It was hugely rewarding to get a nice photo of him contemplating that moment.

Brendan Moran

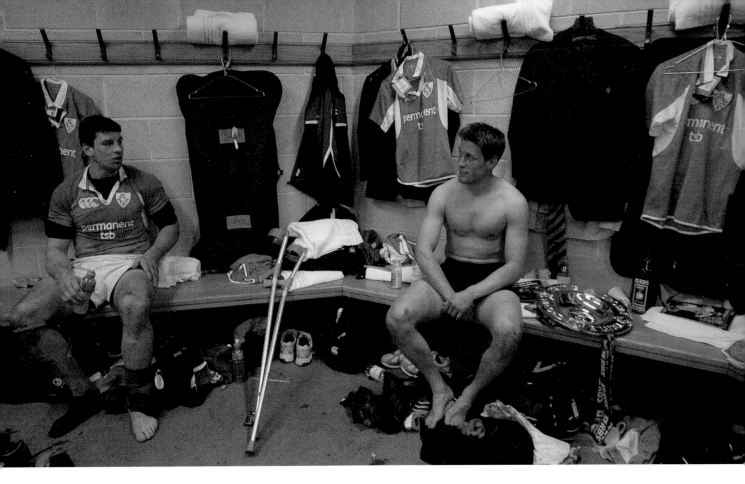
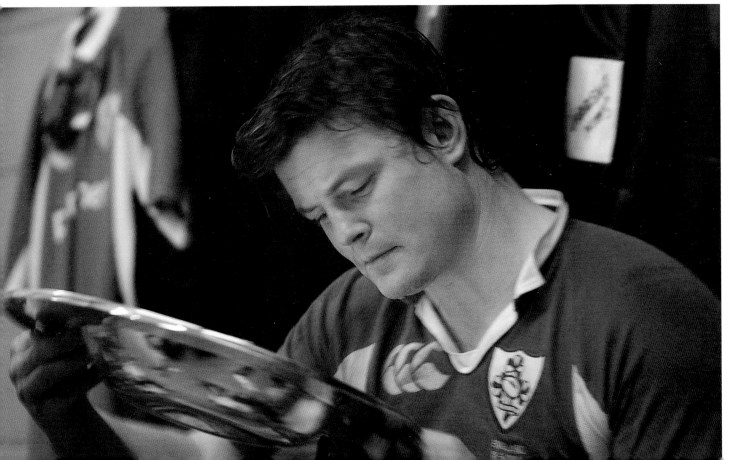

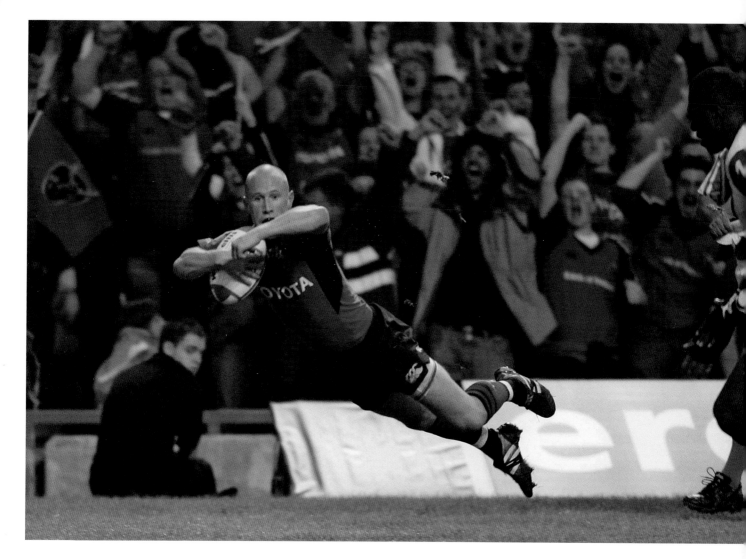

20 May 2006

Munster's Peter Stringer dives for a first-half try against Biarritz Olympique in the Heineken Cup final. The sides were level when Stringer picked the ball up from a Munster scrum and fooled the Biarritz defence by attacking the blindside to score a memorable try. Munster v Biarritz Olympique, Heineken Cup Final, Millennium Stadium, Cardiff.

Brendan Moran / SPORTSFILE

20 May 2006

Munster fans wave flags during the 2006 Heineken Cup final against
Biarritz. It was their side's third final, after defeats in 2000 and 2002.

Brian Lawless / SPORTSFILE

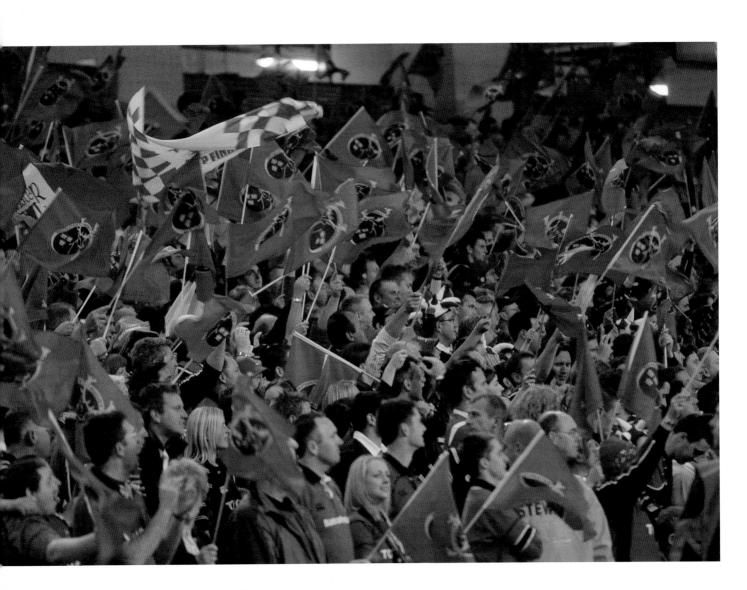

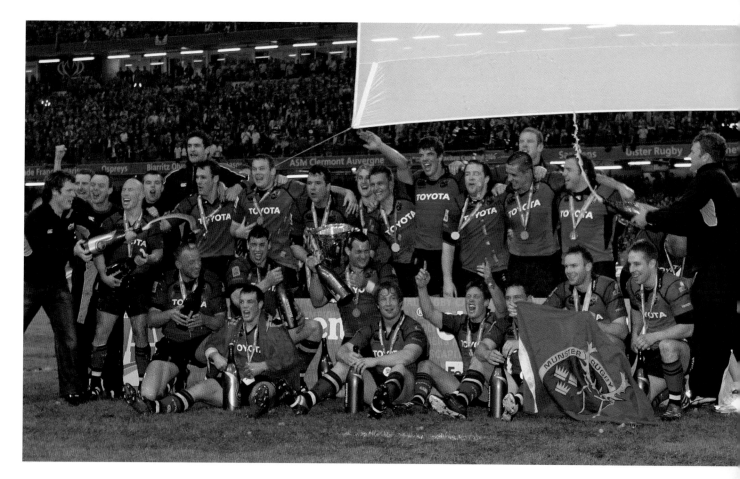

20 May 2006

Captain Anthony Foley and the Munster squad celebrate their first-ever
Heineken Cup win after defeating Biarritz Olympique 23-19 in Cardiff.
Munster v Biarritz Olympique, Heineken Cup Final, Millennium Stadium,
Cardiff.

Tim Parfitt / SPORTSFILE

26 November 2006

Head coach Eddie O'Sullivan waves to the crowd after his team defeated the Pacific Islanders by 61-17 in the 2006 autumn internationals. This match marked the first Ireland caps for Jamie Heaslip, Luke Fitzgerald and Stephen Ferris – and the last international in Lansdowne Road before it was demolished and rebuilt.

Brendan Moran / SPORTSFILE

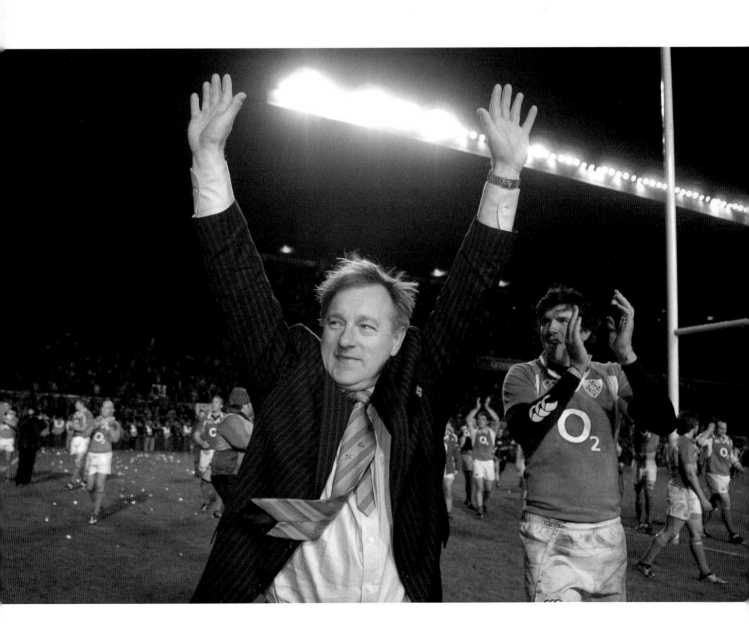

31 December 2006

Jimmy Galloway, a member of the Lansdowne Road ground staff, locks the gate leading to the pitch following the final inter provincial game played there on the last day of 2006. The next time it would open, 2010, it would become known as the Aviva Stadium. Leinster v Ulster, Magners League, Lansdowne Road, Dublin.

David Maher / SPORTSFILE

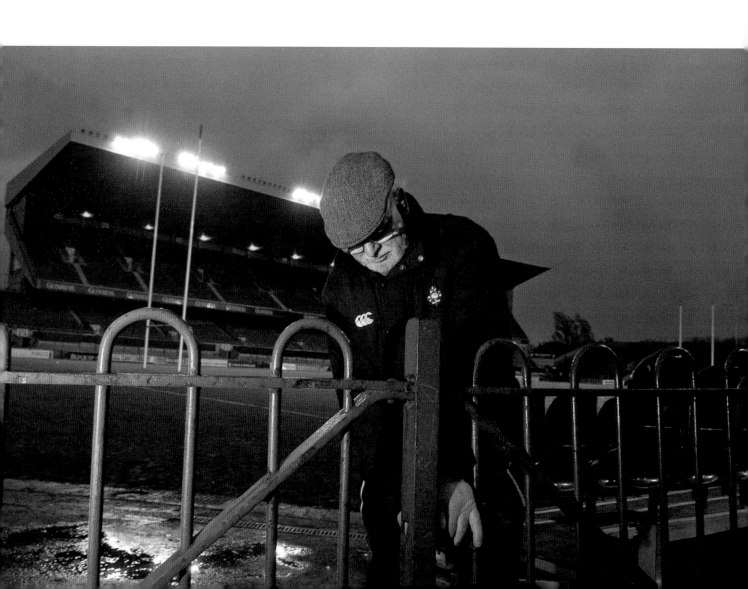

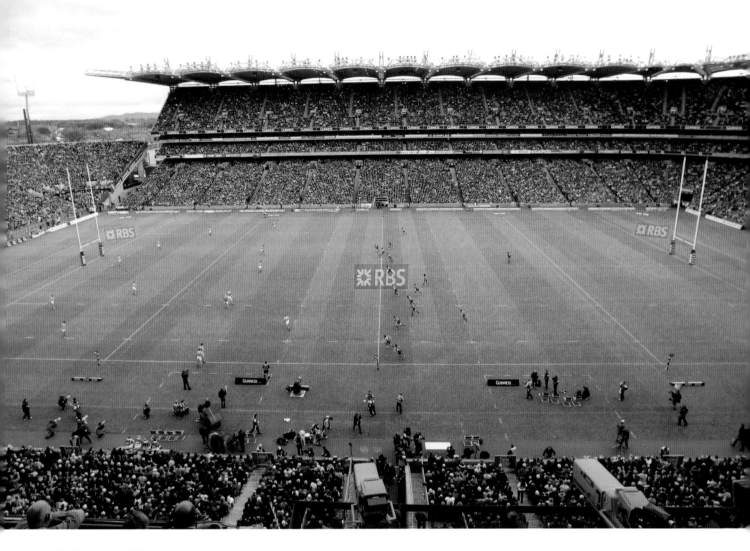

11 February 2007

Kick-off in Croke Park: The first moments of what would be a heart-stopping – and heart-breaking for the home side – Six Nations encounter between Ireland and France. This was the first rugby match played at the GAA's headquarters while Lansdowne Road was being renovated. Ireland v France, RBS Six Nations Rugby Championship, Croke Park, Dublin.

David Maher / SPORTSFILE

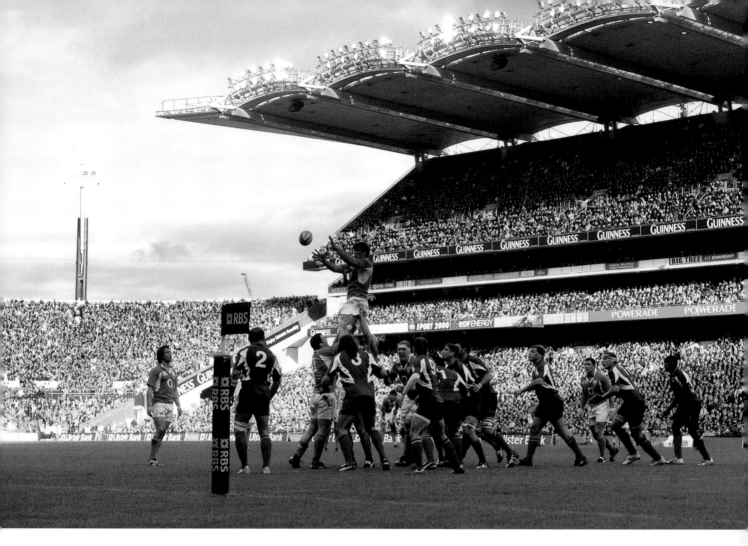

11 February 2007

In the final minutes of the pulsating second half, a penalty from Ronan O'Gara gave Ireland a four-point lead, but a try by Vincent Clerc in the final seconds snatched victory. Here Clerc celebrates his try and ultimately the French victory. Ireland v France, RBS Six Nations Rugby Championship, Croke Park, Dublin.

Brendan Moran / SPORTSFILE

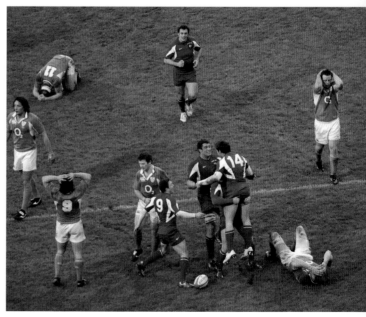

24 February 2007

History in the making: The Ireland and England teams stand for the national anthems before their Six Nations meeting on 24 February 2007. This was the first time 'God Save the Queen' was ever played in the borrowed ground of Croke Park.

Brendan Moran / SPORTSFILE

When it was announced that the Garda and Army No.1 bands would play the national anthems, a spontaneous round of applause rang around the stadium. The bands started and you could clearly hear the words of the English anthem being sung by the players and the many England fans. The anthem finished and there was another huge round of applause.

Then '*Amhrán na bhFiann*' started up with a big roar from the Irish fans. Nearing the end of the anthem, you could see how emotional the Irish players were; the tears in John Hayes' eyes, and the look on Paul O'Connell's face. 'Ireland's Call' was played and sung with gusto and you knew then that Ireland were not going to lose this game. They didn't and won 43-13. The respect shown to the anthems and the match win made this day a proud day to be Irish.

Brendan Moran

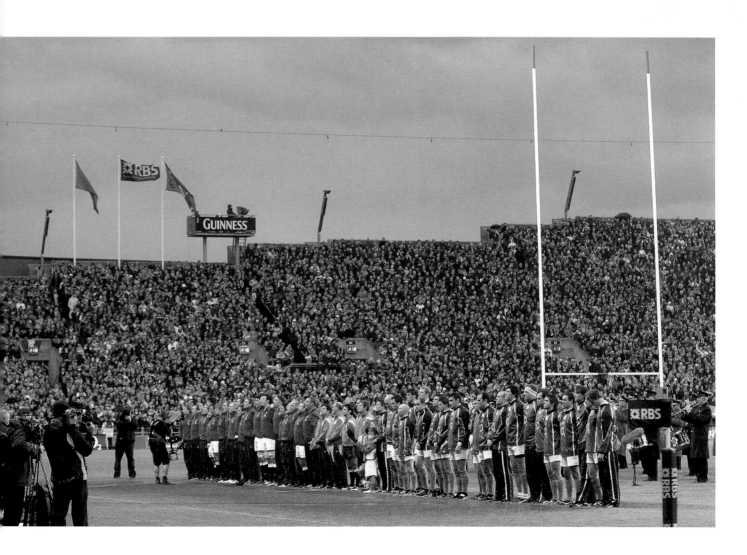

24 February 2007

A general view over Croke Park during the national anthems. Ireland v England, RBS Six Nations Rugby Championship, Croke Park, Dublin.

Brian Lawless / SPORTSFILE

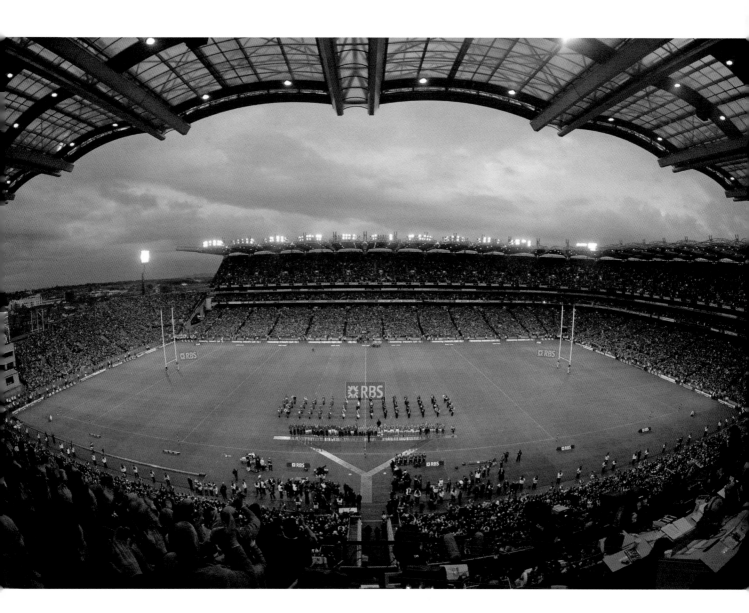

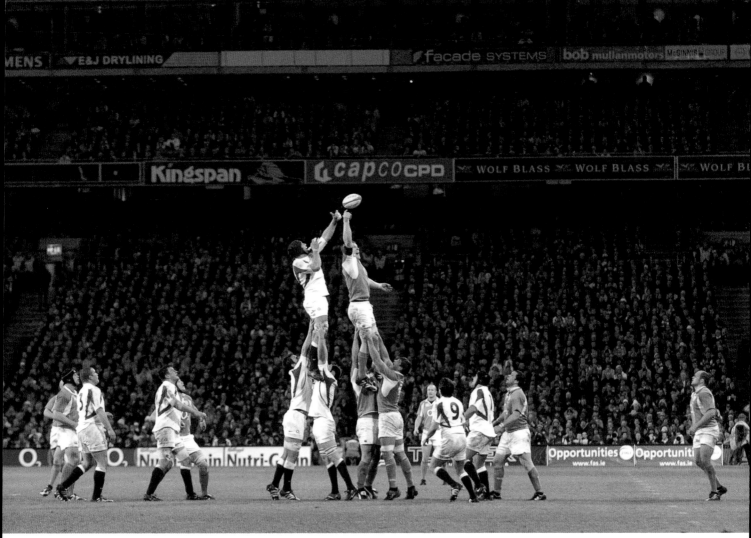

24 February 2007

Paul O'Connell wins possession in a lineout from England's Danny Grewcock. 'We wanted to do the occasion justice,' O'Connell said afterwards. 'It was a pleasure to play out there. Very emotional, a brilliant day.'

Brian Lawless / SPORTSFILE

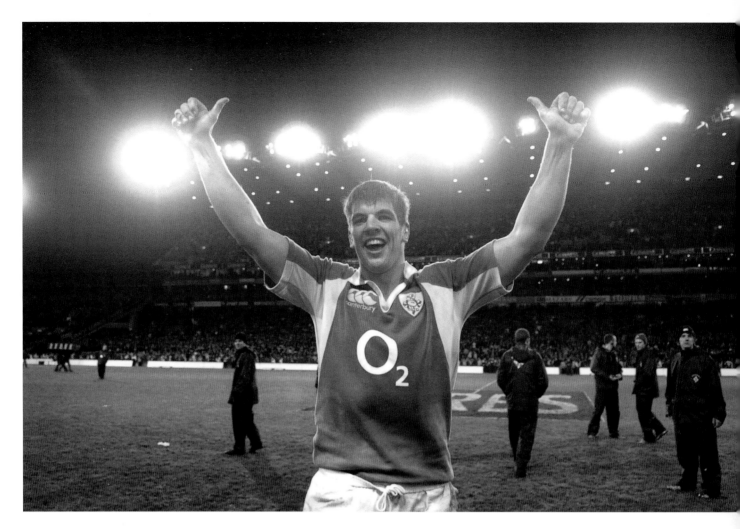

24 February 2007

Donncha O'Callaghan celebrates at the final whistle after Ireland beat
England by a record-breaking 30 points in Croke Park.

Brendan Moran / SPORTSFILE

15 September 2007

Shane Horgan is tackled by Revaz Gigauri and David Khinchigashvili of Georgia. Ireland narrowly avoided an embarrassing defeat by the third-tier side during the 2007 Rugby World Cup in France.

Brendan Moran / SPORTSFILE

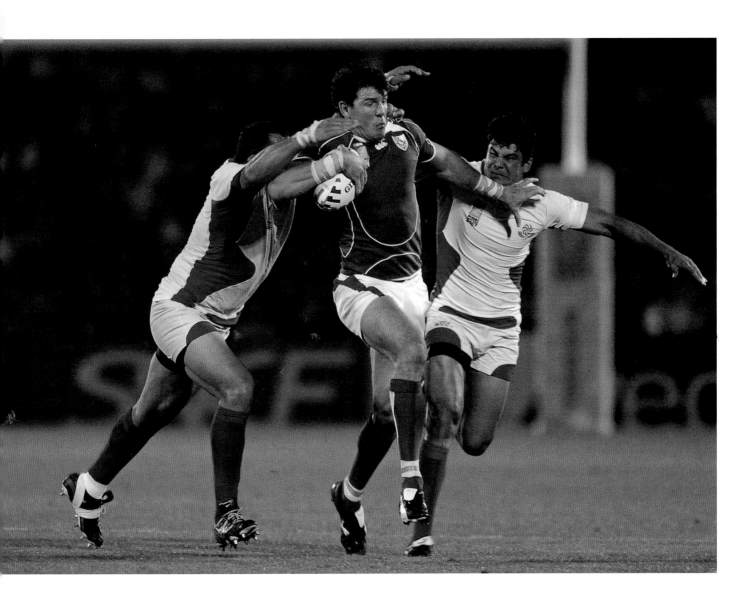

15 September 2007

The Ireland team react as the Georgians score a second try. 2007 Rugby World

Cup, Pool D, Ireland v Georgia, Stade Chaban Delmas, Bordeaux, France.

Brendan Moran / SPORTSFILE

Opposite: 21 September 2007

A nervous Irish fan watches as his team are beaten 25-3 by hosts

France in Pool D of the 2007 Rugby World Cup.

Brendan Moran / SPORTSFILE

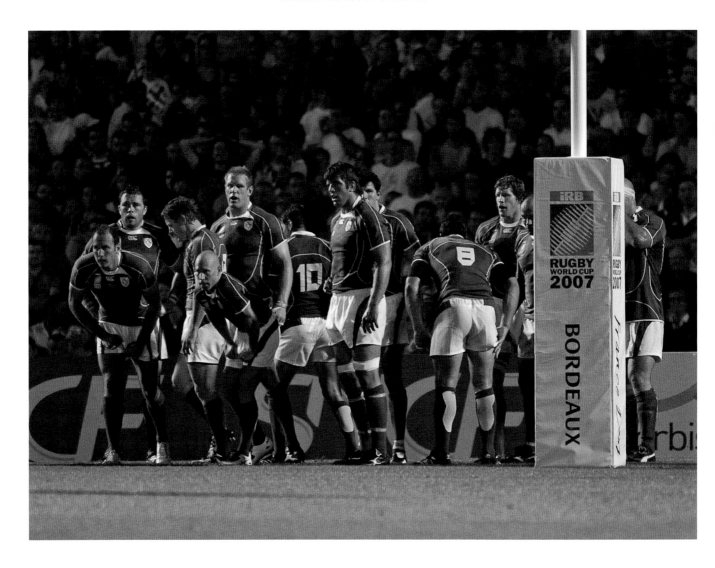

30 September 2007

Ronan O'Gara after final match of the 2007 Rugby World Cup, in which Ireland
were roundly defeated by Argentina in Parc des Princes, Paris. It was the first
time the Irish team failed to make it out of the pool stages.

Brendan Moran / SPORTSFILE

30 September 2007

Denis Hickie's final farewell: The 31-year-old winger, who at the time held the Irish try-scoring record, retired at the end of the tournament. Ireland v Argentina, 2007 Rugby World Cup, Pool D, Parc des Princes, Paris, France.

Brendan Moran / SPORTSFILE

2 February 2008

Ireland kicks off the 2008 Six Nations with a win over Italy in Croke Park.

Girvan Dempsey, seen here holding off a challenge by Leonardo Ghiraldini and

Mauro Bergamasco, scored the only try for the Irish side.

Stephen McCarthy / SPORTSFILE

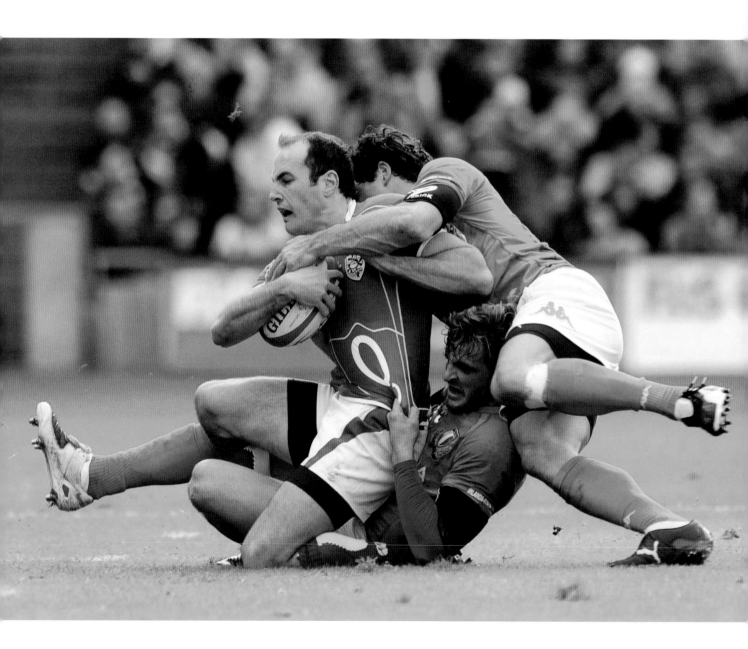

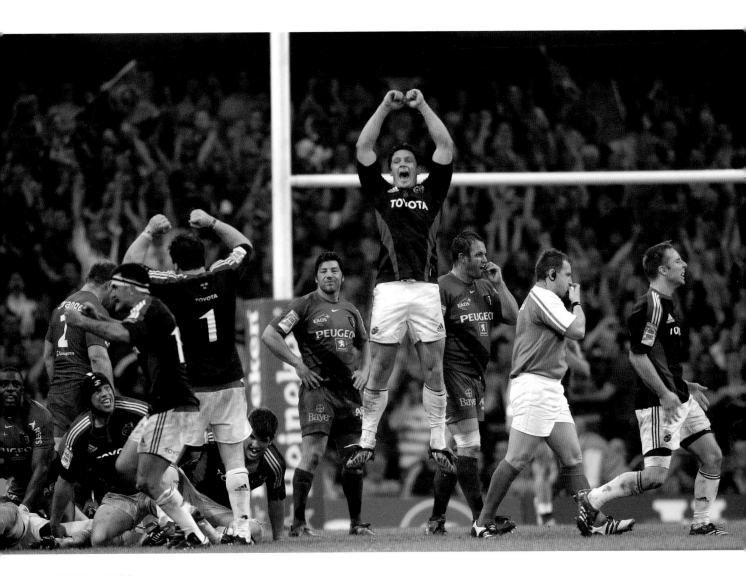

24 May 2008

Munster's David Wallace celebrates at the final whistle of the Heineken
Cup final in the Millennium Stadium, Cardiff. The Irish side triumphed over
Toulouse to bring home their second title in three years.

Peter Morrison / SPORTSFILE

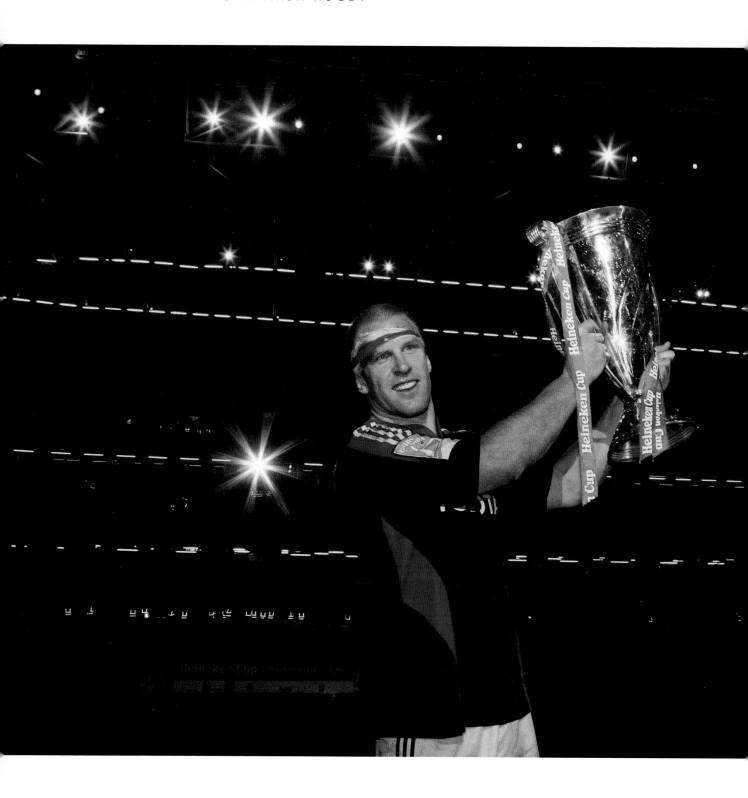

24 May 2008

Captain Paul O'Connell celebrates with the cup. Munster v Toulouse, Heineken Cup Final, Millennium Stadium, Cardiff, Wales.

Oliver McVeigh / SPORTSFILE

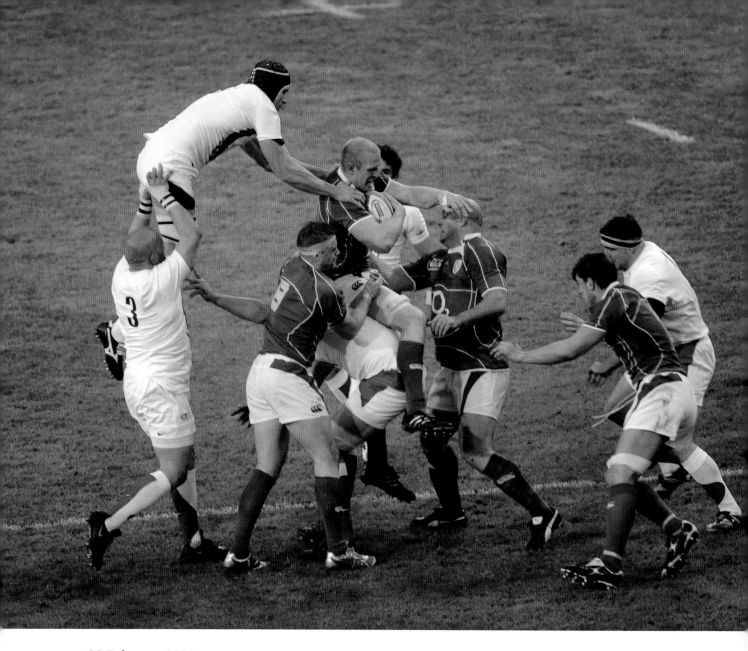

28 February 2009

Paul O'Connell wins possession during a tense Six Nations standoff between
Ireland and England in Croke Park.

Ray McManus / SPORTSFILE

21 March 2009

Tommy Bowe blazes past the Welsh to score Ireland's second try, giving the visitors a temporary lead of 12-6 in the 45th minute of this tense Six Nations clash in the Millennium Stadium, in Cardiff.

Matt Browne / SPORTSFILE

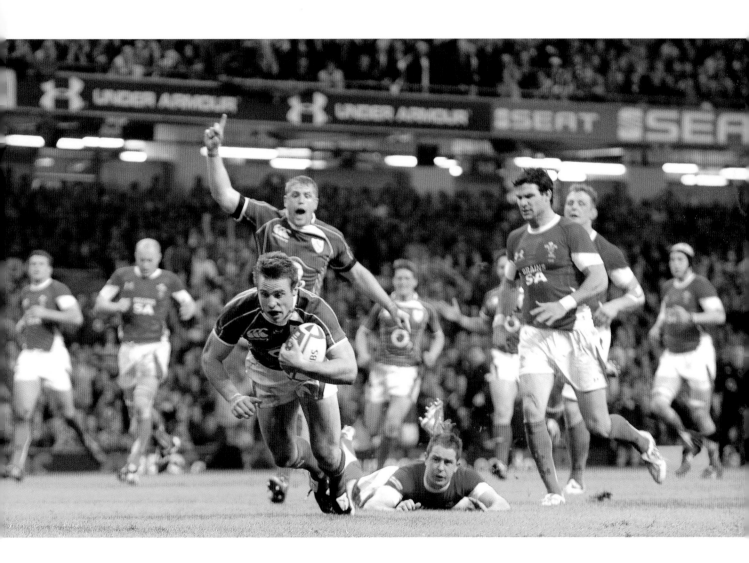

21 March 2009

Make or break: Ronan O'Gara kicks the match-winning drop goal in the 78th minute. Wales v Ireland, RBS Six Nations Championship, Millennium Stadium, Cardiff, Wales.

Stephen McCarthy / SPORTSFILE

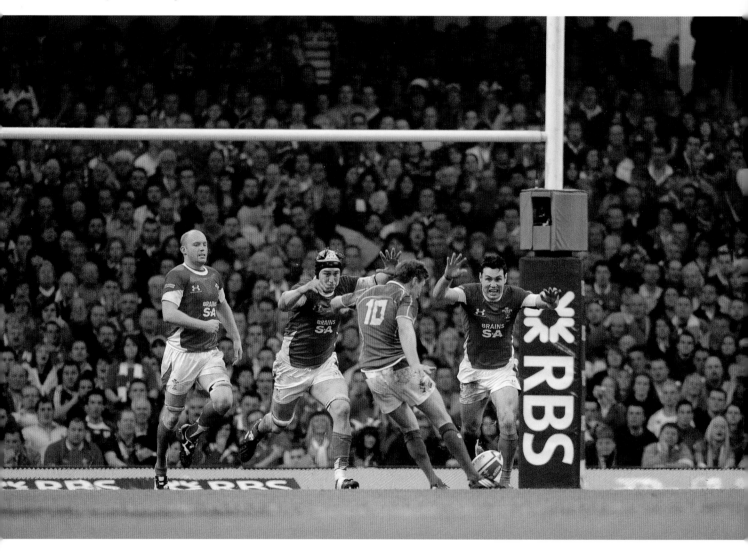

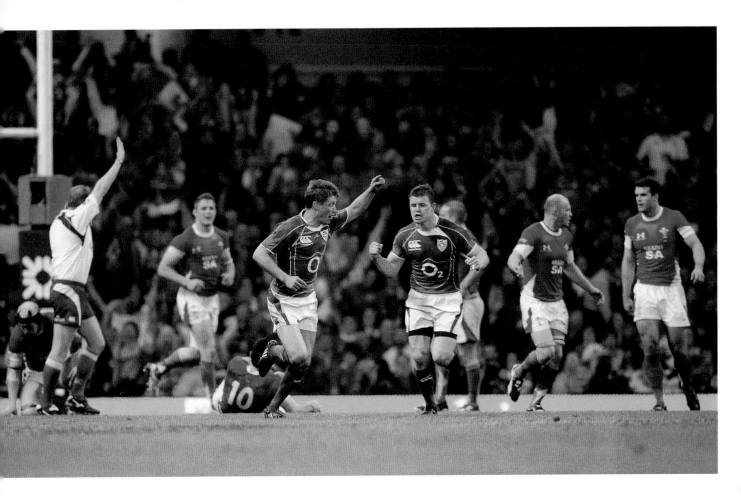

21 March 2009

Break open the champagne: Referee Wayne Barnes signals success for Ronan O'Gara and the Irish players. The celebrations are only beginning. This victory landed Ireland their first 'Grand Slam' since 1948.

Stephen McCarthy / SPORTSFILE

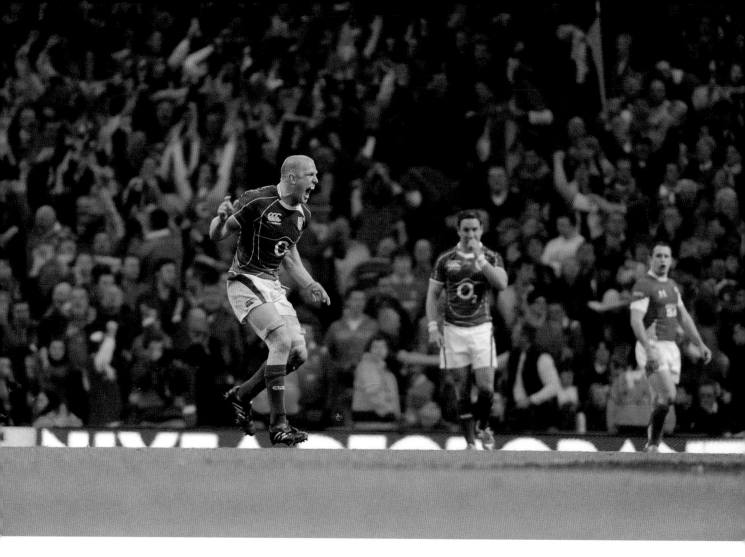

21 March 2009

A jubilant Paul O'Connell at the final whistle: Ireland have taken the Triple

Crown and the Grand Slam.

Matt Browne / SPORTSFILE

21 March 2009

Flanked by the team, captain Brian O'Driscoll and Peter Stringer lift the RBS Six Nations
and the Triple Crown trophies.

Brendan Moran / SPORTSFILE

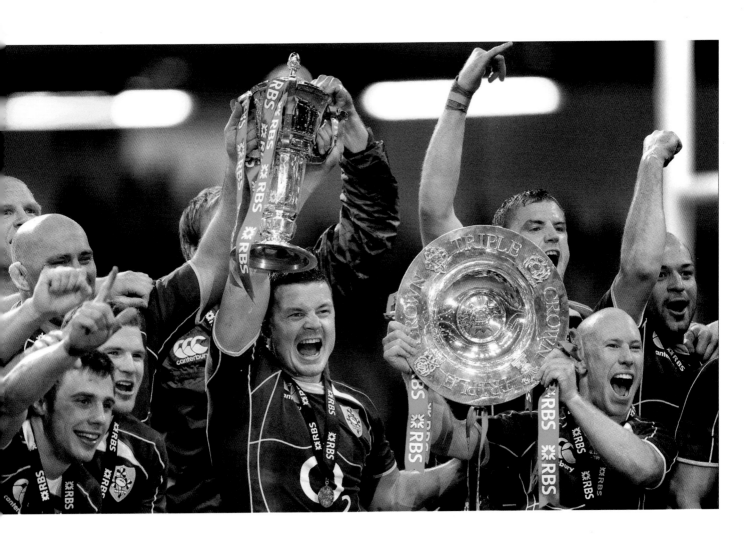

21 March 2009

On one of the best days wearing an Ireland shirt, Ronan O'Gara kisses his precious medal.

Brendan Moran / SPORTSFILE

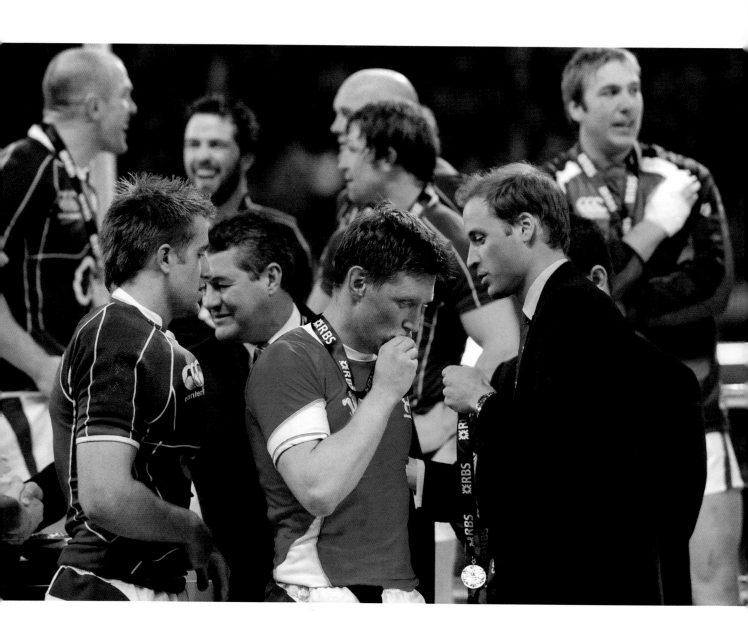

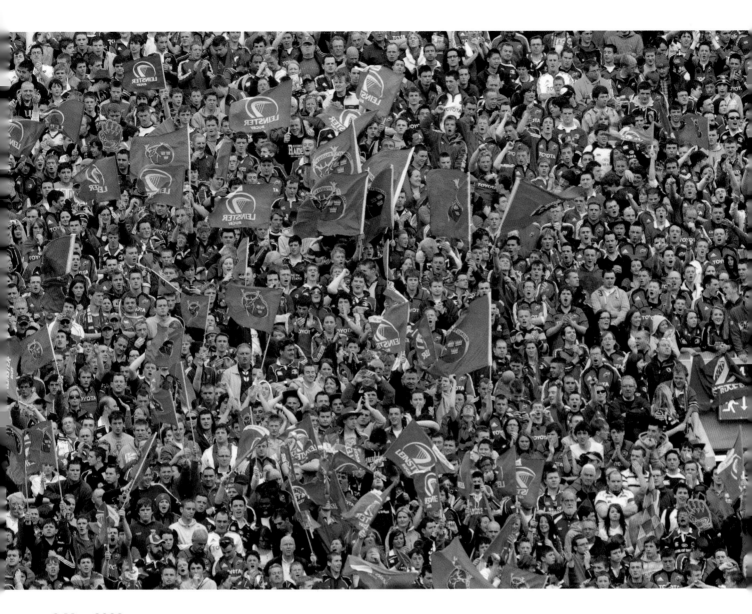

2 May 2009

The 2009 Heineken Cup semi-final between Munster and Leinster took place
in front of 82,208 jubilant fans in Croke Park, a world-record attendance for a
club game.

Pat Murphy / SPORTSFILE

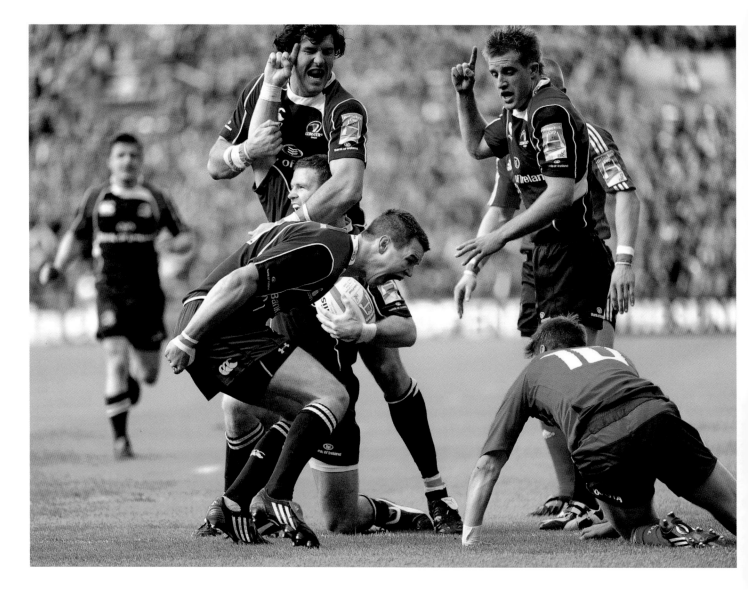

2 May 2009

Jonathan Sexton, Shane Horgan and Luke Fitzgerald of Leinster celebrate
Gordon D'Arcy's try in the 31st minute of the game. Munster v Leinster,
Heineken Cup Semi-Final, Croke Park, Dublin.

Matt Browne / SPORTSFILE

2 May 2009

Leinster's Brian O'Driscoll races clear of Munster's Ronan O'Gara on his way
to scoring his side's third try. After years of heartbreak, Leinster defeated their
great rivals and European Champions Munster on their way to winning their
first Heineken Cup.

Brendan Moran / SPORTSFILE

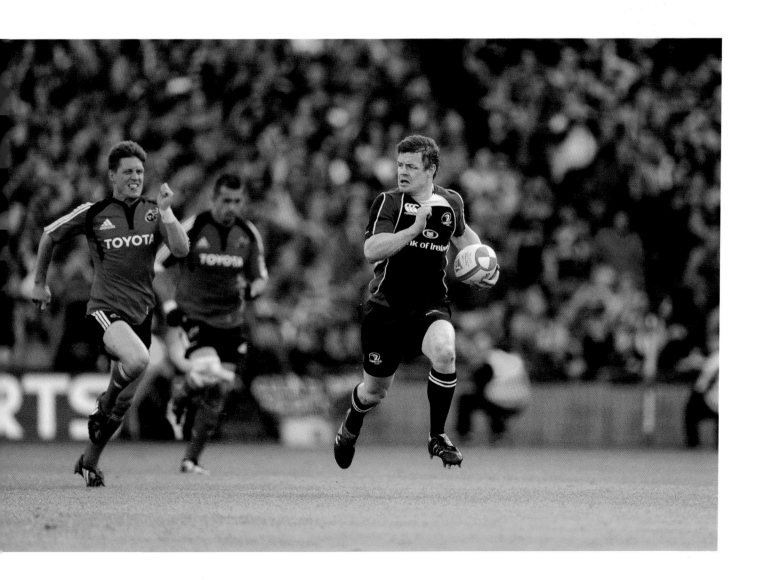

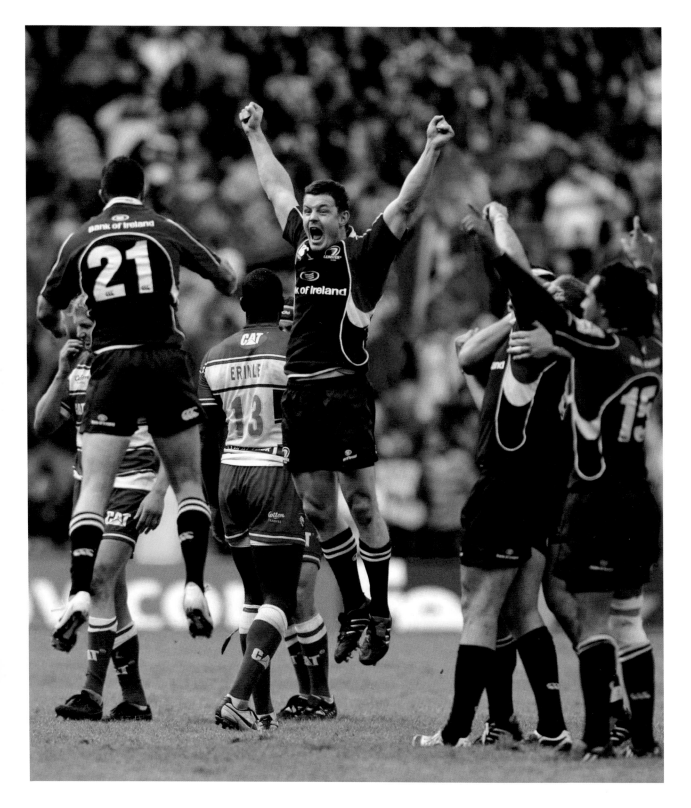

Opposite: 23 May 2009

Brian O'Driscoll celebrates
on the final whistle after
a hard-won victory over
Leicester. Leinster v Leicester
Tigers, Heineken Cup
Final, Murrayfield Stadium,
Edinburgh, Scotland.

Richard Lane / SPORTSFILE

Right: 23 May 2009

Jamie Heaslip, who scored
a try in the 49th minute
of the match, is doused in
champagne by his Leinster
team-mate Isa Nacewa.

Ray McManus / SPORTSFILE

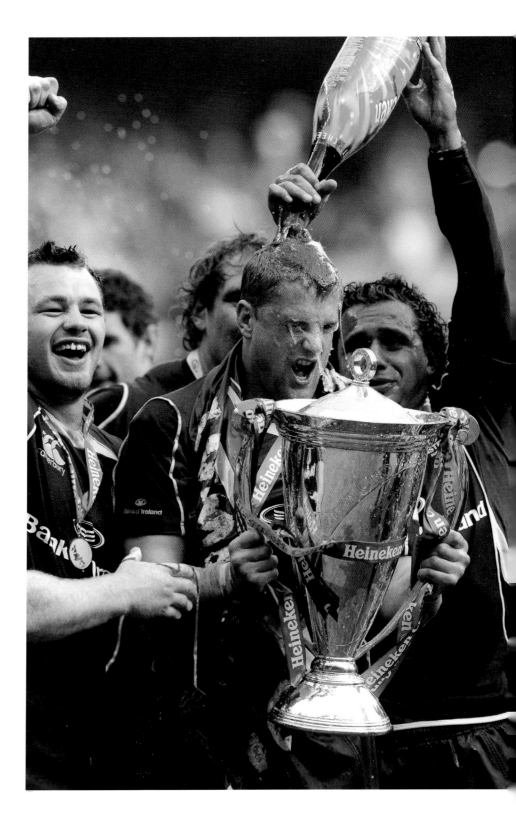

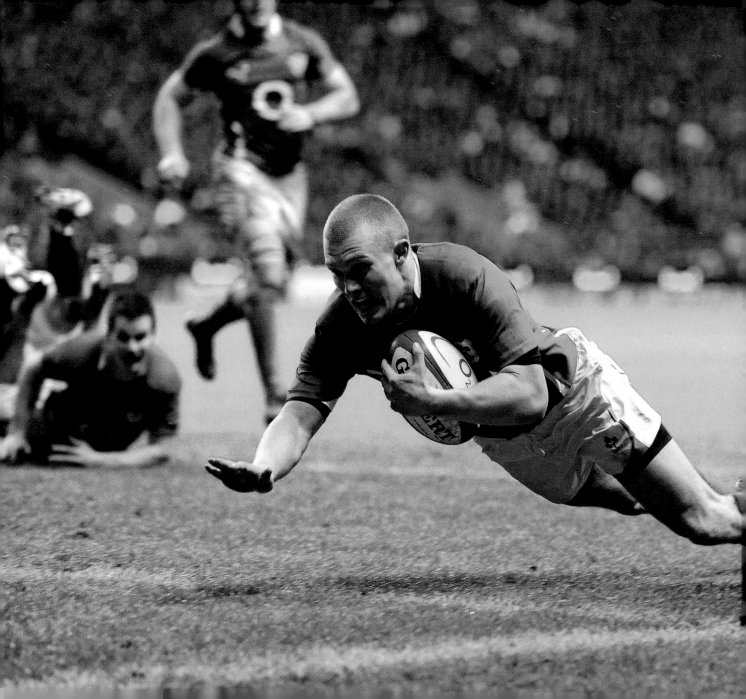

27 February 2010

Ireland's Keith Earls scores his side's second try against England. Ireland's victory here in this RBS Six Nations Rugby Championship clash ended England's grand slam hopes.

Brendan Moran / SPORTSFILE

2010s

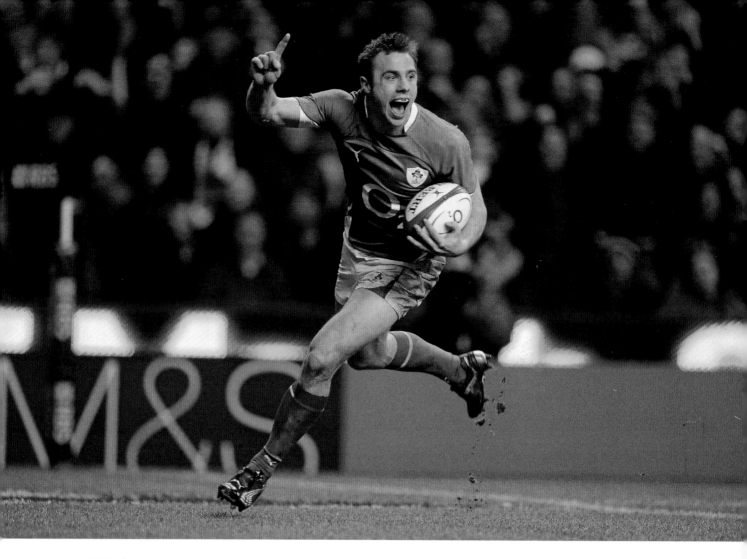

27 February 2010

Ireland's Tommy Bowe celebrates scoring his second and his side's third and winning try against England in Twickenham. Bowe's stellar performances throughout the tournament saw him named player of the tournament.

Brendan Moran / SPORTSFILE

5 February 2011

The Blackrock College second-half scrum-half Conor Crowley releases the ball after a ruck. In a tense clash, made more difficult by the conditions, a late converted try gave Old Belvedere a narrow 10-9 victory. Old Belvedere v Blackrock College RFC, Ulster Bank All-Ireland League Division 1A, Anglesea Road, Ballsbridge, Dublin.

Ray McManus / SPORTSFILE

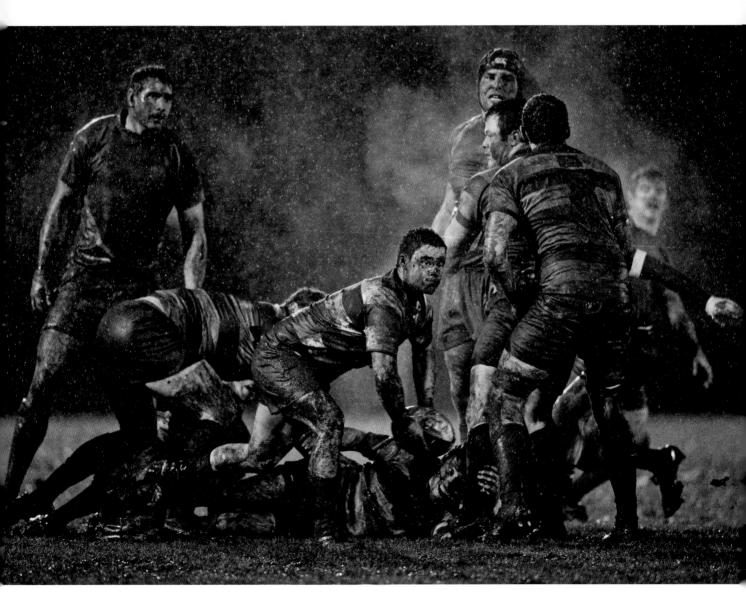

11 February 2011

Marie Louise Reilly, Ireland, sings 'Ireland's Call' before the match. Ireland failed to follow up on their emphatic victory over Italy the previous week as France came away with a 12-14 victory. Ireland v France, Women's Six Nations Rugby Championship, Ashbourne RFC, Ashbourne, Co. Meath.

Brian Lawless / SPORTSFILE

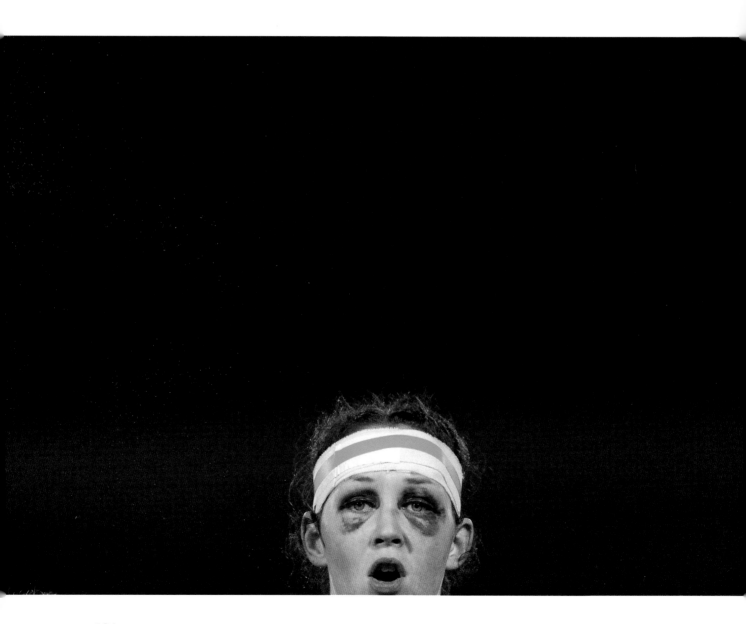

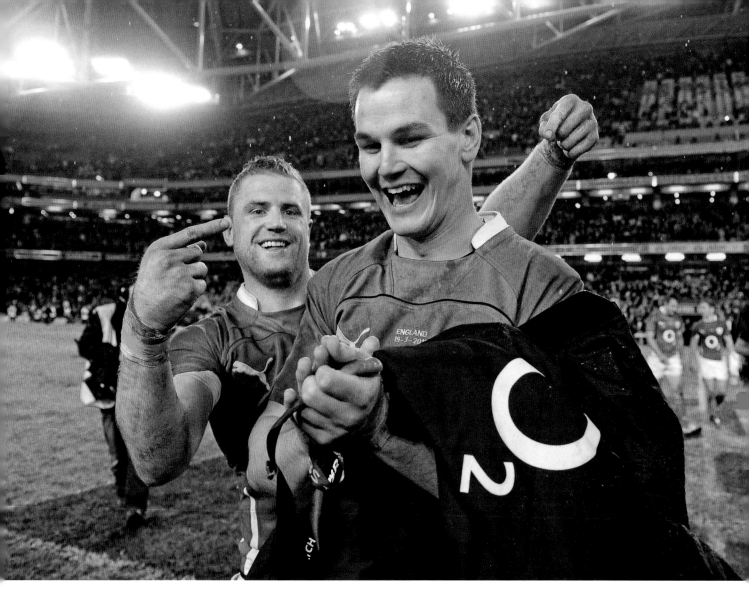

19 March 2011

Ireland's Jonathan Sexton and Jamie Heaslip celebrate after Ireland's 24-8 win over
their rivals from across the pond. The Irish win denied England their first grand slam in
eight years. The game also included a record-breaking 25th Six Nations try for captain,
Brian O'Driscoll. Ireland v England, RBS Six Nations Rugby Championship, Aviva
Stadium, Lansdowne Road, Dublin.

Brendan Moran / SPORTSFILE

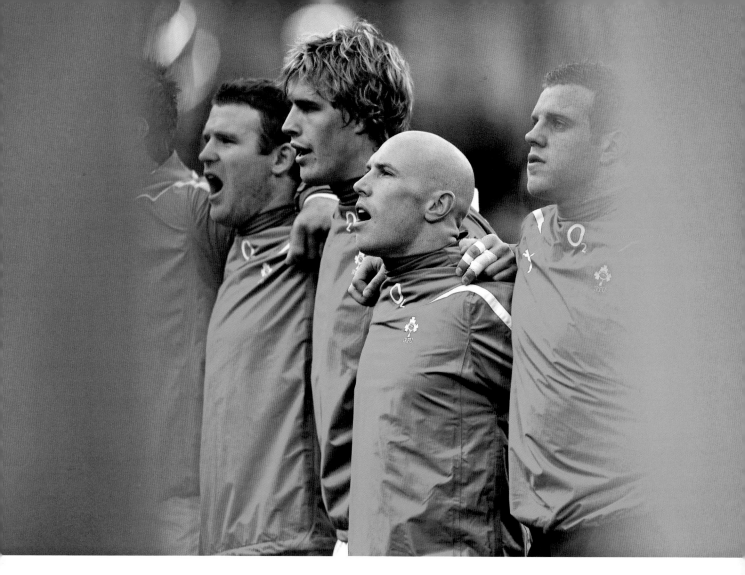

19 March 2011

Ireland's Peter Stringer stands proud and tall during the National Anthem. Ireland v England, RBS Six Nations Rugby Championship, Aviva Stadium, Lansdowne Road, Dublin.

David Maher / SPORTSFILE

21 May 2011

Leinster's Jonathan Sexton, kicks a first half penalty. This was one of 4 penalties
Sexton scored that night. Leinster v Northampton Saints, Heineken Cup Final,
Millennium Stadium, Cardiff, Wales.

Brendan Moran / SPORTSFILE

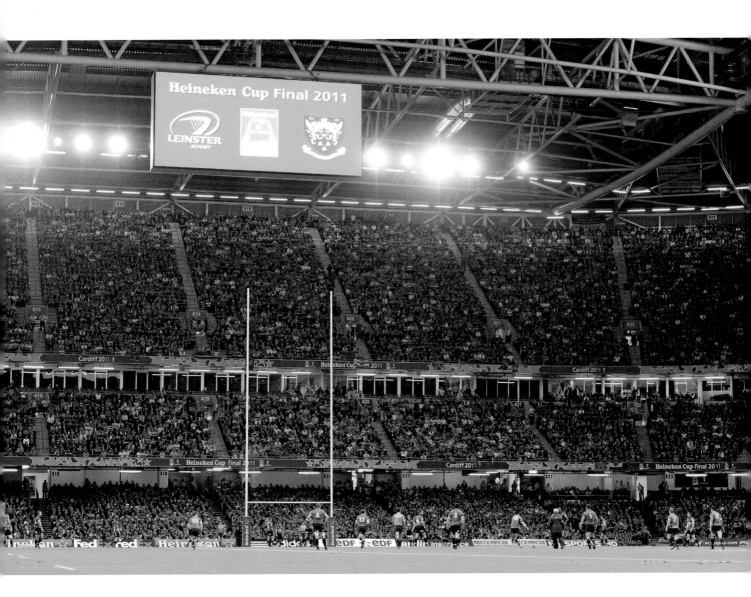

21 May 2011

Jonathan Sexton, Leinster, celebrates scoring his side's first try against Northampton Saints. A scintillating individual display from Sexton, where the fly half scored 28 points, including 2 tries, inspired Leinster to one of the great rugby union comebacks as they came from 22-6 down, to win 33-22.

Brendan Moran / SPORTSFILE

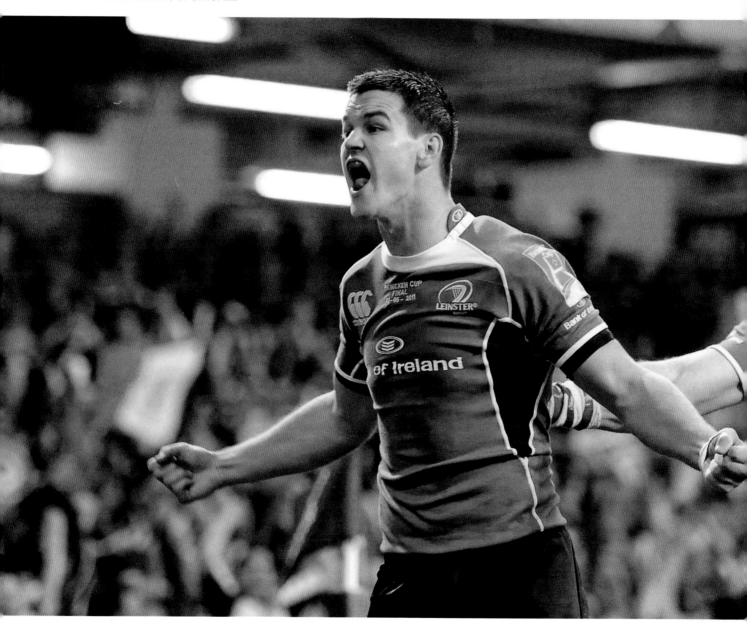

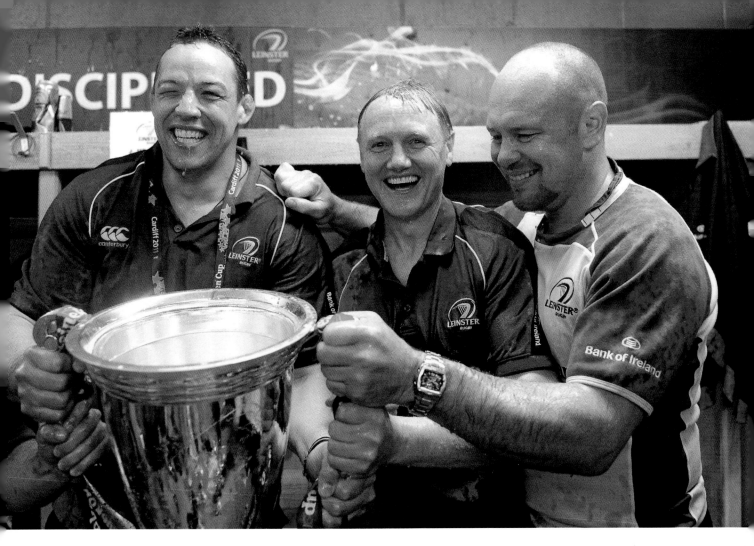

21 May 2011

Leinster forwards coach Jono Gibbes, left, head coach Joe Schmidt and scrum coach Greg Feek, right, celebrate with the Heineken Cup after the game. Schmidt told his players at the interval that they would be 'remembered forever' if they were to dig deep and mount a comeback.

Brendan Moran / SPORTSFILE

21 May 2011

Leinster's Brian O'Driscoll, left, and Shane Horgan spot people in the crowd after the game in the Millennium Stadium.

Brendan Moran / SPORTSFILE

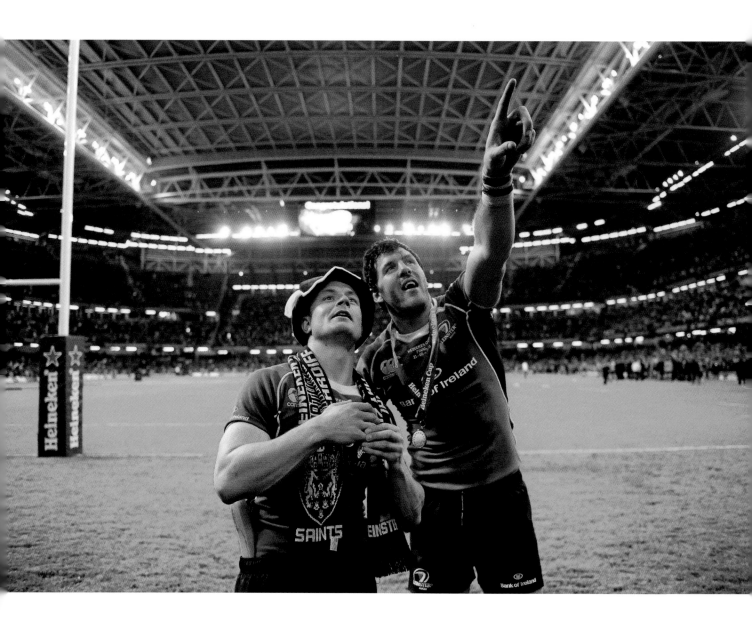

21 May 2011

The Leinster team celebrate with the Heineken Cup after the game.

Brendan Moran / SPORTSFILE

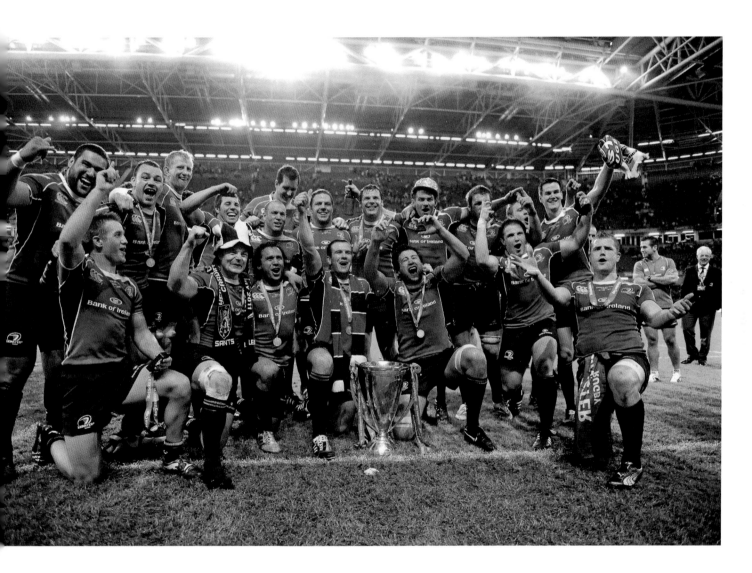

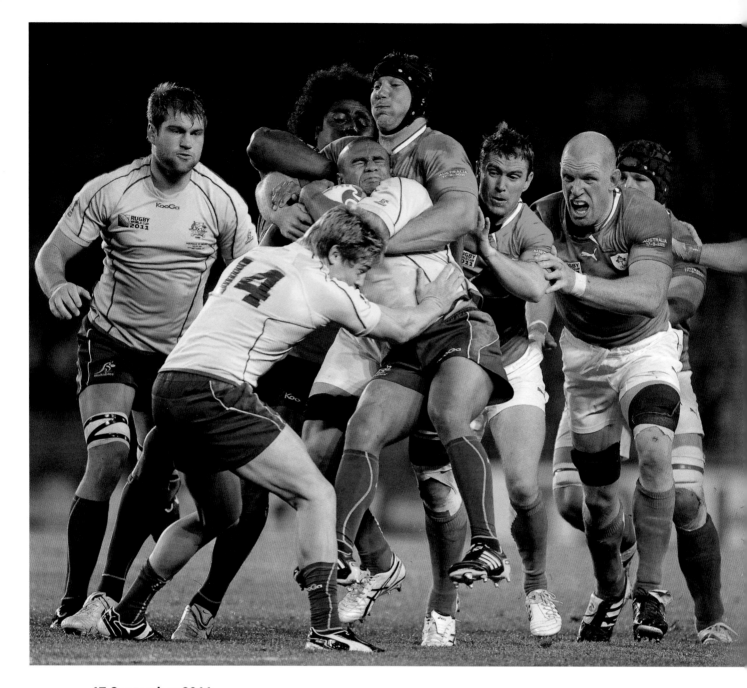

17 September 2011

Just before half-time, Australian scrum-half Will Genia takes the ball from the base of a scrum; it is immediately picked up by Stephen Ferris, with help from Eoin Reddan and Paul O'Connell, and driven back 20 metres and ends up inside his own 22. A play which illustrated Ireland's aggressiveness and helped Ireland to a 15-6 over one of the pre-tournament favourites. Ireland v Australia, 2011 Rugby World Cup, Pool C, Eden Park, Auckland.

Brendan Moran / SPORTSFILE

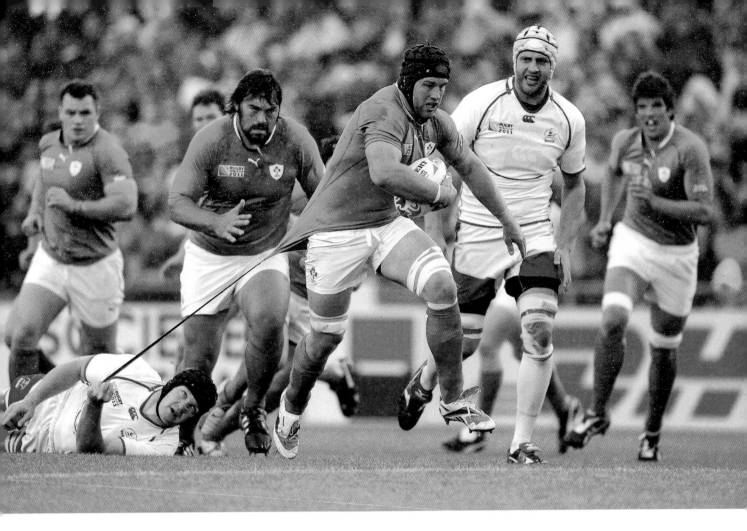

25 September 2011

Ireland's Sean O'Brien has his shirt pulled by Andrey Garbuzov, of Russia, as he goes on a run with the ball. A win here, along with victories over Australia, the US and Italy would see Ireland top their pool. Ireland v Russia, 2011 Rugby World Cup, Pool C, Rotorua International Stadium, Rotorua, New Zealand.

Brendan Moran / SPORTSFILE

8 October 2011

Wales scrum-half Mike Phillips celebrates as Ireland players, including Donnacha Ryan, Mike Ross and Paul O'Connell stand dejected at the final whistle as Ireland bow out of the World Cup at the hands of the eventual 4th place finishers. Ireland v Wales, 2011 Rugby World Cup, Quarter-Final, Wellington Regional Stadium, Wellington, New Zealand.

Brendan Moran / SPORTSFILE

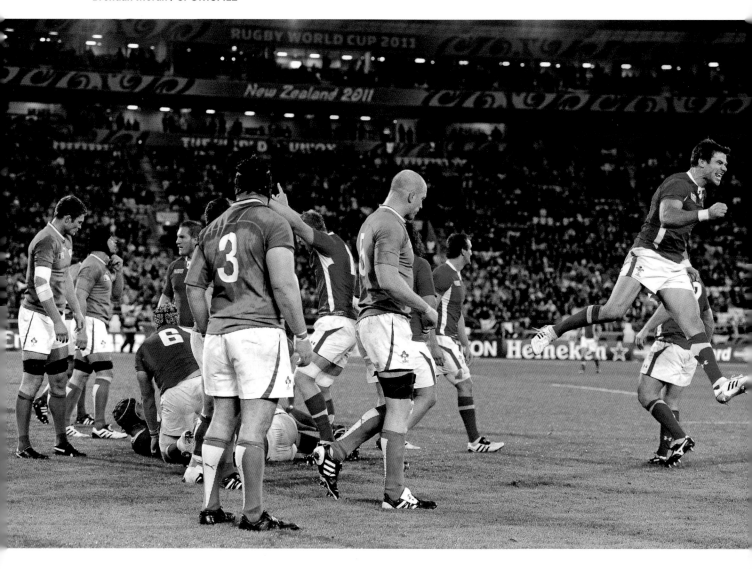

21 April 2012

St Mary's College captain Hugh Hogan, centre, celebrates with supporters and team-mates
including Stephen Bradshaw, right, as he lifts the Division 1 trophy. Mark Sexton, brother
of Ireland star Jonathan, scored 2 tries to inspire his side to the trophy. St Mary's College v
Young Munster, Ulster Bank League Division 1A, Templeville Road, Dublin.

Brendan Moran / SPORTSFILE

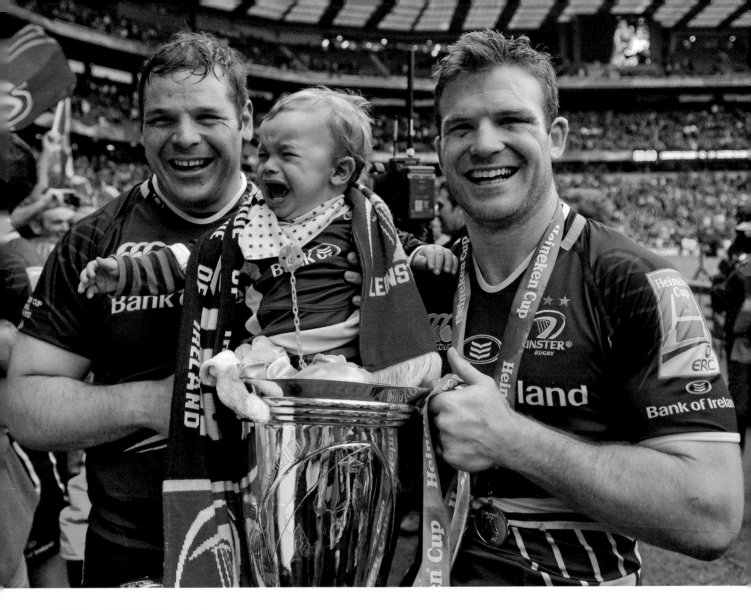

19 May 2012: Left and above:

Leinster head coach Joe Schmidt celebrates after the final whistle as he guides Leinster to their second Heineken Cup victory during his tenure and their third in four years, becoming the first side to achieve this feat. Leinster v Ulster, Heineken Cup Final, Twickenham Stadium, Twickenham, England.

Ray McManus / SPORTSFILE

Leinster's Mike Ross and son Kevin with team-mate Gordon D'Arcy following their victory. Leinster v Ulster, Heineken Cup Final, Twickenham Stadium, Twickenham, England.

Stephen McCarthy / SPORTSFILE

16 June 2012

Donnacha Ryan of Ireland, wins possession in a lineout against New Zealand's Sam Whitelock. This game saw a last-minute drop-goal from Dan Carter snatch away Ireland's best chance of victory over the All Blacks in the series. This was Ireland's first three-Test series against New Zealand. The All Blacks won all three games. New Zealand v Ireland, Steinlager Series 2012, 2nd Test, AMI Stadium, Christchurch, New Zealand.

Dianne Manson / SPORTSFILE

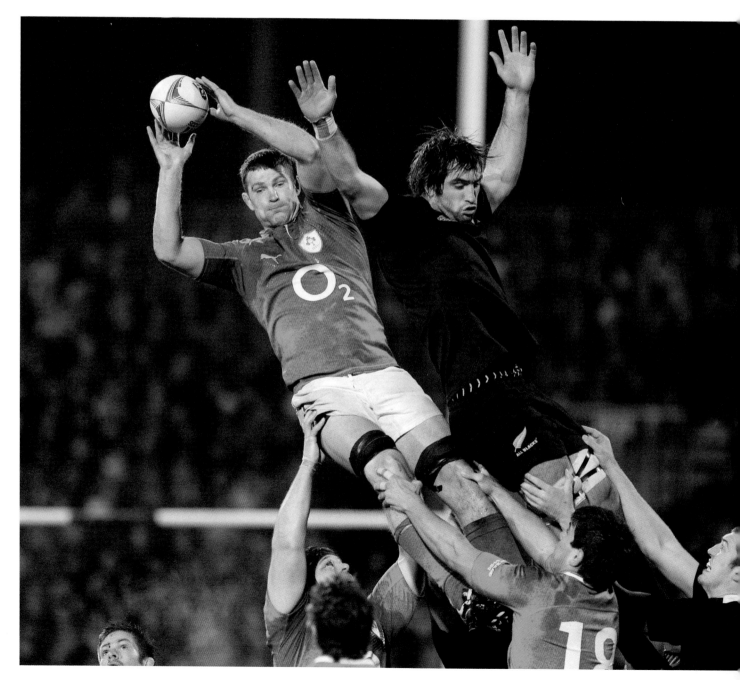

17 March 2013

Ireland's Joy Neville and Lynne Cantwell celebrate after the final whistle as the Ireland women secure their first ever Grand Slam. Italy v Ireland, Women's 6 Nations Rugby Championship, Parabiago, Milan, Italy.

Matt Browne / SPORTSFILE

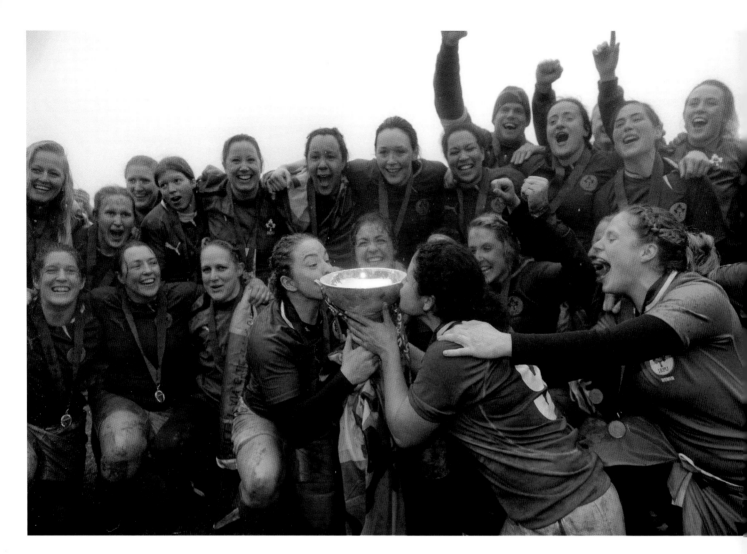

17 March 2013

Ireland captain Niamh Briggs and scrum-half Larissa Muldoon kiss the 6 Nations Trophy as their team-mates celebrate. Briggs scored both penalties as Ireland won by a narrow 3-6 margin.

Matt Browne / SPORTSFILE

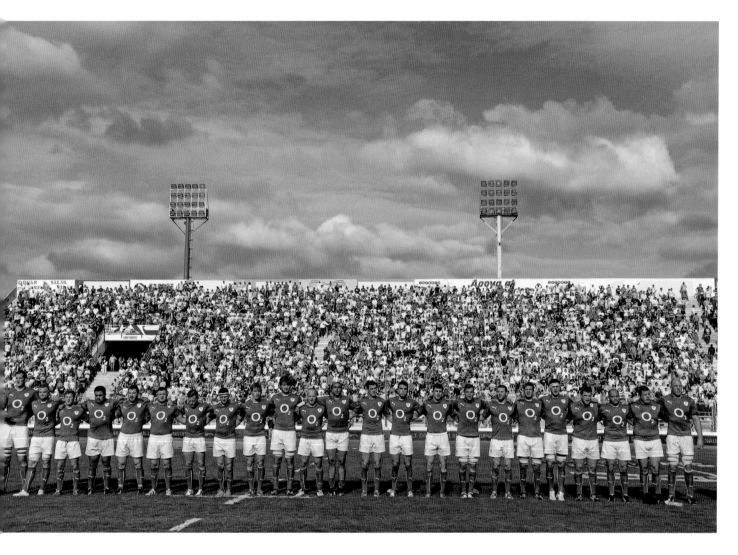

7 June 2014

The Ireland team ahead of the first game of the Summer Tour 2014 in Argentina. A 29-17 victory for the Irish sent them on their way to a 2-0 series win. Argentina v Ireland, Summer Tour 2014, First Test, Estadio Centenario, Resistencia, Chaco, Argentina.

Stephen McCarthy / SPORTSFILE

22 November 2014

Paul O'Connell, Ireland, wins the ball from Luke Jones of Australia. O'Connell is a legendary figure in Irish rugby. He is Ireland's fourth most capped player of all time with 108 appearances and captained the side from 2014 until his retirement in 2016. His influence has transcended the sport of rugby through his voluntary work with organisations such as the Special Olympics and the Dublin-based Haiti charity, Haven. Ireland v Australia, Guinness Series, Aviva Stadium, Lansdowne Road, Dublin.

Brendan Moran / SPORTSFILE

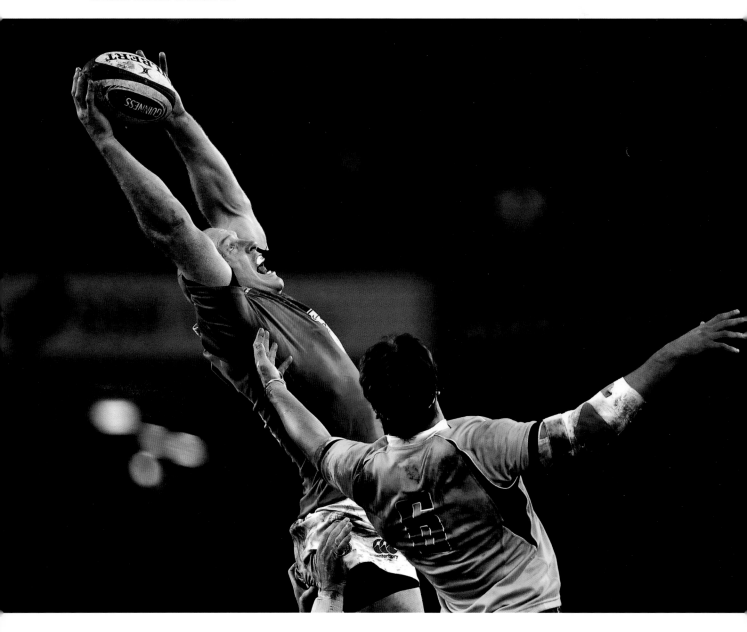

21 March 2015

Ireland captain Paul O'Connell with the RBS Six Nations Championship trophy after the game. This was the third of three Six Nations Championship titles that O'Connell won during his career, the previous two coming in 2009 and 2014. Scotland v Ireland, RBS Six Nations Rugby Championship, BT Murrayfield Stadium, Edinburgh, Scotland.

Brendan Moran / SPORTSFILE

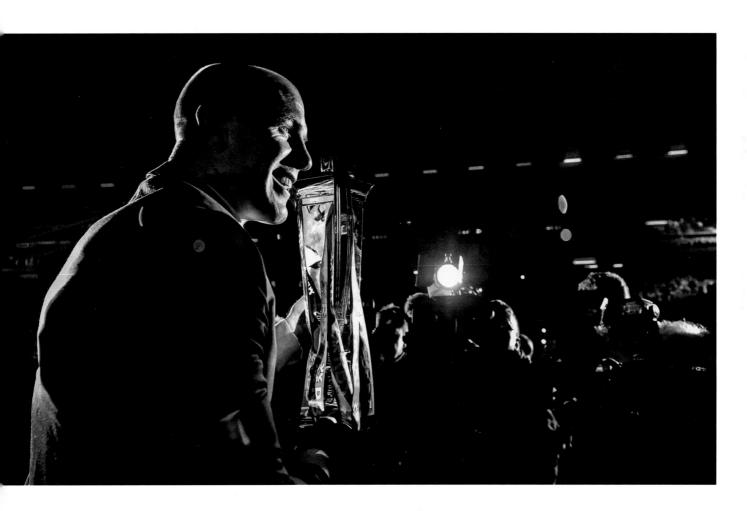

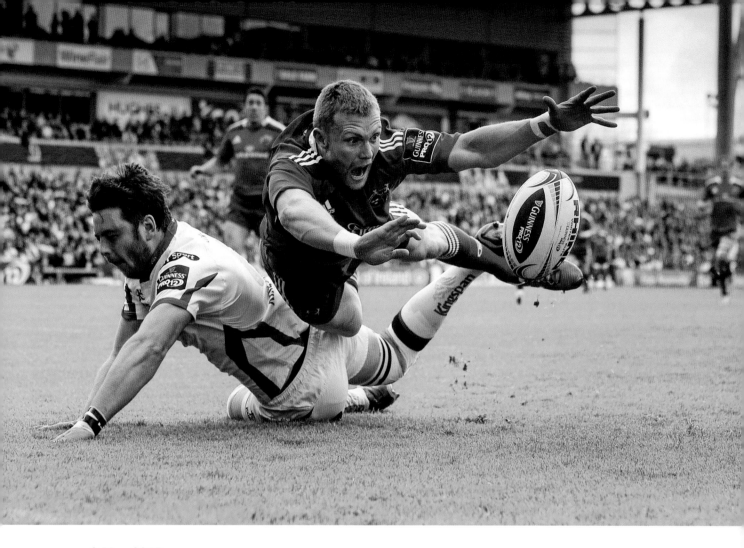

9 May 2015

Munster's Keith Earls outreaches Iain Henderson of Ulster in a tense 23-23 draw. Ulster v Munster, Guinness PRO12, Round 21, Kingspan Stadium, Ravenhill Park, Belfast.

Ramsey Cardy / SPORTSFILE

Opposite: 19 September 2015

Ireland winger Luke Fitzgerald and Matt Evans of Canada both fail to hold possession during Ireland's opening World Cup game which ended in a resounding 50-7 win for the Irish. Ireland v Canada, 2015 Rugby World Cup, Pool D, Millennium Stadium, Cardiff, Wales.

Stephen McCarthy / SPORTSFILE

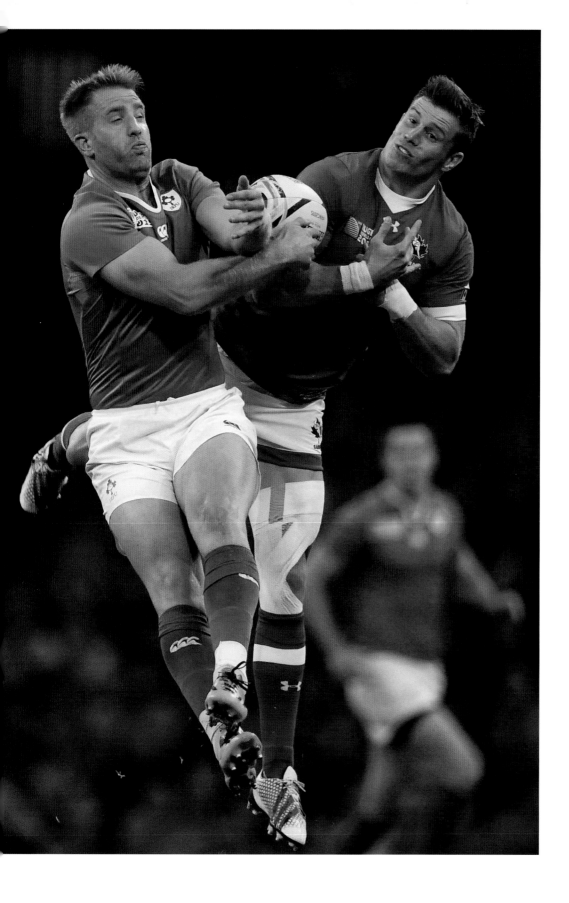

19 September 2015

Jonathan Sexton, Ireland, goes over to score his side's third try, despite the efforts of Matt Evans, left, and Gordon McRorie, Canada. Sexton scored 31 points at World Cup 2015.

Stephen McCarthy / SPORTSFILE

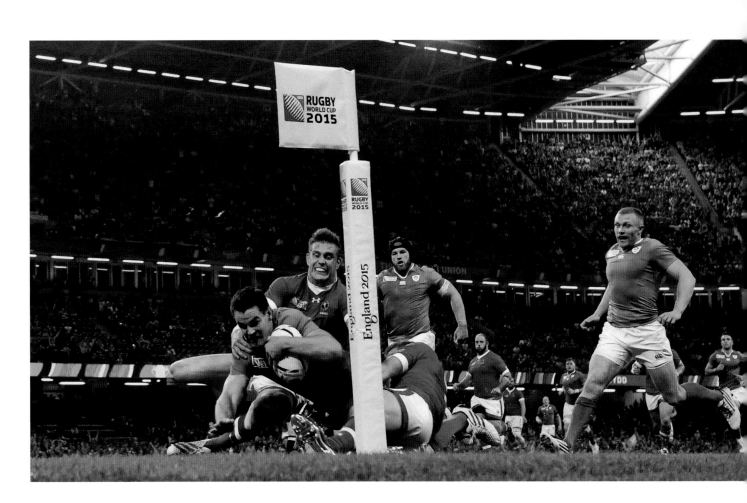

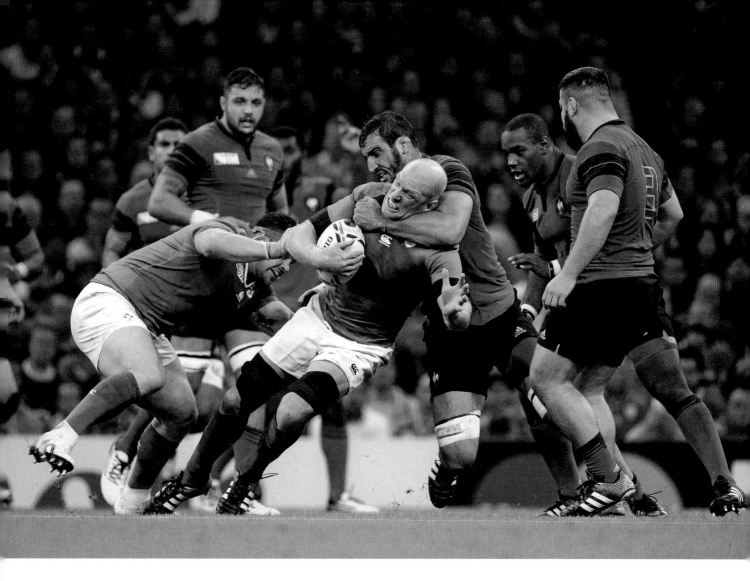

11 October 2015

Yoann Maestri of France gets to grips with Ireland's Paul O'Connell.
The Irish Captain had stated prior to the tournament that he would be
retiring from international duty after the World Cup. O'Connell was
carried off the field with a hamstring injury that later required surgery,
thus proving this game to be his last in an Ireland shirt. Ireland v France,
2015 Rugby World Cup Pool D, Millennium Stadium, Cardiff, Wales.

Brendan Moran / SPORTSFILE

11 October 2015

Ireland head coach Joe Schmidt shakes hands with a supporter while leaving the pitch after the final whistle. This game was a true test of character for Ireland after the talismanic figures of Jonathan Sexton, Paul O'Connell and Peter O'Mahony were all forced off with injury. A 24-9 victory for Ireland saw them top Pool D and set up a quarter final clash with Argentina. Ireland v France, 2015 Rugby World Cup Pool D, Millennium Stadium, Cardiff, Wales.

Brendan Moran / SPORTSFILE

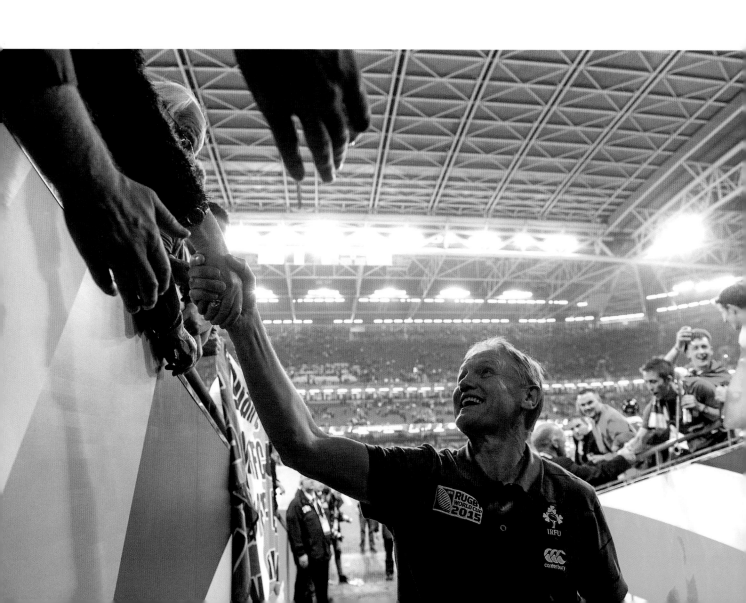

18 October 2015

Jamie Heaslip leaves the field after the game as Ireland bow out of the
World Cup at the quarter finals stage after a 43-20 loss to Argentina.
Ireland v Argentina, 2015 Rugby World Cup Quarter-Final, Millennium
Stadium, Cardiff, Wales.

Brendan Moran / SPORTSFILE

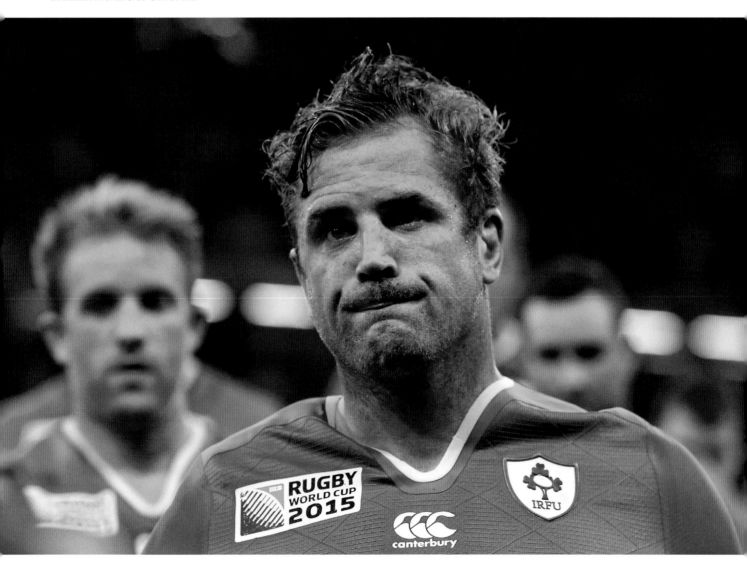

18 October 2015

Dejected Ireland players, including Isaac Boss, Jonathan Sexton, Darren Cave, Sean Cronin, Mike McCarthy, Sean O'Brien, Simon Zebo, Tadhg Furlong, Peter O'Mahony and Paul O'Connell look on as Argentina score a try. Ireland v Argentina, 2015 Rugby World Cup Quarter-Final, Millennium Stadium, Cardiff, Wales.

Brendan Moran / SPORTSFILE

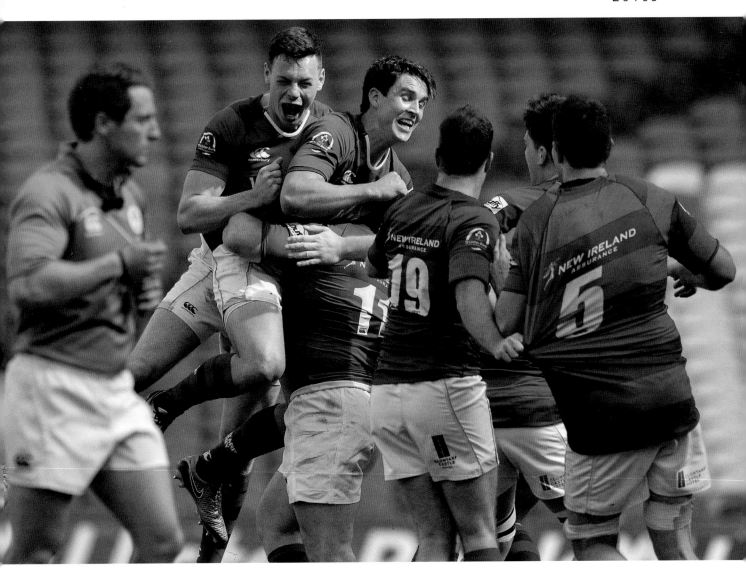

8 May 2016

Man-of-the-match, Joey Carbery and Matt Darcy celebrate with
their Clontarf team-mates at the end of the game. Clontarf claim
their second Division 1A title in three years after the narrow
28-25 victory and six months later Carbery would be part of the
first Irish team to claim victory over the All Blacks. Clontarf v
Cork Constitution, Ulster Bank League, Division 1A, Final, Aviva
Stadium, Lansdowne Road, Dublin.

David Maher / SPORTSFILE

28 May 2016

Connacht captain John Muldoon lifts the trophy as his side are crowned
Guinness PRO12 champions for the first time after beating provincial
rivals Leinster 20-10. After years as the minnows of Irish rugby,
including facing the possibility of being shut down in 2003, this victory
was surely the western province's greatest day. Guinness PRO12 Final
match between Leinster and Connacht at BT Murrayfield Stadium in
Edinburgh, Scotland.

Ramsey Cardy / SPORTSFILE

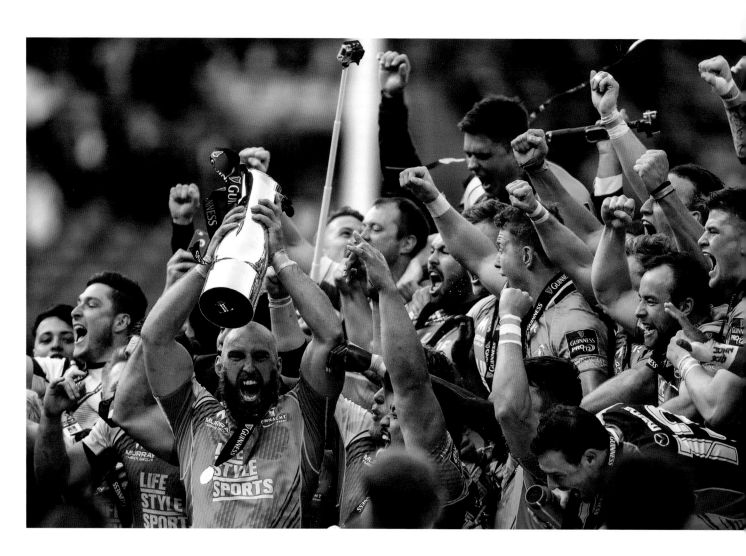

11 June 2016

Conor Murray of Ireland scores his side's second try despite the tackle of Lood de Jager of South Africa to send Ireland on their way to a historic first ever victory over the Springboks on South African soil.

Brendan Moran / SPORTSFILE

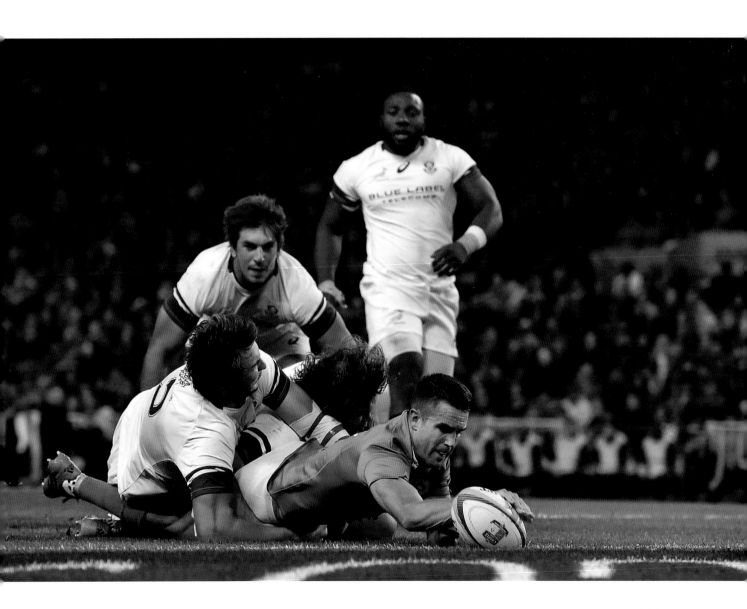

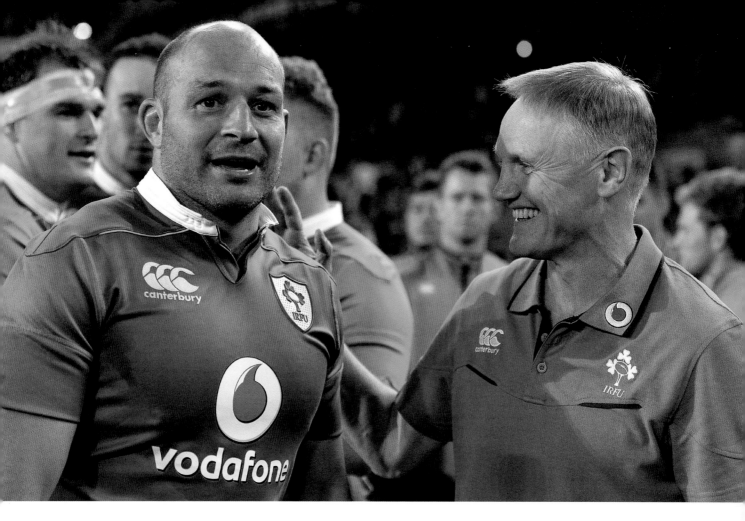

11 June 2016

Ireland captain Rory Best and head coach Joe Schmidt celebrate after the final whistle in the 1st test of the Castle Lager Incoming series between South Africa and Ireland at the DHL Newlands Stadium in Cape Town, South Africa.

Brendan Moran / SPORTSFILE

Opposite: 22 October 2016

Munster's Simon Zebo sheds a tear during a moment of silence in memory of his team's head coach Anthony Foley, who had passed away suddenly the previous Sunday and was laid to rest the day before. Munster v Glasgow Warriors, European Rugby Champions Cup Pool 1 Round 2, Thomond Park, Limerick.

Brendan Moran / SPORTSFILE

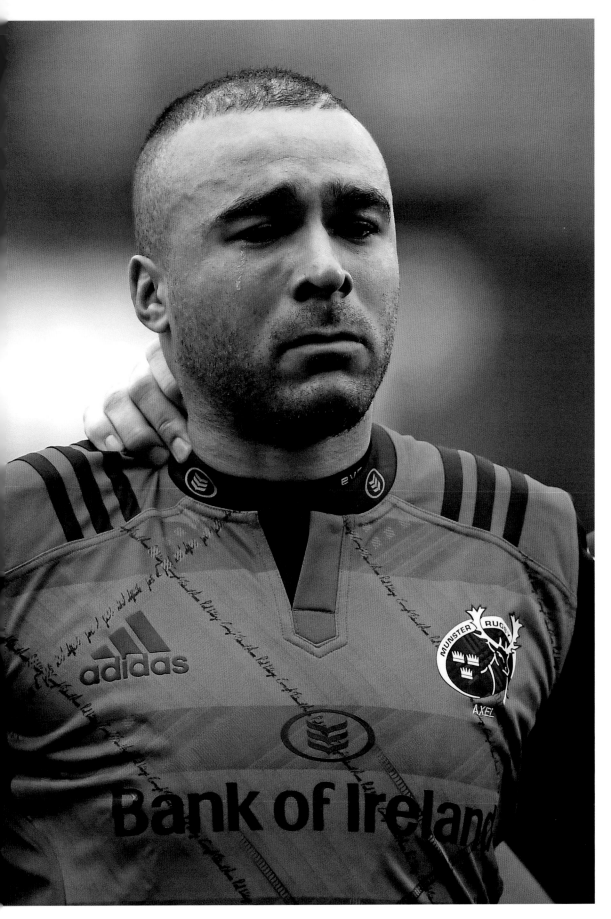

22 October 2016

Munster and Glasgow Warriors players observe a minute's silence in memory of the late Munster Rugby head coach Anthony Foley before the European Rugby Champions Cup Pool 1 Round 2 match between Munster and Glasgow Warriors at Thomond Park in Limerick. The Shannon club man, with whom he won 5 All Ireland League titles, played 202 times for Munster and was capped for Ireland 62 times, died in Paris on November 16, 2016 at the age of 42.

Diarmuid Greene / SPORTSFILE

Opposite: 5 November 2016

Conor Murray of Ireland, despite the tackle of Beauden Barrett of New Zealand, adds to tries from CJ Stander and Jordi Murphy to help his side to a 28-5 half-time lead against the All-Blacks. Ireland would hold up to claim a historic 40-29 victory. International rugby match between Ireland and New Zealand at Soldier Field in Chicago, USA. .

Brendan Moran / SPORTSFILE

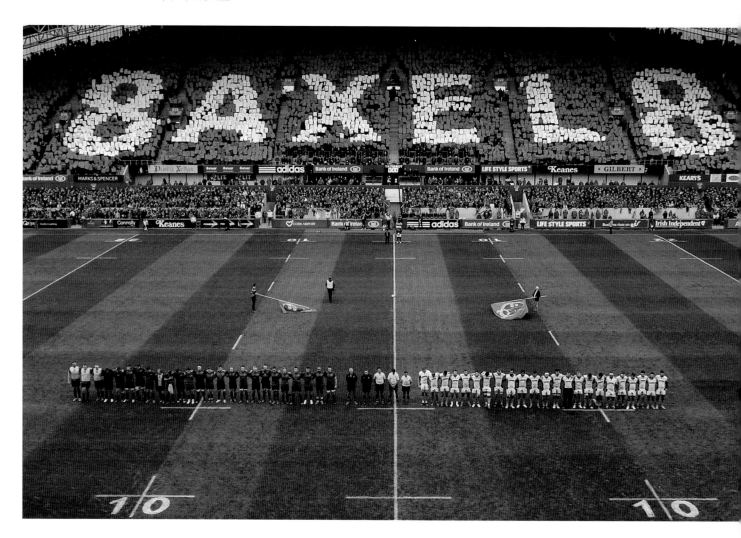

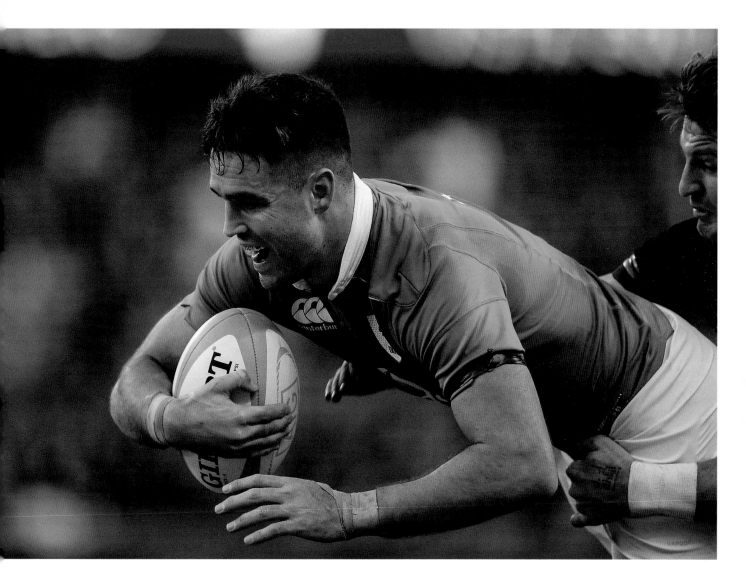

Page 160-161: 5 November 2016

Conor Murray of Ireland is congratulated by team-mate and Munster colleague Simon Zebo, right, after scoring their side's third try against New Zealand.

Brendan Moran / SPORTSFILE

Ireland head coach Joe Schmidt and Devin Toner, who stands at 6' 11", congratulate each other under a scoreboard with the 40-29 result displayed prominently across a stand at the Soldier Field in Chicago, USA.

Brendan Moran / SPORTSFILE

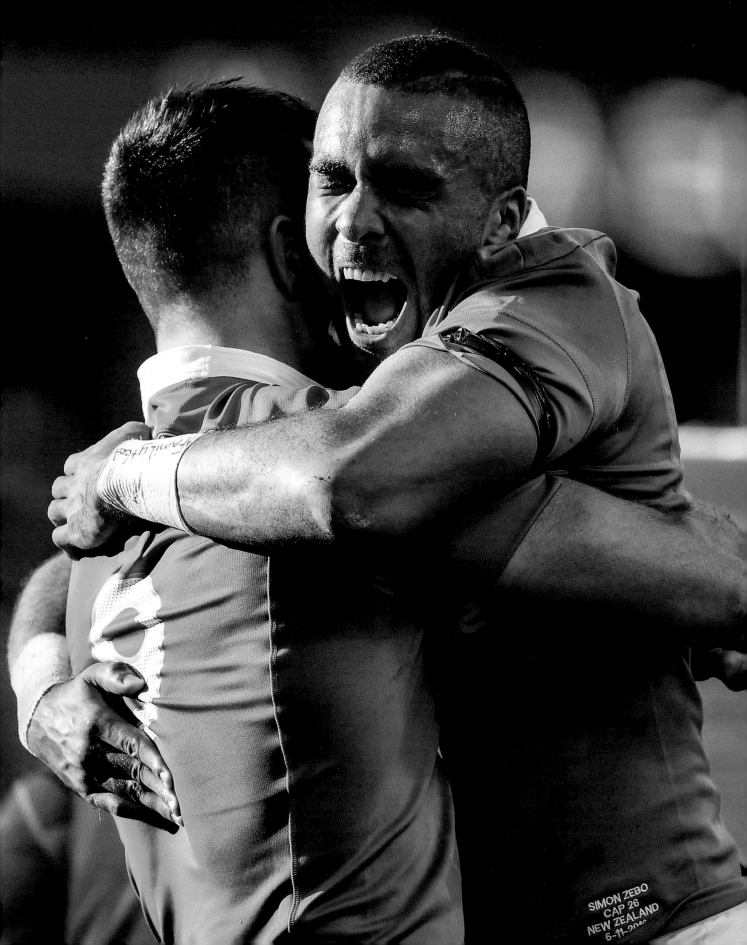

SIMON ZEBO
CAP 26
NEW ZEALAND
5-11-2016

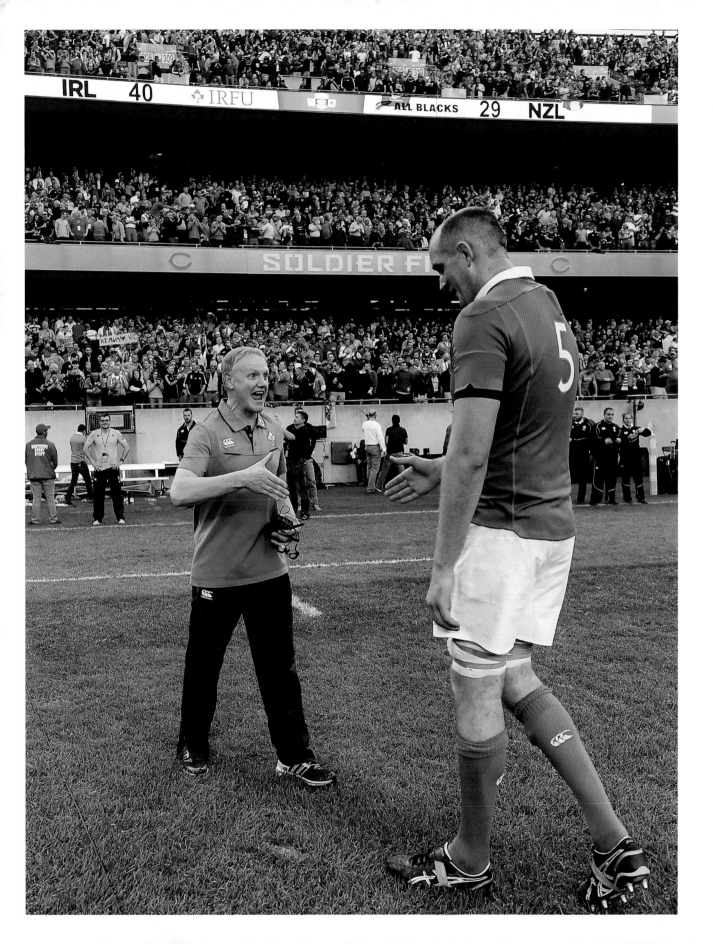

IRL 40 · IRFU ALL BLACKS 29 NZL

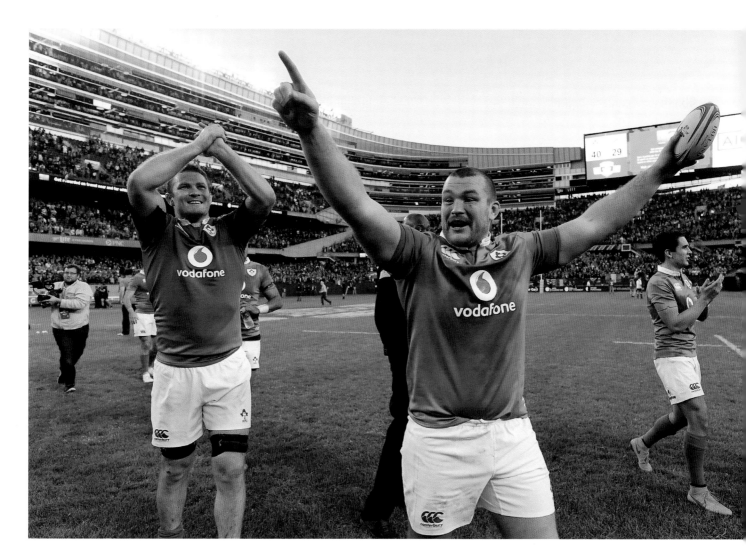

Above: 5 November 2016

Ireland players, from left, Donnacha Ryan, Jack McGrath and Joey Carbery celebrate victory after the International rugby match between Ireland and New Zealand – Ireland's first ever victory over the All Blacks after 29 meetings and 111 years of trying.

Brendan Moran / SPORTSFILE

Opposite: 26 November 2016

Peter O'Mahony, whose impact off the bench helped Ireland to regain control of the game and fend off a second half comeback from Australia, celebrates winning a scrum penalty in the final play of the game during the Autumn International match between Ireland and Australia at the Aviva Stadium in Dublin.

Brendan Moran / SPORTSFILE

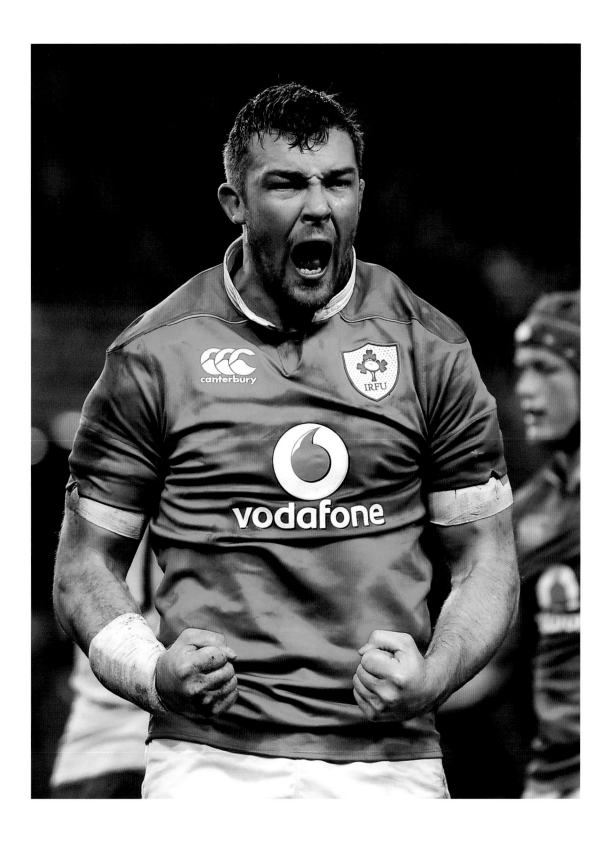

26 November 2016

Ireland captain Rory Best is applauded off the pitch by his team-mates after earning his 100th international cap during the Autumn International match between Ireland and Australia. Best made his debut against New Zealand in 2005.

Brendan Moran / SPORTSFILE

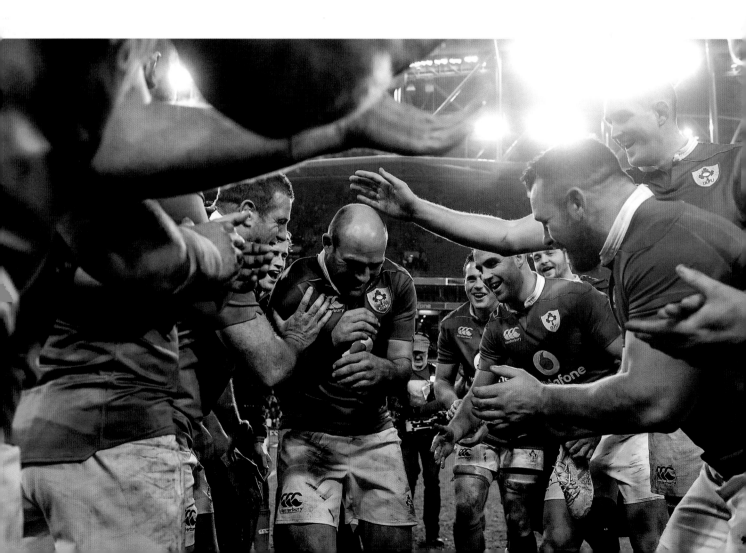

18 March 2017

Courtney Lawes of England wins a lineout ahead of Peter O'Mahony as Ireland once again deny England their Grand Slam dream. Ireland v England, RBS Six Nations Rugby Championship, Aviva Stadium, Dublin.

Brendan Moran / SPORTSFILE

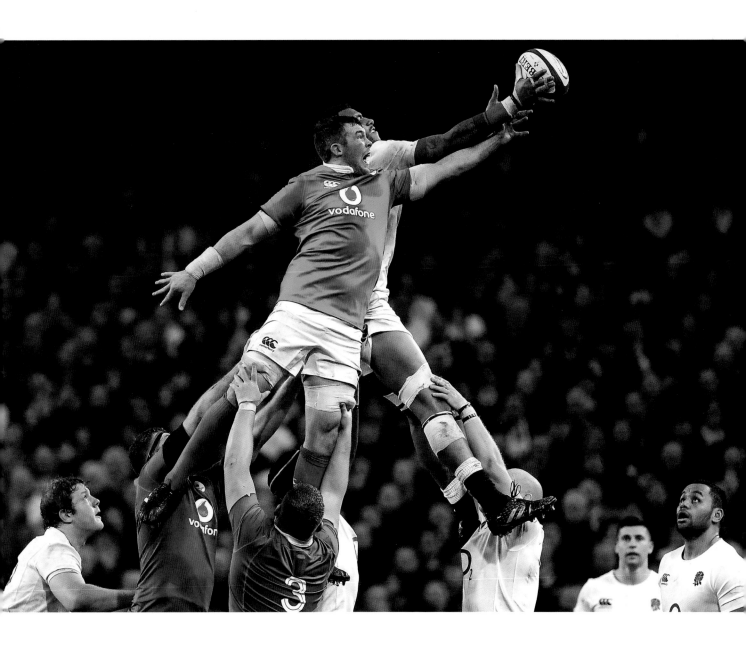

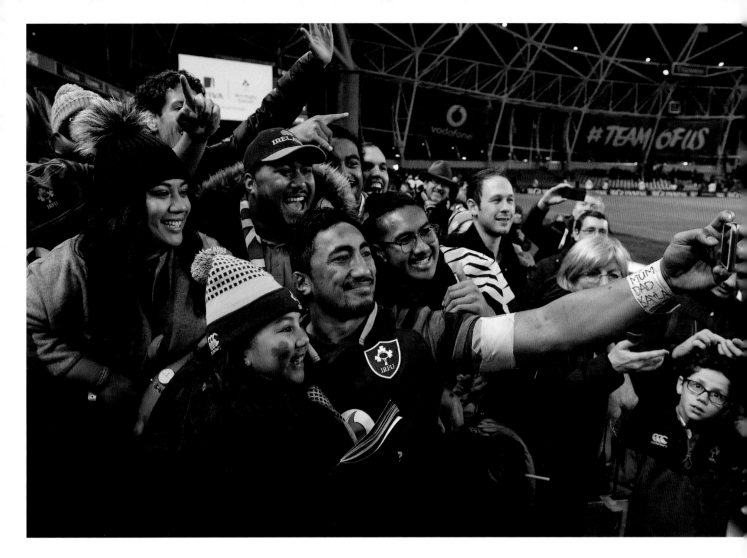

11 November 2017

Bundee Aki takes a selfie with family members and supporters including his six-year-old daughter Adrianna after he finished his debut game for Ireland. Aki, born in Auckland, New Zealand, proved eligible to represent Ireland after three years of residency in the country. Aki's inclusion in the Irish squad, along with the exclusion of Simon Zebo, sparked a debate about residency rules among Irish fans, with many criticising the decision to include Aki in the squad. However, a string of positive performances helped to silence some of his critics. Ireland v South Africa, Guinness Series International, Aviva Stadium, Dublin.

Brendan Moran / SPORTSFILE

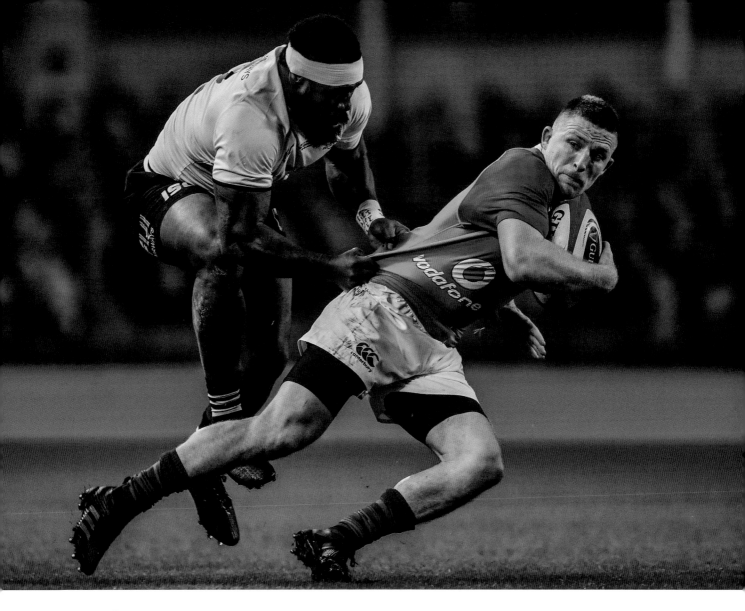

18 November 2017

Man of the Match Andrew Conway is tackled by Levani Botia as Ireland edge
Fiji 23-20. Ireland v Fiji, Guinness Series International, Aviva Stadium, Dublin.

Sam Barnes / SPORTSFILE

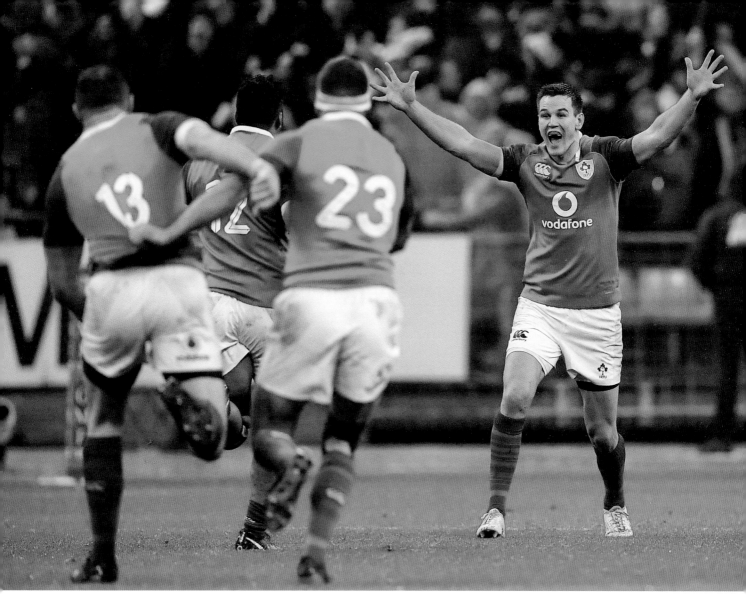

3 February 2018

Jonathan Sexton of Ireland celebrates with team-mates after kicking
the stunning match winning drop goal. Entering the 78th minute,
Ireland begun one last drive from just outside their 22. They forced
themselves forward for 41 phases before Sexton, from 45 metres out,
produced a moment of magic to seal a 15-13 win for Ireland.

Brendan Moran / SPORTSFILE

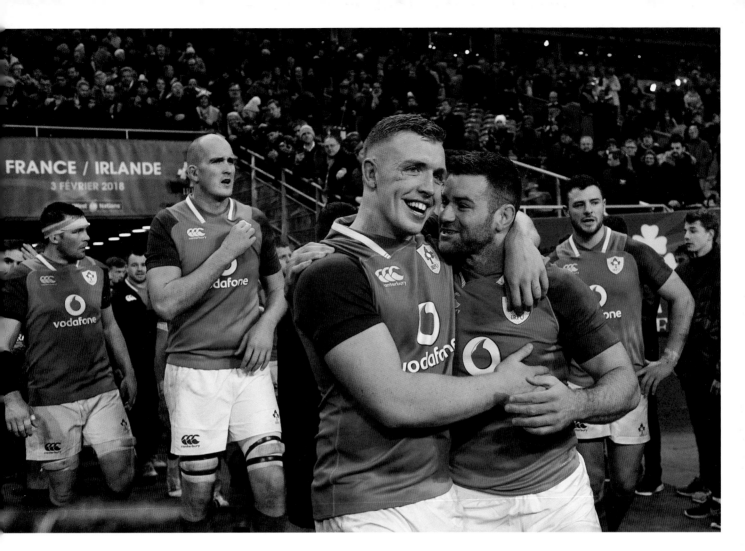

3 February 2018

Dan Leavy, left, and Fergus McFadden of Ireland celebrate following
the NatWest Six Nations Rugby Championship match between
France and Ireland at the Stade de France in Paris, France.

Ramsey Cardy / SPORTSFILE

10 February 2018

Bundee Aki, playing in his first Six Nations Championship, is tackled by Dean Budd of Italy. Ireland v Italy, NatWest Six Nations Rugby Championship, Aviva Stadium, Dublin.

Brendan Moran / SPORTSFILE

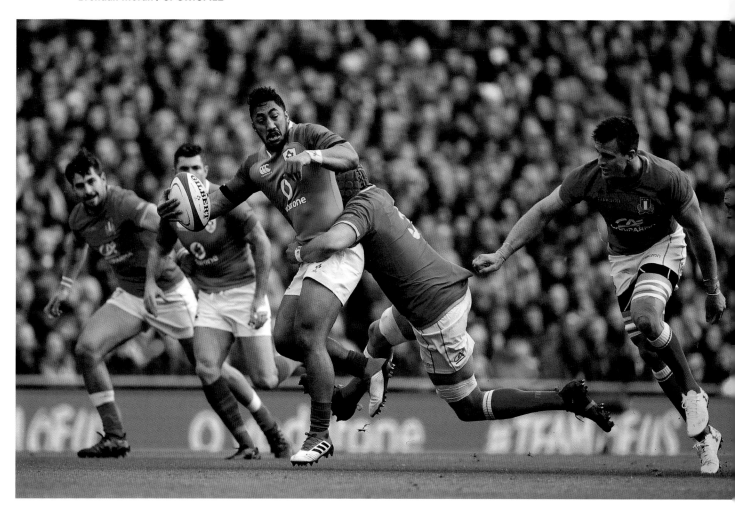

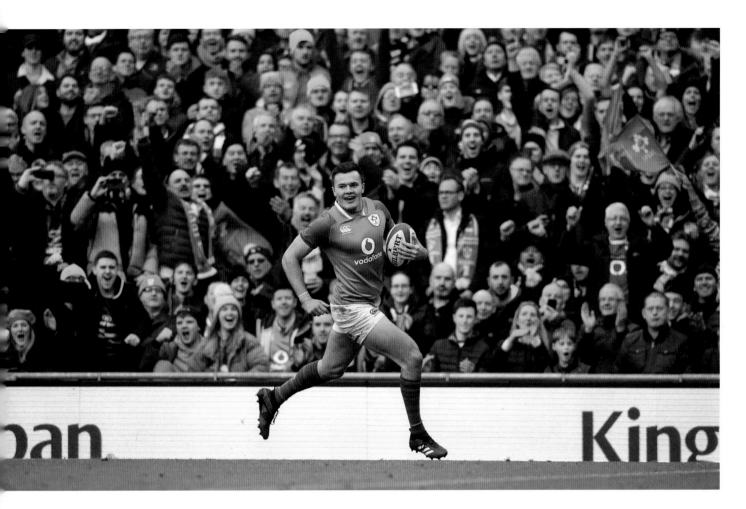

10 February 2018

Jacob Stockdale, Ireland's breakout star of the tournament, runs in to score his side's eighth try during the Six Nations Rugby Championship match between Ireland and Italy at the Aviva Stadium in Dublin.

David Fitzgerald / SPORTSFILE

24 February 2018

Ireland head coach Joe Schmidt with his kiwi compatriot Wales head coach Warren Gatland prior to the game. This was Schmidt's fifth Six Nations Championship as Ireland coach and Gatland, who previously coached Ireland, has been with Wales since 2007. Ireland v Wales, NatWest Six Nations Rugby Championship, Aviva Stadium, Dublin.

Brendan Moran / SPORTSFILE

Opposite: Dan Leavy, who scored one of Ireland's five tries, is tackled by Josh Navidi of Wales during the game.

Brendan Moran / SPORTSFILE

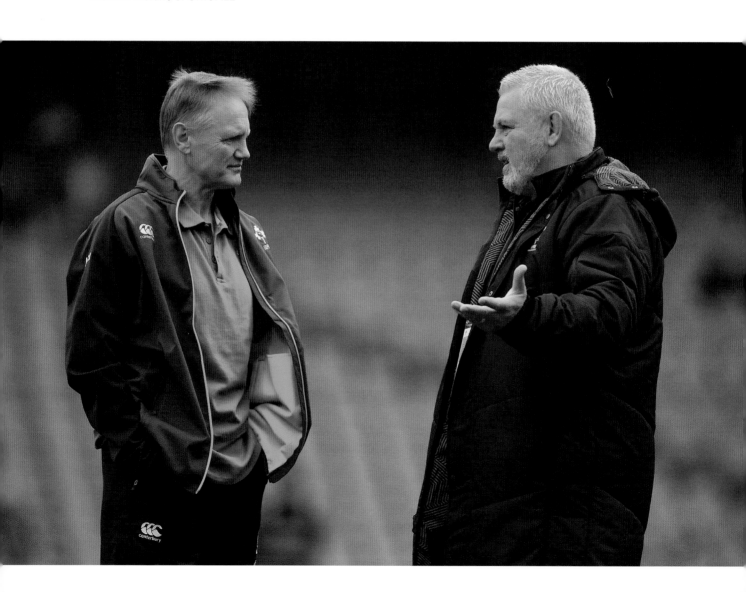

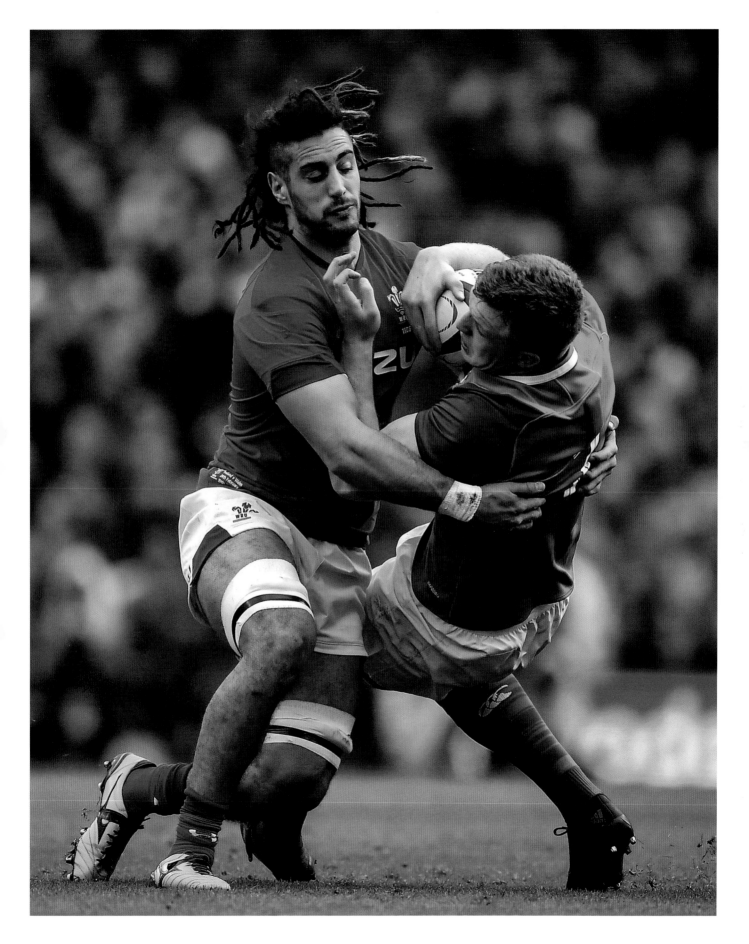

24 February 2018

Daddy's boy: Sean Cronin celebrates with his son Finn after the 37-27 Irish win over Wales, which strengthened Ireland's title challenge.

Brendan Moran / SPORTSFILE

10 March 2018

Dan Leavy of Ireland is tackled by Gordon Reid of Scotland. A 28-8 win for Ireland secured a championship win and gave and set up a dream scenario where Ireland could win the Grand Slam against England at Twickenham on St. Patrick's Day.

Brendan Moran / SPORTSFILE

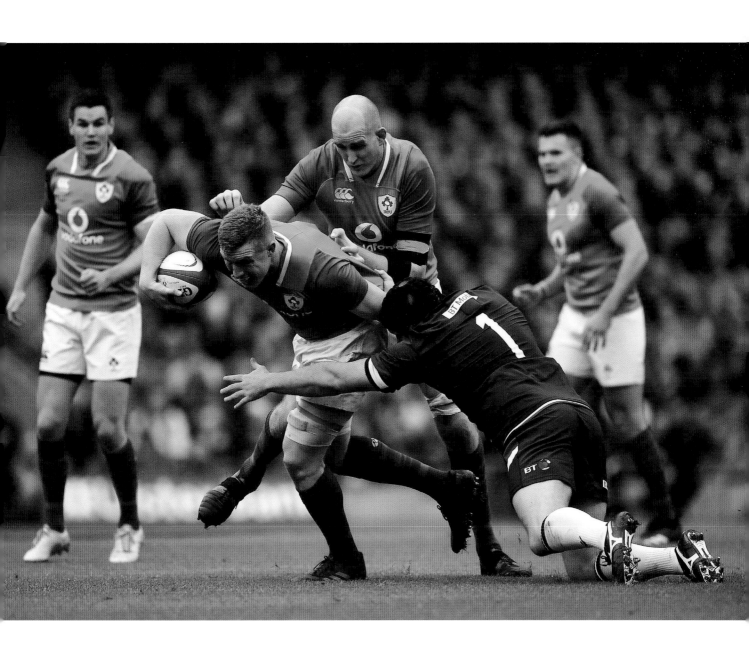

10 March 2018

Ireland players and supporters celebrate after Sean Cronin scored

Ireland's fourth try against Scotland.

Brendan Moran / SPORTSFILE

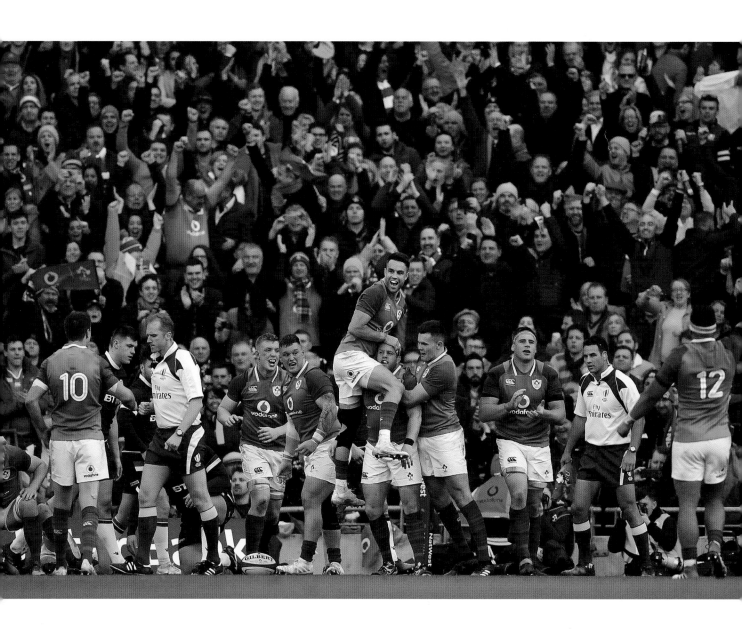

17 March 2018

Anthony Watson of England is tackled by Rob Kearney of Ireland. Kearney, along with team captain Rory Best would win his fourth 6 Nations medal against England. England v Ireland, NatWest Six Nations Rugby Championship, Twickenham Stadium, London.

Ramsey Cardy / SPORTSFILE

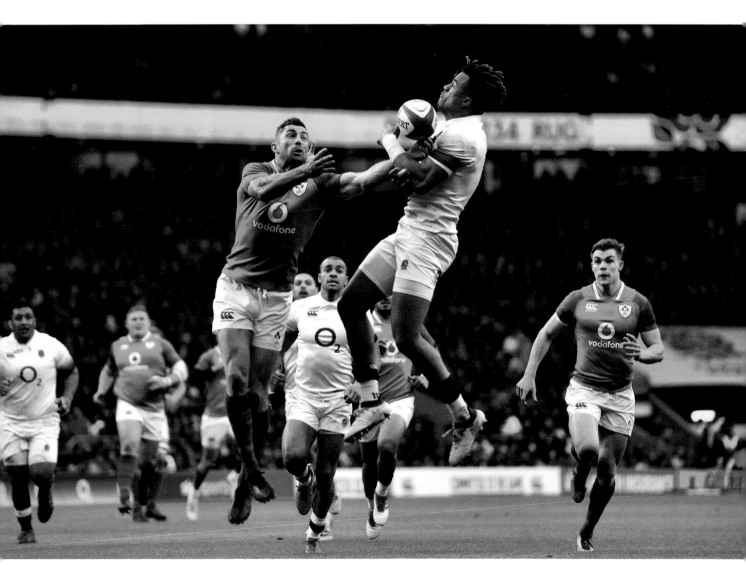

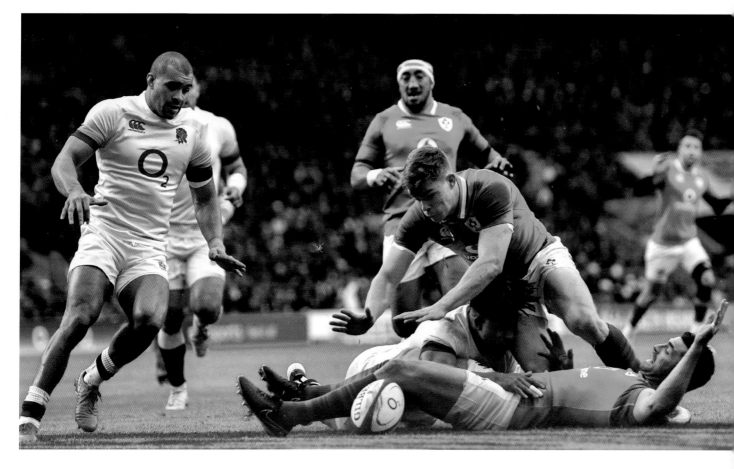

17 March 2018

Garry Ringrose of Ireland dives over to score his side's first try despite the tackle
of Anthony Watson of England in front of 82,000 spectators at Twickenham.

Ramsey Cardy / SPORTSFILE

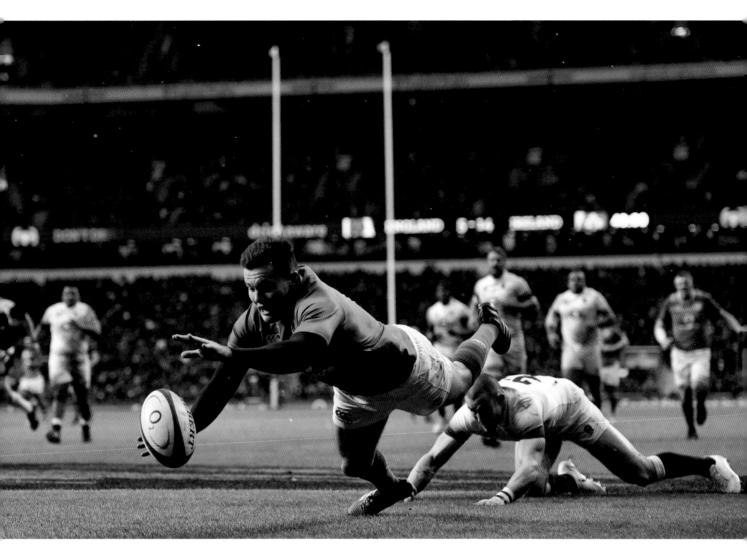

17 March 2018

Jacob Stockdale of Ireland dives over to score his side's third try and his seventh of the championship, setting a new record for most tries scored in a Six Nations championship. Stockdale crowned a fine season by winning the Nevin Spence Young Player of the Year honour at the Rugby Players Ireland Awards.

Ramsey Cardy / SPORTSFILE

It was a bitterly cold day in London, with snow due to arrive by the time the game began. Stockdale had been on fire during the previous games in the Six Nations, so when I saw him kick the ball through the England defence I knew he was going for a record breaking seventh try in the Championship. Once that try was scored it was almost certain Ireland were going to win the Grand Slam.

Ramsey Cardy

17 March 2018

Ireland Captain Rory Best lifts the Six Nations Championship trophy and vice-captains Peter O'Mahony and Jonathan Sexton lift the Triple Crown trophy following Ireland's 24-15 victory over England. Ireland made it a St Patrick's Day to remember by securing their third Grand Slam.

Ramsey Cardy / SPORTSFILE

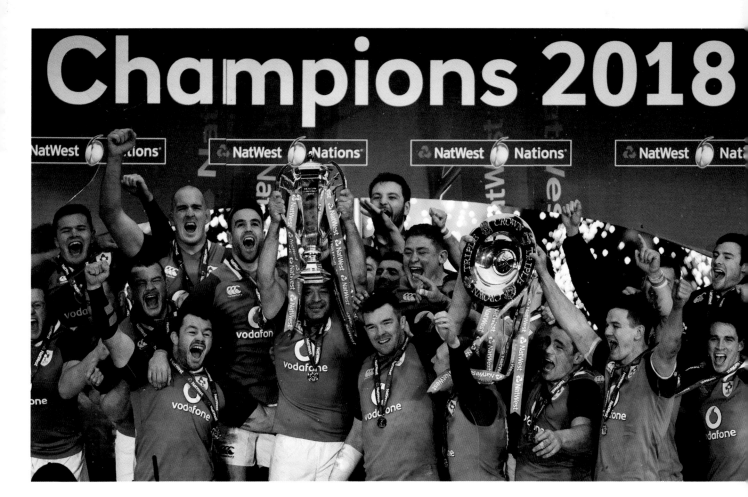

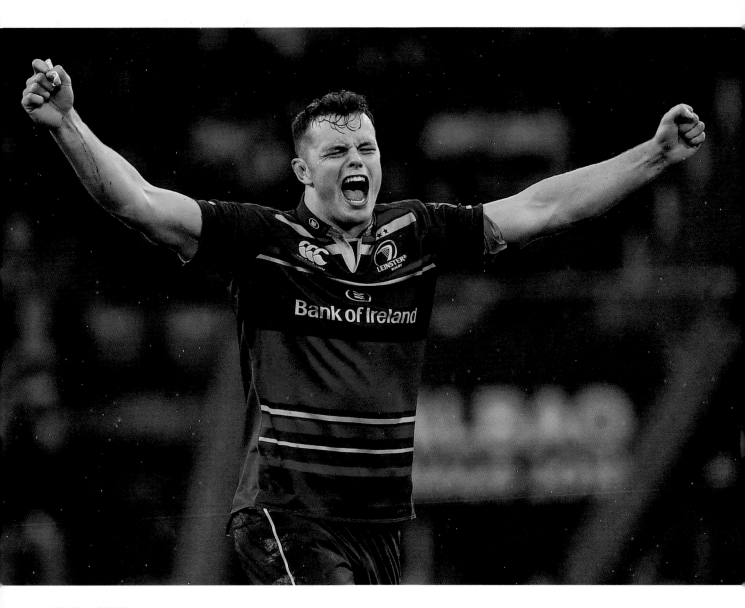

12 May 2018

James Ryan of Leinster celebrates after the European Rugby Champions Cup Final as Leinster edged Racing 92 on a score line of 15-12 to lift the trophy. Leinster v Racing 92, European Rugby Cup Final, San Mames Stadium, Bilbao, Spain.

Brendan Moran / SPORTSFILE

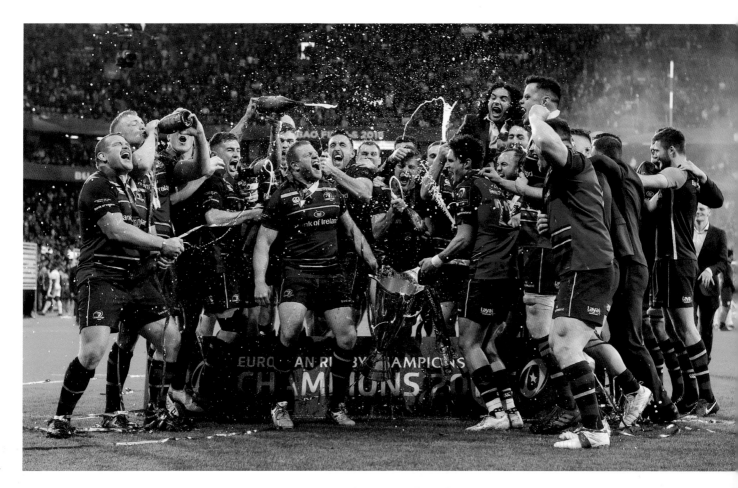

12 May 2018

The Leinster team celebrate as they win their fourth European Cup title.

Brendan Moran / SPORTSFILE

26 May 2018

Leinster celebrate following the Guinnes Pro14 final between Leinster and Scarlets in the Aviva Stadium.

David Fitzgerald / SPORTSFILE

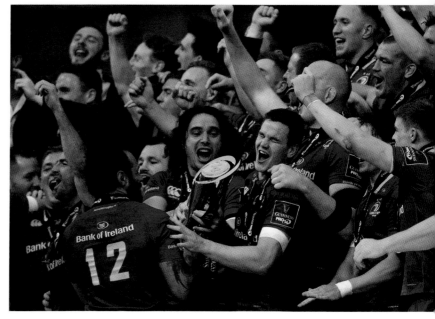

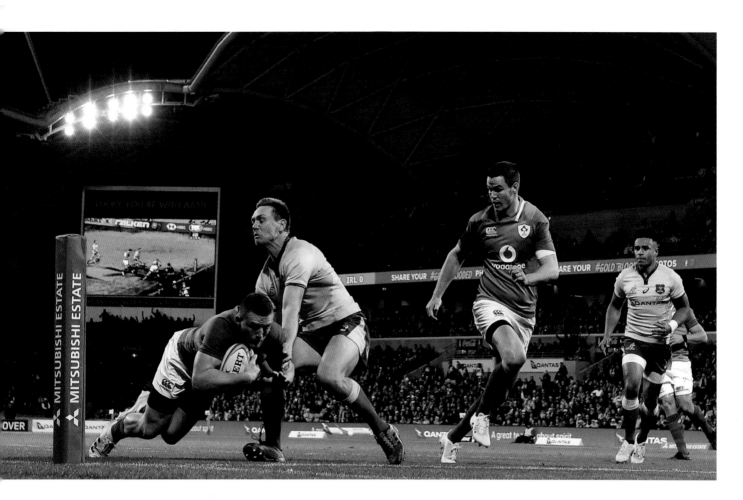

16 June 2018

Andrew Conway of Ireland
scores his side's first try
during Australia v Ireland,
2018 Mitsubishi Estate Ireland
Series 2nd Test, AAMI Park,
Melbourne, Australia.

Brendan Moran / SPORTSFILE

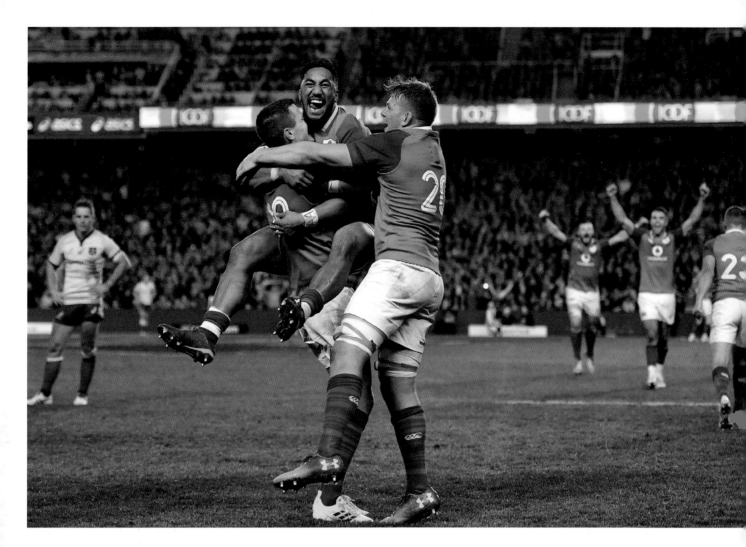

23 June 2018

Jonathan Sexton, Bundee Aki and Jordi Murphy celebrate as Ireland won a series
in Australia for the first time in 39 Years. Australia v Ireland, 2018 Mitsubishi
Estate Ireland Series 3rd Test, Allianz Stadium, Sydney, Australia.

Brendan Moran / SPORTSFILE

3 November 2018

Ian McKinley of Italy during Ireland v Italy, Soldier Field, Chicago, USA.

Brendan Moran / SPORTSFILE

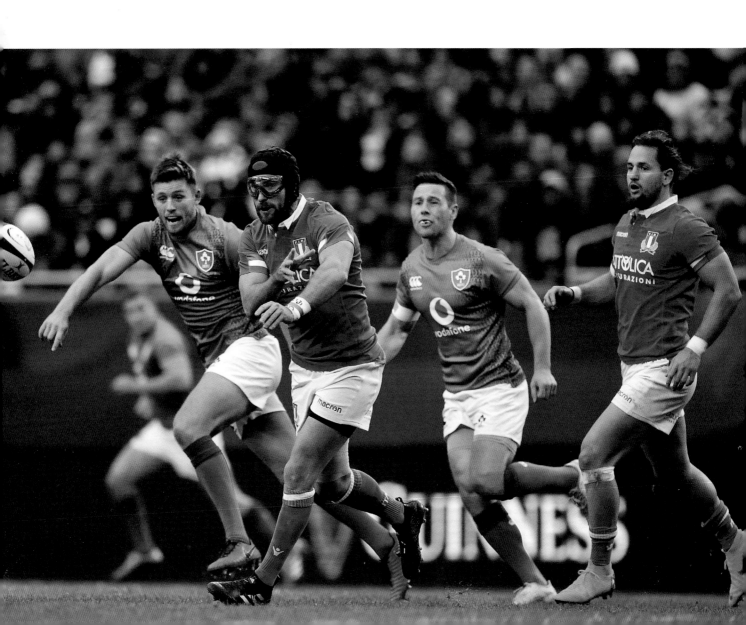

17 November 2018

Jacob Stockdale of Ireland celebrates after scoring the decisive try, following an audacious chip in his own half, against the All-Blacks in the Guinness Series International Ireland v New Zealand match at the Aviva Stadium. His attempted chip minutes earlier was charged down and nearly led to a try at the other end.

Ramsey Cardy / SPORTSFILE

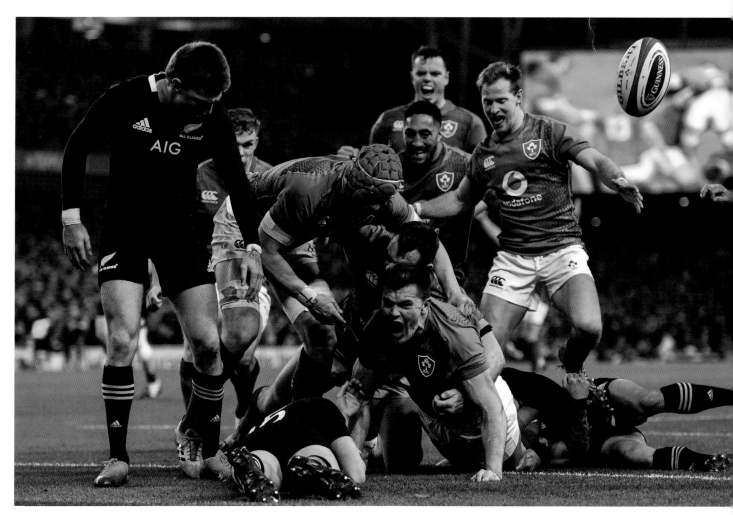

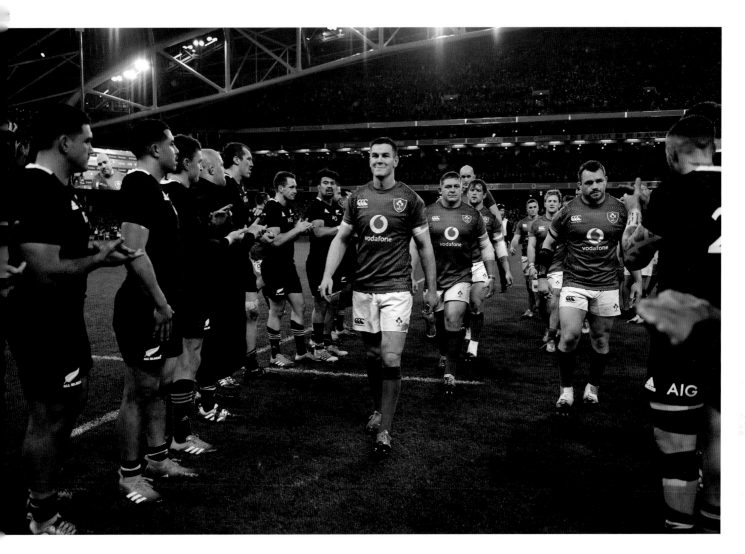

17 November 2018

The whole Ireland team are applauded off the pitch after a scintillating 16-9 win over New Zealand in their Guinness Series International at the Aviva Stadium. This dominant display was Ireland's historic first home win against the All Blacks and capped an amazing year which saw Ireland rise to number two in the world rankings.

Brendan Moran / SPORTSFILE

Opposite: 17 November 2018

World Rugby Player of the Year Jonathan Sexton and Jack McGrath after the Guinness Series International Ireland v New Zealand match at the Aviva Stadium.

David Fitzgerald / SPORTSFILE

24 November 2018

Andrew Conway of Ireland celebrates with Niall Scannel (left) and Darren Sweetnam (behind) after scoring a try at in the Guinness Series International Ireland v USA match at the Aviva Stadium.

Ramsey Cardy/ SPORTSFILE

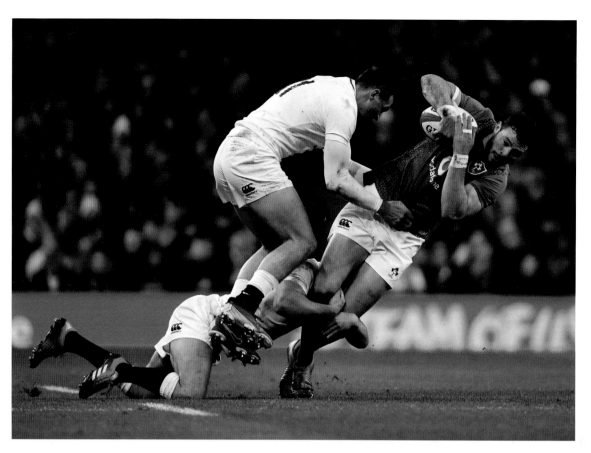
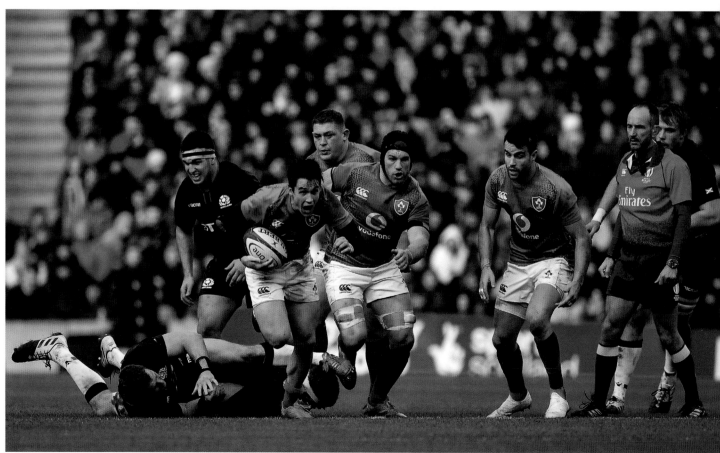

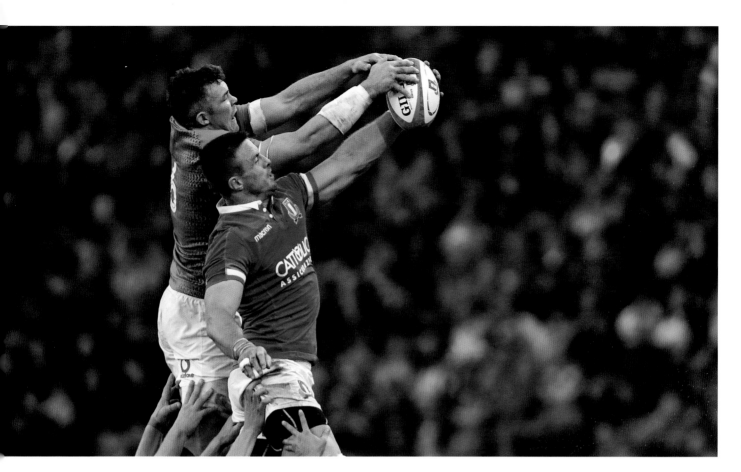

Opposite left: 2 February 2019

Back to earth with a bang: Robbie Henshaw
of Ireland is tackled by Ben Youngs and Jonny
May of England. Guinness Six Nations Rugby
Championship, Aviva Stadium. A resurgent England
dominated and ran out 32-13 winners.

Ramsey Cardy / SPORTSFILE

Above: 24 February 2019

Peter O'Mahony of Ireland. Braam Steyn
of Italy, Guinness Six Nations Rugby
Championship, Stadio Olimpico, Rome.

Ramsey Cardy / SPORTSFILE

Opposite bottom: 9 February 2019

Joey Carbery of Ireland breaks through the tackles
of Stuart MacInally (left) and Rob Harley in the
build up to Keith Earls scoing his side's third try
against Scotland. Guinness Six Nations Rugby
Championship, BT Murrayfield.

Brendan Moran / SPORTSFILE

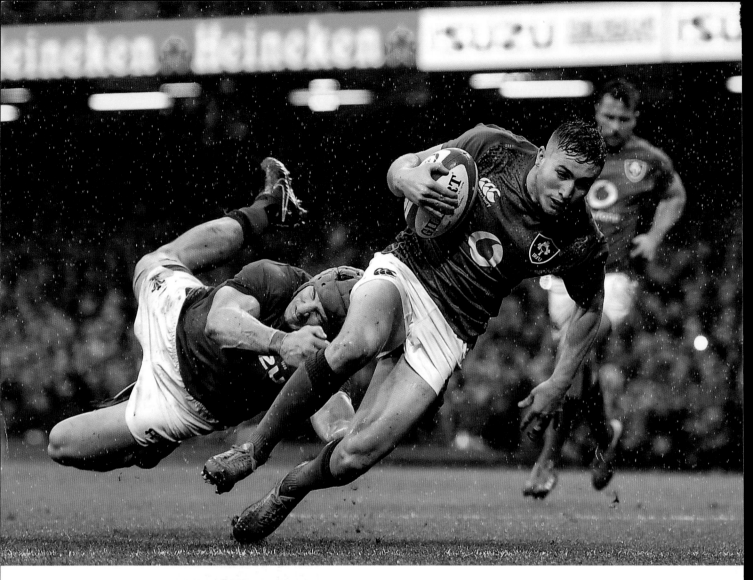

16 March 2019

Above: Jordan Larmour scores Ireland's last minute try despite the tackle of Jonathan Davies, and left, Ireland Vice-Captain, Peter O'Mahony, and Jonathan Sexton during the Guinness Six Nations Rugby Championship, Principality Stadium, Cardiff, Wales. Coach Joe Schmidt's last Six Nations game with Ireland saw Wales claim the Grand Slam with a 25-7 win.

Brendan Moran / SPORTSFILE